By Way of the Cross

By
Carol J. Ross

"O MY LITTLE OLIVE BRANCH"
GENTLE JESUS' NAME FOR CAROL

PUBLISHERS COMMENTS

†

HERE IS A REAL CROSS IN THIS LIFE. This is an extraordinary power filled autobiography as well as an incredible message for the suffering and the handicapped. The story, which we did not edit professionally, would have developed double meanings because who really can talk about pain and suffering but those that are constantly going through this unending challenge. The anger, frustration, perhaps even hate, and the "why me God" phase are all here, but the greatest out of all is the Love she has for her Gentle Jesus.

There are sections on faith and morals that Carol was brought up with, and were taught to her in Catholic Education in the lower grades similar to most brought up in the late forties and fifties. Her life now, like then is filled with pain and reason for discouragement (as of this writing she has been in a severe auto accident which adds to the all too many scars she already carries.)

The Chapters on her family in her early years as well as the growing up years and eventually her married years are filled with scarring of the heart continuously. Her search for happiness in this life is never ending but the realization that there is something that is far more valuable then just this life, begins the growth in her spiritual life which is the basis of this story. These stories are Carols, these happenings are Carols and as these stories begin to filter into your life as you read this book you too will begin to understand what is important.

There are things similar to Carol's experiences happening throughout the World at this very moment and in her next book, *By Way of Rome,* you will understand more. Even in this book she talks of other Visionaries whom she has met, but as you will see they all have their work to accomplish for God, making relationships only passing.

Please don't judge the literary value for if I or any one in the staff were to try and edit this perfectly, I am afraid that our judgement would alter the true message of the book.

DISCLAIMER

†

SINCE THIS BOOK IS AUTOBIOGRAPHICAL IN NATURE and touches only broadly on religious topics and is not intended to be a contribution to the faith and morals of the Catholic Church, it is hereby asserted that it is not necessary to submit it to ecclesiastical authority in accordance with Canon 823 of the 1983 Code of Canon Law.

It is of concern to many that Holy Mother Church does not want her children, especially priests, to visit sites of private revelations, such as "unauthorized" apparition sites. THIS IS NOT TRUE. Pope Urban VIII (1623-1644) has stated:

> In cases which concern private revelation, it is better to believe than not to believe, for if you believe, and it is proven true, you will be happy that you have believed because our Holy Mother Church asked it. If you believe and it should be proven false, you will receive all blessings as if it had been true, because you believed it to be true.

Regarding public and private revelation, the 1994 Catechism of the Catholic Church has this to say:

> 66. The Christian economy, therefore, since it is the new and definitive Covenant, will never pass away; and no new public revelation is to be expected before the glorious manifestation of our Lord Jesus Christ. Yet even if revelation is already complete, it has not been made completely explicit; it remains for Christian faith gradually to grasp its full significance over the course of the centuries. Throughout the ages, there have been so-called "private" revelations, some of which have been recognized by the authority of the Church. They do not belong, however, to the deposit of faith. It is not their role to improve or complete Christ's definitive Revelation, but to help live more fully by it in a certain period of history. Guided by the magisterium of the Church, the sensus fideleum knows how to discern and welcome in these revelations whatever constitutes an authentic call of Christ or his saints to the Church. Christian faith cannot accept "revelations" that claim to surpass or correct the Revelation of which Christ is the fulfillment, as is the case in certain non-

Christian religions and also in certain recent sects which base themselves on "revelations."

<center>†</center>

However, I wish to refer to a book translated in 1912, by a priest of the Chicago Archdiocese, Fiscar Marison. The book is the "City of God," written by Ven. Mary of Agreda (Spain) in the early 17th century. In the introduction, Marison writes about **why** God chooses more women than men in private revelation. Let me share what God has led me to learn:

Private revelation is given as a gift to us from God for the purpose of awareness and of His gift in giving us **higher** truths. He wishes us to **know** and **understand** through discernment.

God does not concern Himself with riches, position, or educated persons. Many who are visionaries or messengers are of a more **humble nature**, with compassionate insights. For example, St. Catherine of Siena, proclaimed a doctor of the Church by Pope Paul VI in 1972.

History has shown that God prefers women for private revelation. History shows these women have the gifts of humility, great piety, love, and are melted into their faith. God sees women as having molded in soul more of these characteristics. These seem to be contributions God looks for in these messengers. In God choosing more women than men, He gives us His understanding from the fruits. Therefore, when a woman is called to His service, and she says yes, such as St. Margaret Mary Alacoque and St. Bernadette Soubirous as examples, we are not bound to believe them, although we are wise to **listen**, pray, fast, and ask His Holy Spirit to help us discern.

<center>†</center>

Though many do believe me; I am understanding of those who wait and watch.

<center>†</center>

History shows that God seems to call on more women for prophecy, because of their inner ability in wisdom.

<center>†</center>

Note: This expresses clearly that the Roman Catholic Church believes and encourages Bible reading and accepting the truths of

Scripture and does encourage the use and reading of the Bible. It also explains why private revelation today is an **awareness** of those promises already told. Therefore, I encourage using valuable time for daily Scripture reading before consideration of private revelation.

> *Some people claim that Catholics are discouraged from reading the Bible. THIS IS NOT TRUE. Since Pope Pius XII's 1943 encyclical letter Divino Afflante Spiritu, **Catholics are encouraged to use and read the Bible.***

The Second Vatican Council (1962-1965) in its Dogmatic Constitution on Divine Revelation (Dei Verbum) states:

> *9. Sacred Tradition and sacred Scripture, then, are bound closely together, and communicate one with the other. For both of them, **flowing out from the same divine well-spring**, come together in some fashion to form one thing, and move towards the same goal. Sacred Scripture is the speech of God as it is put down in writing under the breath of the Holy Spirit. And Tradition transmits in its entirely the Word of God which has been entrusted to the apostles by Christ the Lord and the Holy Spirit. It transmits in its entirely the Word of God which has been entrusted to the apostles by Christ the Lord and the Holy Spirit. It transmits it to the successors of the apostles so that, enlightened by the Spirit of truth, they may faithfully preserve, expound, and spread it abroad by their preaching. Thus it comes about that the Church does not draw her certainty about all revealed truths from the holy Scriptures alone. Hence, both Scripture and Tradition must be accepted and honored with equal feelings of devotion and reverence.*

And quoting the Second Vatican Council's Dei Verbum, the 1994 Catechism of the Catholic Church states:

> *103. "... the Church has always venerated the Scriptures as she venerates the Lord's Body. She never ceases to present to the faithful the bread of life, taken from the one table of God's Word and Christ's Body."*

> *131. "And such is the force and power of the Word of God that it can serve the Church as her support and vigor and the children of the church as strength for their faith, food for the soul, and a pure and lasting font of spiritual life." Hence "access to Sacred Scripture must be open wide to the Christian faithful."*

TABLE OF CONTENTS

✝

TABLE OF CONTENTS

†

TABLE OF CONTENTS

†

PRIVATE REVELATION IS AN awareness; a reminder of God's Scripture. It provides the incentive, along with prayer and meditation, to grow deeper in love with our Father through Divine Jesus, the Holy Spirit, and Blessed Mary, (through prayer and devotion.)

†

I do not wish for you to feel superior or inferior, if you do not believe in private revelation. You are not obligated to believe. Private revelation is for awareness; all salvation has been accomplished already by Jesus.

†

A priest gave me a good guideline when we were in Medjugorje. He said, "If the revelation brings glory to God, and it is not separate from the Bible or Church teachings, you may find guidance in this. For the evil one, in his falseness, will not give you peace, happiness, or hope. He will not bring you closer to a transformed, converted, better holiness with others."

†

I do not ask any faith to sanction the visions I have seen, or to validate any apparition sites where they have occurred. This will all come to be—in God's timing.

†

I am a simple woman. One only need know me, to realize that these words come from His Holy Spirit inspiring me. My husband and many friends are my support, as well as my critics. In this book, all things come together.

†

I attribute this book to all my family, close friends, and co-workers, who have persuaded me over the years to pour out my soul in writing. I dedicate this book to a few of the many who have been a great inspiration in my spiritual growth:

Thanks to Jesus for His word, for being my Teacher and friend. Thanks to Blessed Mother, my Caretaker.

In memory of my father, Sylvester and my grand-father, Thomas.

My holy husband Robert Ross who encourages and aids me; my friend Martin Miller who spiritually guides me and is always my confidant; Grandmother Bernadette, who taught me devotions; my teachers Sister Cyrina and Sister Carola; a saintly woman Adora; evangelist, Pat Robertson; model of sainthood; Mother Theresa; and my past and present spiritual directors.

I sincerely thank God's "little secretary," Ginny

Lopez and Michele Winkler, who devoted much time asking His Holy Spirit to guide them in this publication. I give thanks as well to Jim, who was led to us by Our Lady and by His Holy Spirit who has made this all possible.

I give thanks to Our Lady for the gift of fine art given to all in this book by professionally known artist, Prudy McKenzie.

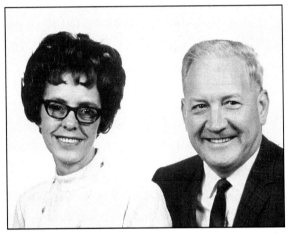

I dedicate the chronicles of my life, my faith, to my parents who planted a Christian seed, Maude & Sylvester "May their souls rest with Our Eternal Father."

FORWARD

†

IF, AFTER READING THIS BOOK, you wish to be judgmental, critical, unforgiving I will accept it as my cross to bear.

In 1993, my parish priest gave me much to think, pray, and fast about. He warned me that not only what I say, but my life and my soul, as well, will be laid bare before the world for judgment. If you knew, that Mother Church was extremely protective of Her Children, you would understand the scrutiny one must undergo in revealing what is written in one's soul.

After two priests painted a bleak picture for me, I placed their warnings and the awesome things that have happened to me before my Divine Jesus. After spending long hours in reading scripture, meditating, fasting, soul searching, and considering what this could mean for my family, I was given peace. My Bible fumbled open in my hands.

> *"For I tell you this, you will never see me again until you are ready to welcome the one sent to you from God." (Matthew 23, 39).*

I said, *"Thank You, Jesus. Thank You, O Holy Spirit."* With scriptures opened, I read further, His Holy Spirit led me to understanding.

†

If Mary Magdelene, who had a burning desire to love her God and a passion not to be lost or separated from Him, could speak out, why can't I?

Although she is depicted by some as a sinner who was grateful for Gentle Jesus' mercy and forgiveness, her love heightened for this friend, Jesus.

Gentle Jesus, knowing Mary's deep, most innocent love for Him as her God, so loved her that he came to her in a vision, consoling her grief.

Although she obeyed His instructions, who would believe this grieving woman, now so joyful from seeing her God!

Even one of the apostles, her friend, who knew her well, did not believe her. Would an entire town?

But, courageously she told the truth of **her apparitions**, regardless of the scorn she would receive. Mary Magdelene announced:

> " . . . that she had seen Jesus, and he was alive!" (Mark 16: 10, 11)

If the weak apostles, who feared death spoke out, why can't I? Gentle Jesus, understanding their human fear, came in an apparition to them. And they all came forth in a new courage.

> They announced: " . . . we all are witnesses that Jesus rose from the dead." (Acts 2: 32)

Who am I to be frightened by the possibility of scorn

and subjected to those of little faith. Would it not be worse for me to lie? Would you feel more comfortable if I were to keep silent? After all, I am given a great assignment by God. He has chosen me to be a **witness**. **He has entrusted me**, as He did Mary of Magdelene, and the apostles of His day, to say in my testimony:

<p style="text-align:center">†</p>

"I have seen our Risen Savior. I have seen Him! He has spoken to me!"

<p style="text-align:center">†</p>

I have seen His Presence in the Sacramental Glow around the Eucharist, as well as in apparitions.

Can I deny what I have seen? Can I deny what I have heard? Can I take His assignment to me as a witness lightly?

I went back to my priest and spiritual director assigned to me by my Bishop, and in writing I stated: "I am of sound mind and on no medications. I have made a decision to continue to witness. (10/93)."

♦ ♦ ♦

Jesus, Jesus, I come in Your Name, my
Savior.
I ask in Your Name, that You bless those who
have lost their way,
Lost hope in their relationships with You.

Bless those who have fallen deeply into sin,
And feel "left outside," lonely, depressed, and angry.
I ask that all the fears, heartaches, needs, hardships,
and pain
Be removed.

Restore their life in Your Light.
Give faith to their souls,
And cover them with Your veil of Mercy.
Let all know You are near.

Teach them to reach up and sing Your Name,
And You will be there.
Work a miracle.
Deliver their souls into Your Peace.
Amen.
(Little Olive Branch)

True Beliefs

I AM CONCERNED THAT those of you who are misinformed will want to say: "Here they go again—adoring Mary, worshiping idols, having hallucinations."

I wish to tell you, my brothers and sisters in Christ Jesus, that true Catholics do not adore or worship anyone or anything except our one and only Almighty God.

<div align="center">†</div>

We do place great *honor* upon the Virgin Mother of our Savior, Jesus. For He also loves His Mother and has made her Queen of Heaven.

We do not idolize a statue or picture. They are *merely reminders* of someone who once lived on this earth and is now in Heaven, just as a bust of your grandfather or photo of your dear mother is placed on a mantle or wall. Some may claim that a picture of Christ is the same as the Eucharist. This is *nonsense* and those who claim this are confused. God is not in any piece of man's artwork. The Holy Eucharist *is* the Body and Blood of Jesus Christ. This is our true belief.

The crucifix is a cross to which is attached a corpus, the figure of Christ crucified. Once again, it is a reminder. We do **not** put Mary on the cross. If you should see such a crucifix, it is a gimmick to make money. It is **not acceptable** by the Catholic Church. Satan is doing all he can at this time to cause distraction, division, and confusion. Sure she suffered as a mother would, but she was not crucified for us, ONLY JESUS was sacrificed for us. Truly, I understand the suffering of a Mother for her dying child.

<div align="center">†</div>

When unexplainable events happen, our Mother Church takes great care in examining what possibly appears to be a miracle. We have been known to receive "awareness" gifts; phenomena such as blood or tears coming from pictures or statues. These liquids are collected for scrutiny and testing by the Church. This does not mean we are now idolizing a statue. It means only that Divine Jesus or Blessed Mary may be calling our **attention** to an **awareness** of some special message. We understand that Their heavenly spirits **are not present within** the statue or picture. His presence is everywhere.

God's Presence, the Holy Spirit, dwells in our souls when we cleanse ourselves and call upon the Holy Spirit to enter. God is present in His Word, and we are fulfilled in Wisdom by His Word. God's Presence is with us in prayer. God's Presence is with

us in moments when we are not even aware of Him being with us. His Presence—Body, Blood, Soul, and Divinity—is also with us in our Holy Eucharist. In all of these times, God has a message for us: *"I LOVE YOU. I AM HERE WITH YOU."*

Why is it so difficult for some to believe that Jesus or Mary or any heavenly being can visit earth, and yet accept that a loved one can appear to them after death? Some claim that a picture of the deceased suddenly flipped over at the moment of death. Some tell of an entire family smelling the fragrance of Dad's pipe after he was gone. Some remember a light streaking across the room, or feeling a draft when no windows or doors were open, when speaking of a deceased loved one. Some have felt uneasy, as though an unseen someone were close by, and many have experienced taps on the back, or have heard a rapping on the window or door, sometimes on the second floor with no stairs or balcony near. Only hours later they find out that someone they cared about has died. Our family has always believed that the soul who knocks is begging us to pray for them to see God.

If you can believe in phenomena of this kind, then why is it not possible that the Eternal God can do wonders, sending beings into this world to bring about glory! Why can you not believe He, who can do all things, can and does come to chosen witnesses, in spirit and in being.

If ever there was a time when religions needed to understand the true beliefs of their brothers and sisters, it is now. What caused confusion between religions in the first place? I was told it was because of the many different interpretations.

Is there time for another two thousand years of theology? Possibly, but according to the Bible and the signs of the times, *NO!* Is there time for the puzzle of religions to come together for a larger picture *DESIGNED* by God? Yes, and it could be so easy. It is called *PEACE, UNDERSTANDING, RESPECT, TRUST, LOVE* of one another, living in harmony.

To label oneself by a religion is segregation. To say, "I am a child of God," is to hold respect for all God's children and their beliefs. All for the *glory* of our one and only God.

†

Today there are those who choose to remember that God gave us fearsome laws—live by them or else. There are also those who wish to forget the laws of God given through Abraham, Moses, and Jesus.

†

Because of so much confusion in interpretation, I firmly believe Jesus is close to us today, giving messages, leaving instructions, coming in Spirit to men, women, children, and leaders of denominations

around the world, that we may take heed quickly to convert our lives and help the souls of others.

<p style="text-align:center">†</p>

God's gifts of joys and sufferings, were meant to **mold** me into who I am today for His plan. We live many chapters in life, and the **seasons** of our lives are in our experiences. In God's timing and choice, a new chapter of life began for me with the beginning of visions.

<p style="text-align:center">†</p>

I believe in miracles of change from within. Later on you will read of miracles by faith in my autobiography, as well as receiving miraculous signs.

<p style="text-align:center">†</p>

This is my story of my life with Our Lord.

<p style="text-align:center"></p>

Innocent Love

I was BORN IN 1938, in a garage that my parents, Sylvester and Maude used as a home during the depression. This birth place was a port city or lumber town called Muskegon, located along the harbor shores of Lake Michigan.

†

We lived a very modest family life. During the Depression, Dad was forced to work for the state. This shamed him, and though we lived on mostly garden vegetables, Dad with his meager salary was able to rent a home by the time I was one year old. It was a great day when Dad was hired by Continental Motors (now known as Teledyne) where he worked as a laborer until retirement. My quiet mother was a gentle housewife, though she was very sickly.

†

So, at a very young age I became a caretaker of our home. I recall by four years old, I could prepare pies, cook a dinner, and help keep an orderly home. I was second to the oldest child and Mom depended on me most of all. Learning about Jesus was hearing one wonderful story after another. Learning a song from a

Protestant playmate "Jesus loves me, Yes, I know," was also a teaching. Though in those days to sing a Protestant song, I was spanked. Daddy feared the Protestant thinking would influence me. This is what he was taught and therefore, taught me. Our Protestant friends were taught the same prejudices, to stay away from Catholics they are a cult. Of course, this all was the result of not understanding or being respectful of another's faith.

<div align="center">†</div>

Grandpa Thomas, also was a great teacher, he was tall and a powerful man in opinions, but he was gentle with me. He would read the bible to me, teaching me stories, including why priests could call Jesus to become living in the Eucharist. Each visit Grandpa and I did two things: we worked in his garden, and he read the bible to me. I do not recall ever saying the rosary with Grandpa though I remember a rosary laid on the arm of his chair.

<div align="center">†</div>

Still four years old, I began to have a very personal relationship with Sweet Jesus. It did not seem to matter that I didn't have a doll and was content with paper dolls; for I had a real person to love and who I knew loved me. He was Sweet Jesus.

15

I wanted a baby sister so much because my older brother Dick, often did not want me to play with him. So I asked Jesus one day for a baby sister. I knew then that prayers were powerful! Two baby sisters were born to our family. I thanked Jesus for answering my request.

<center>†</center>

By the time I was seven, I was blessed with caring for my twin sisters as if they were my own. Through the raising of them I learned how to balance time, and surely, how to care for children so that one day through this gifted experience I could raise my own children.

<center>♦♦</center>

We moved to the foot of the hill and Daddy began to remodel our home. In the early forties, materials were hard to come by and we often went to Cadillac, Michigan to get supplies. This made a nice trip north. I also remember the stamps of the forties and even the yellow ball inside of the white margarine that when squeezed, it colored the spread to make it look like butter. I remember the print on the flour sacks. We would save them so we could sew skirts and other garments.

<center>†</center>

I was not spoiled with material goods. In fact, my bed was a sofa and my dresser was a box at the end of the sofa. I wore hand-me-downs from my cousins. I was happy to have them, and Mom Maude occasion-

16

ally sewed a garment for me.

My father, Sylvester, taught me the rosary by gathering the family together, on our knees in a unity circle, after supper.

♦♦

I remember my sixth birthday (my only birthday party until I was fifty-five). I especially remember the pale floral dress my two aunts bought me, the sparkling hair bow and the blue glass dishes that my grandmother gave me. It was my Grandma Bernadette, who also gave me my faith. She talked to Jesus, praying and singing hymns every time I was with her. I felt cared for by Grandma Bernadette, and she hugged me when the others did not. Few knew Grandma as I did. She prayed with me at her home altar with her blessed lit candles. She would bless me with holy water on every visit.

♦♦♦♦

Seven & In Love

S PRING IN MICHIGAN is damp, chilly, and barren, but each day that the sun pops through brings the gift of hope. A new spring begins for most with the preparing of the soil, planting seeds and checking the fall pruning for the new spring buds.

I remember my Daddy preparing the family garden. Just as Daddy prepared the soil for the blossoming of vegetables, and pruned the trees for the blossoming of fruit, so too, he was the first man in my life to prepare me for the blossoming of my faith. He taught me about Jesus through church and songs. Daddy loved to sing. I watched and listened as he taught me through lyrics, statues, rosaries, pictures and prayer books. Every relative's home had sacramental items (religious articles) like statues of Mary and Jesus, crucifixes, pictures, and rosaries. In church I was taught to light candles, asking to be a light in God's eye that He may hear my request. We used holy water regularly, and knelt to pray; we sat to listen, and stood to sing. The liturgy of the Mass was in Latin, so we did not understand the words except those in a song we were familiar with. However, God made it possible for me

to understand much of the meaning. I loved Mass from early childhood. I wished I could have been an altar girl, but it was unheard of in those days. So I planned one day to have the honor of cleaning God's house. In the second grade I attended the public schools. My first cousin Freddie and I, who were like twins, had to walk three miles to St. Mary's school downtown. Sometimes we were treated to bus fare.

<div align="center">†</div>

In class, we were taught only by nuns, and from this religion class, we learned our lessons from the old *Baltimore Catechism.*

<div align="center">†</div>

From early age through first grade, Freddie and I were close. I truly loved him. Even today, he is still a great influence in my life. Once he even considered studying for the priesthood.

<div align="center">†</div>

We prayed, played, and learned together. I trusted Freddie with all my thoughts. I mention Freddie because he was the center of my life.

<div align="center">♦ ♦ ♦ ♦</div>

Hearing about God's Holy Spirit was a mystery (one which took faith that we were being told the truth by our parents and nuns and the bible.) The more we

learned to pray, repeating the prayers over, the more I began to understand and believe in the meaning of the prayers. I enjoyed praying and depending on my Jesus to love me. He had become a close, loving, and needed Friend. Also, learning about the Holy Trinity from the nuns helped me to know God as loving.

◆◆

One spring in Michigan, I remember kneeling with Grandma Bernadette in the old church of Our Lady of Grace on Jackson Street. She would sometimes have tears at Communion and she always lit a candle at a side altar before leaving the church. Grandma was poor, but she usually dropped money in the collection basket.

As young as I was, she always talked to me about the need to be a virgin. I did not understand the meaning of the word at six years old, but the word virgin was imbedded in my brain. To be a virgin was to be a nice girl, this I knew, and the reminder of the word meant Our Virgin Mary.

†

Through Grandma Bernadette, I was also led to grow in understanding of Jesus' mercy for all, although she preached often on mortal sin, purgatory, and damnation by God's hand for those who didn't try.

◆◆◆

Influenced by my Daddy, he also taught me more about Jesus' suffering for us on the cross. He took me

to the stations of the cross during Lent. Through these prayers, even a small child becomes sad that Jesus went through so much physical suffering. In the stations, I learned about His Mother's heartache as she looked upon her Son's suffering.

Through reflecting on the pictures and statues, the stories were more vivid and real to understand. This remembrance was just like seeing a photo of Grandpa Michael, who died before I was born. After seeing his picture he seemed more real to me.

<div align="center">♦ ♦ ♦</div>

As I learned who Sweet Jesus truly was, I became closer and closer to Him. I believed He was with me at all times. I would talk with Jesus while walking, and devoutly pray to Him at night. I prayed not only the prayers that Daddy taught and all Catholics say, but prayer from my feelings, heart, and voice. By the age seven, I believed that Jesus was somehow really mysteriously present in Bread and Wine in the Mass. As a child, I did not need to understand the nature of this transformation. Through my childhood faith, I believed! I believed that the Holy Spirit was the feeling I had when I was sure someone or something was close. When I was afraid or hurt, His Holy Spirit consoled me. I have never believed this was merely a state of mind; I believe His Holy Spirit comes to children, too, and Jesus really loves children.

<div align="center">†</div>

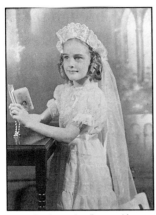

Carol—1945 at 7 years old.
Her First Holy Communion.

In May of 1945, on my First Communion day, I received a white lacy dress, white lace veil, and white shoes.

My Aunt Mary told me that I looked like a Princess and I felt like a Princess too.

Having completed my sacrament of penance (confession), my soul was as clean now as my white dress. My heart was so open and hungry for Jesus' Presence to come into me through Holy Communion, receiving the gift of Host and Wine, made Body and Blood by the miracle power bestowed on all priests! Wow!

I remember being in a procession. It was as though I was alone. I just wanted the line to move so that I could receive my First Holy Communion, my Jesus!

♦♦

Jesus really loved me! He came to me, little me, in Communion! I felt like His little bride who would be in love with Him forever!

†

At every church I visited, I wanted to sit as close to the tabernacle as I could, so that I could be close to His Holy Presence.

♦♦

Back in the 1940's, there were no extraordinary

22

ministers of the Eucharist (popularly called Eucharistic Ministers). Not even nuns touched the Holy Host. Only a priest could touch the Holy Eucharist, this being not an unchangeable dogma of the church, but liturgical law which was changed by the Second Vatican Council (1962-1965).

We devoutly knelt before the carved, wooden crucifix at a railing in front of the altar steps. As our Blessed Sacrament came near, we opened our mouths and put out our tongues to receive His Presence in the Host! An altar boy would show reverence, holding a paten beneath our chins, for fear that even a crumb of our mystical Presence of God might accidentally fall.

I was fed the seed of faith by my Daddy, our Holy Spirit reigned, and my faith and my love blossomed!

◆ ◆ ◆

My first *meaningful love* was at age seven: **My Jesus.**

His Presence is Brilliant

OCTOBER IN MICHIGAN IS a most beautiful month. I love this season the most. It's cooler, less humid, and still a season of life and color. Fruits are bearing. To me this is not fall. I would call it Indian summer, for I come alive in this wonderful, colorful season! Oh, God is so wonderful to paint such a picturesque dreamland each year of several shades of green crimson, orange, gold, yellow and rich browns.

†

In 1948, I was ten. My friend, Janet, and I strolled to Our Lady of Grace Church on Saturday for our usual monthly confessions. Our modest attempts to find sin usually gave our priest a chuckle.

My sins always seemed to be a repeat. *"I'm sorry I was not able to keep quiet and not fight with my brother. I really try. He was a tease and often mean at times. I keep promising I won't fight; then, I do. If I didn't have to live in the same house with him—tell me, Father, did you fight, too?"* He laughed. We often had this same conversation. This was my sin as a child; I fought with brother Dickie. Father would grant me

absolution and the usual penance: three Hail Marys, three Our Fathers, and a good Act of Contrition. Each time I'd promise to try even harder.

<p style="text-align:center">†</p>

When Janet and I returned to our pews on this particular Saturday, we could hear the choir ending practice in the choir loft. An elderly man was lighting a candle at a side shrine, and I recall the priest leaving the confessional and going into the sacristy as he tugged the stole from his shoulders.

As we knelt in the left front pew, in front of the tabernacle of Our Lady of Grace Church, I was talking with my Jesus as I always did. Soon I heard "click," like metal touching, and I looked from the crucifix to the tabernacle in front of us.

I saw the golden doors open! Inside was a brilliant, illuminating light! The light became so brilliant, that I could not see the ciborium that was inside. Then the doors began to close.

As the doors were closing, Father came into the church. He, too, saw the doors close by themselves.

Father came over to us and said, "Were those doors open?" As if he was not sure of what he saw.

I replied, *"Yes, Father, and a bright light is left on inside."*

Father placed his hand to my head, "Christ's child," he said. His smile and soft eyes let us know that he

was pleased.

The following Monday Janet and I told our teacher at St. Mary's School. Sister took us over to see Father Dark. He questioned us both. I straightened the skirt of my dark blue jumper and made sure my uniform and sparkling white ironed blouse were in order before speaking to Father. After all, to be called before our priest was like visiting the president! (Janet and I had not told our family—only Sister. We thought that "God's things" belonged with God's "working people.") Besides as a younger girl, when I spoke of Jesus loving me, I usually was punished.

<div align="center">†</div>

Father Dark of St. Mary's church came in, he seemed large, and with a deep voice He said to me: "Young lady, I hear you believe something happened in church." Before he could say more, I spoke up, *"Not your church, Father, but at Our Lady of Grace, on Saturday, after confessions."* "Tell me what you told Sister," Father Dark asked.

"Father, this is true," I said. "We were in the front pew in front of the tabernacle, and the gold doors just opened wide! No one was there opening them, but they opened. And a bright light came on! It stayed all the while I was talking to Jesus. The doors closed slowly, with a very bright light left on inside. And Father saw the gold doors close, too. Ask Father." From that day on Father Dark never forgot our names

around school or church.

<center>†</center>

What did all this mean? For years we could not understand why this happened. Why did God show His Presence in His brilliant Light to us as children? I asked this of priests over the years. One priest told me while I was still a child: "One day you may know why. This may be only the beginning."

Little did I know how right that priest was.

<center>♦ ♦ ♦</center>

Today I know why, at the age of ten, I saw His Presence in the tabernacle. I have been given the gift of *a love and a hunger* for His Holy Eucharist. Many future visions I have witnessed have been near the tabernacle holding the Eucharist. Surely I have been shown, over and over, that I am called to *share* our Eucharistic wonders through evangelizing.

<center>♦ ♦ ♦ ♦</center>

†

"Let the little children come to me . . . "
(Matthew 19:14)

†

Heavenly Father, thank You,
That I am Your child.
You guide me, walk with me,
Play and listen to me.
As Your child,
I know I may ask You to care.
By Your word, I know You love me.
For the Bible tells me so.
Amen.
(Little Olive Branch)

Washed in Spirit

OUR LIVING SPACE was cramped. It was my good fortune to have the heat register beside my sofa. I would jump out of bed directly onto it during those freezing midwestern winter mornings and shake myself awake. I still can recall the toasty warm sensation on my feet.

I did not have a childhood as most children would know it. I spent very little time being a little girl. At seven years old, I babysat for others and at eight years old I washed celery at a nearby celery bed, filled my wagon with it and later sold it door to door. In those days you turned over your earnings to your parents. I regularly wore hand-me-downs from my cousins. Often I was teased at school for wearing my uniform on days it was not required. But the crisp white blouses and shirts I wore had been meticulously starched and ironed by my mother, who believed cleanliness was next to godliness.

<div align="center">†</div>

In addition to my fathers' teachings, our early religious years were greatly influenced by the priests and nuns in our parish. Then, devotion to God set a stan-

dard for my soul that remains to this day. They gave my life a wholesome foundation.

My father was a good man who was raised in a "very strict" manner. He didn't have much formal education. He knew no other way than to raise his children the same as he was raised.

My parents believed in using the strap and Mom threatened, "Just you wait until your Dad gets home." Needless to say, I learned obedience early. And it wasn't until my late twenties as a mother of five children that I even dared to attempt to establish my independence.

<p style="text-align:center">†</p>

My mother and father both came from large families. All the relatives lived close to one another and socialized on a regular basis. It was a rule that we visit Grandma Barbara and Grandpa Thomas every week. My great grandmother, Mary, lived to be one hundred seven. Even now I wear my hair as she did, in a long braid and sometimes wrapped in a bun on the top of my head.

On my father's side I had a close, loving relationship with Grandma Bernadette, Aunt Bea and Aunt Mary. As the first granddaughter born on this side of the family, I was cuddled a lot.

<p style="text-align:center">†</p>

In second grade, I still attended the public school I loved school! I enjoyed each day and eagerly prepared

for my lessons! There, I could leave all my cares and chores at home. By third grade I was in parochial school, there I could be just a little girl. I can still recall the wonderful happy feelings I had every day at Mass and prayer.

<div align="center">†</div>

The years passed, it was 1950. I was to be Confirmed by the Bishop in colorful vestments and miter. He would anoint my forehead, pat my face and I would become a soldier of Jesus Christ; washed in His Holy Spirit. This day held greater excitement for me than the day President Harry Truman raised me up in his arms at the train station.

<div align="center">†</div>

I wore the hand-made suit my mom had made for me. Aunt Irene was my sponsor and my Confirmation name was Marie Theresa. When the Bishop posed the proverbial question "Do you know the meaning of Confirmation? My hand shot up. Being the littlest one, I sat directly in front of him and frantically waved my arm. I never expected to be acknowledged by His Excellency but he called on me. I answered, *"I expect to walk out today, never to be the same girl. I know I have promised to give all my life to Jesus, and to stand up for Him Who is my Faith, all my life. I am to be active in my Church and do for others. I must love all God's children and help them. I must stay holy and obey all of God's laws and the laws of the*

Catholic Church."

His Excellency stated, "You plan to do all that?" And people laughed.

But I was not embarrassed. I remember smiling back at him and saying, *"Yes, I sure do."*

If only he had known how much I really meant in my heart, that all of me was on this earth only to do whatever God wanted me to do. Surely, if everyone had the innocent faith and trust, and the honest desire of a child, getting to Heaven would be easy.

<div align="center">†</div>

On my Confirmation Day I made my promises to God and to my Church by my own will. *As I knelt in the pew with my eyes closed, I felt as though I was alone with God, and a great feeling of comfort came over me. I remember thinking that Jesus must be very close. When I went up to the altar and stood before our Bishop, he used my name. But I felt as though I was standing before Jesus, even though I knew the Bishop was only taking Jesus' place. As he prayed over me, I basked in peace and love.* Surely it was our Holy Spirit with me on this wonderful day of promises! I was making my covenant with God!

<div align="center">†</div>

Surely, on my Confirmation day, I received a waterfall, a super washing!

<div align="center">†</div>

Recently, I had a conversation with a woman who

said she had received the Sacrament of Confirmation at the age of seventeen. But she didn't understand then or now the graces bestowed upon her by the Holy Spirit. For this reason she had delayed having her daughter confirmed until after she turned eighteen.

<p style="text-align:center">†</p>

I told her, *"Praise Jesus, you have become my friend. Let me do as I promised that day and tell you of the Gentle Jesus I know and of the wonderful Catholic Church to which I belong."* For two hours we talked. She also said that there were times when she couldn't help herself feel prejudice towards the poor and minorities. They both disgusted her.

I held her in my arms and then said, *"I love you even when others don't like you. I love my black brothers and sisters because they were given the same whisper of breath from God as ourselves. I love those who are in poverty because it gives me the chance to do what I promised to do, care and love all my brothers and sisters in Christ. They all give me a way to earn Heaven. Come with me this week and we will find people in need and help them. Don't fear them. Reach out with me. You will love the feeling in your soul as you are appreciated by Jesus."*

She agreed. She has spent several years now working, collecting food and supplies for the poor. She calls on the Holy Spirit to give her wisdom and discernment. She will never be the same. She is truly

33

confirmed.

 Time passed. Today, the child I was, is a measure of who I am. We are molded by each event and each belief.

♦ ♦ ♦

†

Holy Spirit, come.
Help me to welcome all my brothers and sisters.
Give me strength through Your Will, to help others.
Let me be led by Your Hand,
That I am in the right place to help
My suffering family of this world.
Let me see the beauty and unique molding
of each human.
May Your Light, that lives in all, be seen by me.
May I recognize a goodness in all
By showing mercy and love for others.
Open my heart to others' needs.
Fill me with a compassion that all are equal
And welcome into Your Heavenly Home, me,
the least.
I know You made everybody to be
somebody unique,
For we are all in Your Image.
Holy Spirit, come.
Soften the hearts of all men, women, and children.
Give hope and courage to those depressed,
That they may face challenges and temptations.
I believe in Your Victory over satan!

I believe in Peace through Your Word!
Amen.
(Little Olive Branch)

CHAPTER 6

Illness is Not the Disease: Ignorance is

I FELT EMOTIONALLY OLDER than the other girls my age because of the responsibility I had at home. I enjoyed talking with my aunts or the nuns more than girls my age. I believe it was for this reason that my parents allowed me to date at a very young age. Dating meant meeting a boy at a roller rink, school dance or football game. Maybe a group of kids would go together to a movie. *Going steady* rings were one dollar, and everybody had to wear one. Boys wore fuchsia socks, white buck shoes, and crew cuts. Girls wore loose cardigan sweaters, saddle shoes, and pony tails.

Being ***popular*** in the true sense, meant that you had many friends and were involved in most of the school events. I belonged to the basketball cheerleaders, played drums in the band, and sang in the choir. Someone was always calling me for a date, and girls never called a boy. Parents met and approved of your dates ***before*** you went out with them. Boys did not honk the horn. They had to arrive at the door and promise to have you back by curfew. Grandma Bernadette gave me a hat pin which I kept in my

purse. This was for jabbing a boy if he tried to get too close. Grandma gave us our guidelines. You remained a sweet girl by Grandmas' rules.

Life was wonderful. I loved high school! I loved life. I loved my closeness with our Blessed Mother, and my best friend, Jesus, who stayed with me, even as I grew up.

<div align="center">†</div>

During the fall of that year, I had many sore throats and fevers. I went to school exhausted, walking six miles in the cold with bare legs and no fall raincoat. Each day I became weaker but I was determined not to miss school. My mind was awake and quick and I was eager to learn, even in algebra class.

It was in this algebra class where I got sick. My friend Phyllis and I giggled and chatted as we sat down for our lesson. The teacher was talking when I became aware that I was struggling to concentrate. One moment I was feeling very hot and the next moment I was very cold. I tried to shake it off. I hoped it would go away so I wouldn't be sent home. The bell rang to change classes and the other kids leaped from their seats and took off. Phyllis waited by the chalk board as I slowly gathered my papers and books. *I began to lean sideways expecting my legs to move. I strained to move my legs, but they would not move. I struggled but no movement. My left arm felt heavy and my papers and books fell from my hands. I could not*

Illness is Not the Disease: Ignorance is

hold them. I yelled out to Phyllis that I was in trouble and needed her help. She ran for the teacher and they notified the principal's office, which notified my Dad who arrived immediately. With the help of a teacher, he carried me out to his car. On the way to the doctor's office, Dad drove home to pick up Mom. From the doctor's office, I was ordered to the emergency room. Dad and Mom were told, "She may have polio."

♦ ♦

I was left alone in a room for sometime before I was given what was called a "jackknife," spinal tap, x-rays and blood tests. My parents were given shots and sent home. I was placed inside a metal tube (Iron Lung) and put into a quarantined room. I couldn't feel anything and my arms nor legs could move. I was overwhelmed with all that was happening to me. This was a time when the bottom dropped out of my teenage world. No one came to visit me. Polio struck fear in the hearts of everyone. I was lonely, confused and frightened. I was shut off from all that I cared about and loved in my teen life.

♦ ♦ ♦

I was angry, anger is a natural feeling. It begins with the emotions you feel when your body has failed you. I feared I might never return to the life I knew or ever be allowed to be close to my family or friends again. Later, I would come to know that anger dies only when you accept your condition and understand it as

a learning gift.

<center>†</center>

One day, alone in the hospital in the iron tube, I was crying and talking with Blessed Mother Mary and St. Therese of the Child Jesus (the Little Flower), I asked the Blessed Mother if I looked funny because my face was half-paralyzed. I cried myself to sleep that afternoon. When the nurse woke me from my nap, she asked, Who came to see you?"

I said, *"No one. I was only talking to the Blessed Mother."*

"Then where did this rose come from?", the nurse said to me as she reached into the tube and took the rose out.

<center>†</center>

"I don't know", I answered. Whenever I see a rose today, I often remember this other sweet rose and I smile. Someone loved me.

<center>♦ ♦</center>

Even then, I understood that I was in this tank because, for some reason, God must have another plan for me. But couldn't it wait? I decided I wanted to walk, no matter how much pain I endured. However, physical therapy had to wait, because they could not put me in with the other patients. Those who did work with me wore masks and gowns for the first few weeks. (This was before the "sugar cube" and during the polio epidemic days.) Many died in the 50's and many were paralyzed forever, but I was blessed and

40

was sure I had much more to do with my life than sit in a wheelchair, if God willed it.

<div align="center">✝</div>

Some visitors came to see me. I do remember how happy I was when my school friends, Jimmy and Phyllis, slipped into the hospital to see me, and how my cousin and friends encouraged me to walk again. They were not afraid of catching my polio virus.

<div align="center">✝</div>

But I did wonder why, as Christians, my church and my school did not make any efforts to write or to come see me. They didn't even let me know that they were praying for me. In my loneliness, I felt neglected and abandoned.

<div align="center">✝</div>

One day my fingers moved, then, slowly, my arms. I remember how painful it was when my legs were lifted and then dropped by an uncharitable attendant. I needed to look at the floor to see if my feet were touching because I couldn't feel them.

<div align="center">✝</div>

My inability to take care of my smallest needs was a great learning process for me. The lesson to be learned was humility and patience.

<div align="center">♦ ♦</div>

When I was finally released from the hospital. I could move my legs slowly. My right leg and ankle

were twisted inward and my leg was so limp that I dragged my body. In the hospital, I had crutches, and worked out; and often I would lay my hands on my legs and pray very hard for them to gain the strength to move again.

◆◆

I went home without crutches, because the hospital did not supply them and because the out-patient therapy was not covered by insurance. The therapy was dropped. I needed special orthopedic shoes and crutches. Dad said he was unable to pay for them. Thanks to Dad, he made me self-reliable. So, I called my Aunt Orva and she gave me the chance to baby sit and do other chores. I shared one-half of my wages with my Daddy and the rest went to pay for crutches and a few whirlpool treatments.

†

On one occasion, I had hobbled to the local hospital and tried to make arrangements to pay slowly, if only I could have therapy. But the two women in the administrative office said, "Only if your Dad will sign." But that I knew would not be. My Dad always stayed clear of debts. So I just saved up and went to therapy when I could afford it, since they would let me come on a cash basis only.

◆◆

While I was away, I longed for the day when I could return to school. To say I was excited or anxious

would be to understate how I felt. My Grandma Bernadette gave me two tokens for the bus ride to and from school. Although crippled, it was a joy to return for my education and to be with my beloved friends.

<p style="text-align:center">†</p>

Most of my friends were glad to see me, except for two girls who had been jealous of me before my illness. Taking revenge on me, they spread false rumors about reasons for my absence. They said I was having a child out of wedlock. That was a "vicious lie", because I was a chaste girl. I confronted the two classmates about their scandalous rumors and an argument ensued with my friend Phyllis. Within minutes one of the girls reached out to strike Phyllis, while the other pushed me down the steps. Phyllis quickly ran to the office to get help for me while the two girls stepped over me at the foot of the steps and left.

<p style="text-align:center">†</p>

The next day, in retaliation, the girls enticed their mothers to have me expelled from school by using the excuse that the other children might catch my polio. The mothers of the girls who came to the school were not aware that they were being used to cover up the girls' lies and gossip. When I tried to explain to the principal (a priest), why these girls wanted me expelled, he stopped me from speaking. Father knew the girls' parents; my parents, no one knew.

He called my parents to come and get me. This

43

incident was to have a real emotional impact on me for years because I was denied my right to an education for awhile. I was hurt that the principal could be so lacking in compassion and insight, especially a Priest. How could he fear those mothers more than being fair? But the fear of this illness, polio, could generate this reaction in people in those days, just as AIDS does today.

♦ ♦

The following week, out of boredom and determination to prove it was not right for me to be expelled, I hobbled three miles on crutches to the county high school, only to experience tremendous physical and emotional pain. I maneuvered myself up the stairs by sitting on a step and bracing myself up one step at a time. When I reached the top, struggling to pull the heavy door open, I wedged my shoulder between the door and casing until I could work my way in through another set of doors, and then turned left down a very long corridor to the principals office. Once in the office, I asked to speak to him. He asked me why I was there and I said that I wanted to enroll in school to continue my education.

He asked, "Where have you been?"

"At Catholic Central," I told him, explaining to him about how the mothers were used and why I was made to leave.

He answered, **"You can't come here. We don't**

44

have classes here for handicapped people. You must *realize* that you can't learn as you did. I'm sorry, but not here."

I replied, "Sir, my legs have some paralysis remaining, not my brain. Please, let me come. I know I will obtain good marks."

He said, "No, I can't do that. We don't have the facilities for you."

<div align="center">†</div>

I went down the hall with students who were walking quickly, fooling around, laughing, and whistling. I felt gutted, empty and discarded. I went back to the steps, sat, and worked my way down. I was also embarrassed at my rejection.

<div align="center">♦ ♦ ♦</div>

While on my way home, I was hobbling with my crutches on the snowy, icy sidewalk when I began to lose my balance. I was halfway into a fall, with one crutch already down, when it felt as though someone grabbed me in mid-air. I was being held up while I reached down for my crutch. I looked around to see who came to my aid, but no one was near me. Some teens had passed me earlier, but no one helped me cross the slippery intersection. The unwillingness of observers to help a person in need called to mind the prayer, *"Father, forgive them, for they know not what they do."* (Luke 23:34). Each lack of mercy gave me a reason to pray.

The indifference of others often gave me a reason to speak with God. ***Sickness is not an illness, ignorance is the disease.***

♦ ♦ ♦

Simple acts of charity can repair the ills of a sick society.

†

When I arrived home and shared my disappointment with my mother. I said, *"I must find a school that cares about me. Maybe an attorney can help. The United States government says that all children are entitled to an education."*

Mom stated, "That's nonsense. We can't afford an attorney."

I will never forget how easily she ignored my needs, although, I recall being ashamed for even considering such a cost. My parents never contacted the school or even made a phone call to defend me or my rights. But they did **teach me to accept what you can't change**, at least for now. My mother was a shy woman who never made waves, while my father, who grew up with only a little elementary schooling, just accepted the situation. I hope this helps you to understand why I accepted them as they were and loved them. I still recall thoughts that I knew even then, I would never let this injustice happen to my own child, if I were to have children one day. For the time being, I had to accept

that I had to set aside my education for awhile.

<div align="center">†</div>

I walked to our county library and read books on the same subjects my friend, Phyllis, was taking in school. I often borrowed her textbooks.

<div align="center">†</div>

Again, I called Catholic Central and asked the principal if I could come back to school if I stayed on the main floor and had my lessons brought to me by my friend. "No, that's not possible," Father said. "We can't start taking in handicapped people or we will need to set up a totally separate educational system."

"Why?" I asked, *"Why a separate educational system? My brain has not changed, just my legs. Please let me come."*

Father said, "No, don't ask—Good bye, child."

<div align="center">†</div>

I remember praying, *"Jesus let me love this priest even when he is hurting me."*

<div align="center">†</div>

Although my high school education was interrupted I was determined to fulfull my dream of getting a high school education .

<div align="center">†</div>

My strength was from Jesus. Social justice was just as important to me then as it is today. I joined other women in volunteer efforts to collect donations by

47

going door to door for the first school system to facilitate the handicapped in our town. This was such an important issue not just for me but for other handicapped people. (I was so appalled when in the 1980's children with AIDS were taken out of the schools. History was repeating itself).

♦♦♦

Several years later, while raising children and working long hours, I completed my education as far as I had time and funds to do so. Although, I never had the privilege of completing college (a deep desire of mine), I graduated from the college of *"hard knocks."* Whenever eligible, I received certificates for advancement in careers. *I've always believed that the more knowledge you have, the more you can do for others.*

♦♦♦

What is the great illness in this world? *"Ignorance of the needs of your brothers and sisters; ignoring their trials,"* even going so far as to become the enemy of the afflicted. Repeated ignorance I have found, comes from lack of knowledge. When you don't understand an illness or handicap, you can cause a more serious lifetime crippling, **preventing** the affected person from an **opportunity** to use and **develop** his remaining strengths, especially the pampering which parents give, or society enables, which promotes fears that they too could have the same difficulties.

♦♦

The handicapped have *always* been around. Those

born with an affliction, as well as those who acquire one, have *always* been chosen and molded by God to give all of us the opportunity to gain graces through the exercise of the virtue of mercy.

<div align="center">†</div>

The handicapped are not a new invention. So why are we still trying to decide *where* they fit in? We are *all* normal, regardless of any **afflictions**.

To say that a person is not normal because of a body part is nonsense. If one is a *danger* to others, he must be separated from the rest, but even prisoners are allowed education and health care.

<div align="center">♦♦</div>

Who is going to play God and decide one affliction is worse than another? Who decides if it is a waste to spend funds on an education for someone whom others feel will never be of quality use? Many made that decision for me in the 1950's. Oh, how wrong they were! I am valuable. I have quality *for God's plans*. I gave seven wholesome citizens to this world, all unique and needed by society. My grandchildren are a part of tomorrow!

God gave me enough health that I could give of myself to the needs of others all my life. Praise to only Jesus! I have been useful. For Jesus, I have lived a life of quality and purpose. I know that Jesus in me has led me to do much more with my mind, knowledge, and heart full of love than those without handicaps. I have

49

seen wasted lives, crumbling excuses, squandered opportunities. I have met people who were the least thought of in school and are now successful. Upon going to a class reunion one year, as I observed our class, I shook my head. No, I didn't graduate with these people, but most know that my diploma was denied because of the ignorance of the day. Do I see respect in them?

<div align="center">†</div>

Oh, yes! **Your state of mind is your success; your trust in God to give you *wisdom* is your strength. Go for it!**

<div align="center">†</div>

You will *succeed* when you pray for *His* plan and when you use the talent that our God naturally gave you. You will be happy in life when you *accept* and go with *God's* plan, allowing Him to mold you.

<div align="center">†</div>

As we grow, opportunities change. Is God's plan only for one road in life? Not for me. I have lived many chapters in my life. This book only *begins* to fill you in on the multiple changes I've experienced. We adapt to each change. We create a new path, and we follow that path to the riches God has for us.

<div align="center">♦ ♦</div>

I remain the same person with each year, but richer in gifts of wisdom and understanding, through God's

goodness. I am fascinated to learn more and more about God: Father, Son, and Holy Spirit. My goal in life is Heaven! Loving all my brothers and sisters in this world, regardless of color, nationality, religion, illness and disease, or culture, is a growth experience.

♦ ♦

History repeats itself through ignorance, war, failure, hate, economic differences, and *disease*. If you wish to make this world a better place, make the change. ***Begin with your own family.*** Make peace within your own job. Make peace within your own community of churches. Become respectful and peaceful within your own government. Become respectful and peaceful within your own self. How can we change the world unless we change ourselves and become Christlike?

51

†

Lord, I have a great need.
Sometimes I am near bottom.
This need is so overwhelming,
It defies an answer.

In the midst, I look to You,
Because I know You are
The Answer to give me Hope.

I pray that one day
Your Will be done;
That all men and women will be kind,
Free, and live in Respect
For one another and Peace.

In Your Name,
I serve You, Jesus,
My Divine Merciful Jesus.
Amen.
(Little Olive Branch)

Illness is Not the Disease: Ignorance is

Ignorance of the Day

†

WHEN ALL MY ATTEMPTS to return to school failed, I began to concentrate on obtaining physical therapy at the local hospital. My efforts to receive the treatments came to the same sad end: lack of funding. My dad's insurance did not cover my needs.

In those **days of ignorance**, my Father was sure this may be my only chance for marriage, especially if my polio progressed. My Dad being a very pragmatic man, decided if I wasn't able to go to school, I must find work or get *married,* for I must not remain idle.

Quickly, I began to call for jobs until I finally landed one as an elevator operator at the Lyman Building downtown. Three weeks after I began my new job, the elevator collapsed and fell to the bottom floor. I was hurt, but refused to make an issue of it because I didn't want to lose my job. At the end of the first month, my boss realized that he had not asked for my Social Security number. (No one ever told me that I needed a Social Security card). He let me go, saying, "No number, no job! Besides I could get into a lot of trouble if the owner finds out I have a handicapped person running the elevator. No one hires handicapped people, you know."

♦ ♦ ♦

Well, in 1954, I was learning that to be a victim of polio was like having the plague, just as being a victim of AIDS today is like having leprosy.

In the mid-50's, I was dating my second cousin, while my brother was dating his sister. It was common among our relatives for cousins to marry. (Even our grandparents, who were cousins, married. For two generations, three sisters married three brother-cousins).

My cousin was helpful to me during my illness by aiding me to recover from being crippled. I will remember to ask God's blessing on him always.

<p style="text-align:center">♦ ♦</p>

My father had said it would be best if I married. My polio symptoms had stabilized, but there was no guarantee that they would not come back. In those days of ignorance, my Father was sure this may be my only chance to marry, especially if my polio progressed. My Dad's cousin owed him a sum of money over a family estate they were investigating at the time. I still recall hearing Dad talk of the marriage arrangement with his cousin. (One could look at this as a dowry).

<p style="text-align:center">†</p>

However, the priest (who had a lack of prudence) whom Dad contacted, agreed with Dad: it's good that I marry. When I told the priest I was obeying my Dad's plans, the priest said, "Children should obey." At that time, I was too immature to have been alarmed

Illness is Not the Disease: Ignorance is

by what the priest had said. This priest, like my Dad, came from the old customs where obedience was more important than prudence. Moreover, my Dad's parents were also cousins, and so it was, in the days of ignorance. It was a natural arrangement by the standards of their family culture.

♦ ♦ ♦

I never felt I could make choices as a child. Dad had the final say in all matters. I grew up not to question Dad's decisions, but to obey. Dad thought marriage to my cousin would be good for me. He put everything into motion for the wedding of our youth and Mom and I took over. My friends, aunts, uncles, and grandparents were appalled that I was getting married so young. At one point, I returned the ring to my fiance through my neighbor, Joe. But Dad made me take the engagement ring back again. After all, my second cousin was considered a nice, marriageable boy of nineteen.

I remember back in those days, I was so tiny for my age that when Mom took me to Grossman's department store for my beautiful white, satin, bridal dress, the size five had to be altered much smaller to fit me.

†

Perhaps, it would be alright for me to get married. I quickly learned, I only changed authority figures. It all happened as if I were dreaming. We both played the role of being in love, and we had the wedding in

55

the Catholic church. This church was chosen because it had no stairs in order to accommodate my physical condition. Married at sixteen, I did not understand my vows, because some of the words were unknown to me. Nor did I understand that a wife's role required obedience in marriage duties. Within two years, we welcomed two baby boys into the world.

Baby's Breath: Epidemic of 1957

O N JUNE 28, 1957, after a ten-month pregnancy and seventy-two hours of hard labor, our second son, Randy, was born. He seemed perfect even though he weighed only 5 pounds, 4 ounces. A general checkup was done at the hospital before he was released to bring home. For some reason, blood work was overlooked.

Randy was a pretty baby; even then, his eyes were his best feature. Though I nursed him, no amount of cuddling would keep him from continual crying. It seemed as if he was in continuous pain. I would look for an open pin, a hard belly, fever, anything to understand why he slept so rarely and cried unceasingly.

On the fourth day, he began a fever that registered 104° degrees. I packed his head in ice and washed him, bringing down his temperature to 101° degrees. I forced water into him so he wouldn't become dehydrated. Finally, his cry was like a shriek for help. I phoned our family doctor and stated that his condition was not normal, that our other son had not been at all like this.

Our doctor did not discard my concern. "Bring him

into my office," he said. Then after a moment's silence he said, "I will be at your home in fifteen minutes, have your baby undressed."

He examined Randy totally and gave him an injection, saying that Randy must be placed in the hospital immediately. He said we were to come with him and if the problem was what he thought, all of our family would need to be inoculated.

In the hospital we wore masks and gowns, staying close to our son. After seven hours, our doctor reported, "Your son is very ill. He has spinal meningitis; obviously, born with it." I had never heard of this disease.

<center>†</center>

Other parents gathered in a family room with us and exchanged horror stories. I could hardly bear to leave my son's side. Each day I saw fewer babies, hearing that the others had died. Each day as I tried to caress my baby, his head would arch back, along with his lower spine and legs. His body began to take the shape of a backwards shrimp. His screams were so intense but there seemed to be no controlling his fever. I was physically drained and anguished. I would offer my little baby to my God: *"Your Will, Jesus. You did not create this child to suffer. He was born for a purpose. Save him, Jesus. Breathe love on him and save him."*

Little Randy settled for awhile into sleep. Parents

sobbed and a crib was taken from the ward. As we left the hospital, I felt as if I was being dragged. My heart raced to stay with my baby; my husband tugged on my arm to leave, saying that our other son needed me, too. Randy was three weeks old and Francis Jr. was now eleven and a half months old.

We were told that our home was quarantined for a few weeks, and all persons who had been with us **must** be inoculated immediately. Once the diagnosis was made, most family and friends stayed clear of the home. Even both sets of grandparents did not go to the hospital to sit with us. We spent our time twisting rosary beads, praying, waiting for a miracle. Our doctor, a close family friend for whom our son was named, stayed long hours at the hospital. At one point, he, too, held my rosary and joined us in prayer as we waited to see if the drugs would help our son.

Parents who have held their dying child in their arms, or held its hand, turning cold and gray, know the tearing hurt, the piercing pain to the brain, the weight that swells through to the heart, as their child screams in agony. As I held my baby close, I felt a brush of *breath* along my cheek, moving, also, my baby's hair. I could see no doors or windows open, and I thought with a smile: *"It must be Jesus giving Baby breath."*

◆ ◆ ◆

I still remember how my character was to obey my husband's wish, since his family reunion was not

59

where I wanted to be. The baseball game was hours too long, and I spent the day caring for nieces and nephews and wanting just to leave and go to our baby. Most of our cousins and in-laws mocked me as being foolish as there was nothing I could do for Randy. I went out onto the ball field and asked my husband again could we go. "Not yet." Finally, I walked over to the woods alone and cried, "What if my baby would die before we could get there?" I recall saying, *"Jesus, I don't want to sin by disobeying my husband but I want to hold my baby."* Then I felt a peace, and I felt God understood. I assured myself it was alright to walk to the hospital. So I left a note and walked three miles or more, before my husband noticed I was gone. Later, his car pulled up along side me and together we went to the hospital.

♦ ♦ ♦

After six days more of suffering, Randy's fever reached 106° degrees. Our doctor stated that shortly he could go into a coma. He stayed with our baby through the night. We went home as he instructed us to do. We told our doctor that he had our permission to do whatever needed to be done. We trusted in Jesus, the Greatest Physician, to guide him.

†

Little Randy recovered! Later, he was placed in therapy for muscle toning. At age six we placed him into tap dancing and acrobat classes to help strengthen his

60

back. We were told that his back might develop a backward curve as he grew, so we took special measures to keep him upright. I never feared, for I knew inside that Jesus chose to *safeguard* the life of my child. I was just as confident that Jesus would restore him, and, **surely, He did!**

I **still** pray that one day Randy will be a deacon or a great evangelist by God's Will. Surely, his purpose will be for God's Glory.

◆ ◆ ◆

Light of All Light

B Y 1958, MY POLIO was well in remission, my strength was back and I looked and felt normal. Before the decade ended, we had increased our family with the addition of a third baby boy, and by January of 1960 I was already carrying a fourth child. February's winter in Michigan means puffs of snow, icy sidewalks, icicles hanging from the roofs, and a respect for spring, motivating hope that warm weather will break soon.

†

The thirteenth of February was like any other winter day. After bundling up three children, I tied a rope to the waists of two of them so they would be safe and not leap into traffic before I could grab them. I carried the baby in my arms. I placed the first two children on a sled and trotted through snowdrifts, icy streets and a set of railroad tracks to a nearby drug store. By the time I returned home, I was wet, my feet and legs pink with cold. That night I soaked in a hot bath and drank warm lemonade to shrug off the chill and dragged-out feeling. Several days later, I became sick with a deep cold, aching all over. Within four days I was burning

up with fever, too sick even to walk.

◆◆

Arriving at the hospital, I insisted on clutching my scapular in one hand and my rosary in the other. The nurses spent as much time listening for the child that I was carrying, as they did treating me and giving me injections. I don't remember how much time had passed, but I do remember that it was near morning and I was being attended by three nurses. I recall I was worse because my chest felt as if it was weighed down by a brick building.

†

To this day, I clearly recall this unique experience in my life. I survived what is referred to as a "near death experience." For me, this was physical and spiritual in nature. For others, it may be only spiritual. I do not call it a near death experience. I recall being shown death and being taken to one of Gods' abodes and given knowledge of life-after to share with others.

†

I was very ill with double pneumonia, I heard someone say, "She's gone." I could see my body below me. I could still think, see and hear. I could see a corridor down which I traveled, even though I had no body. I could hear once again, "She is gone."

†

I shot above my parent's home, several miles away,

I could *see* the roof and the area around the house. Then, suddenly, I was inside the house, *hearing* Dad's voice in the kitchen. Even though I had no body!

<center>†</center>

From then on, it was all very quick—a "shot" here and a "shot" there—as if there were no time span, no seconds, nor hours. Suddenly I was **back** looking over my body! Then my soul was in a space near my body. I was given sight, to **relive** my entire life. Within moments, actions were brought before me, I had *feelings*, remembering my own judgement of my life. I remember now–that I decided *"It's not so bad."* I remember my feelings starving to want to be with God. It is a severe burning desire in thought. (I now believe that this is what our church refers to as purgatory), a cleansing, not a place, but a span of time your thought is craving God. Then I looked upwards and found myself being drawn upwards into a tunnel of light. I do not recall my body going through the light, for I seemed to be a being of energy. I believe it was my **soul**. I remember a peacefulness.

<center>♦ ♦</center>

Beyond the funnel of light, there was no end—just *bright light, with no end to the light!*

<center>†</center>

Coming towards me was an illuminating being—a woman! She was beyond all beauty! She glowed with a light from inside. I was drawn into her light, through

Light of All Light

her, and I exulted, wanting to see God. There was an illuminating light around the outside of her as well. She did not speak to me or give me her name. Her arms were extended to me. She was dressed in blue and white. Her eyes were pure and so beautiful. Her hair was dark and she looked softly and lovingly at me with her pure blue eyes. Her hands were graciously opened.

♦ ♦

It was after I had come through the tunnel of light and into (the never-ending light) that I now had the form of a painless body, and I was dressed in white. I remember this as I had turned my head and raised my left arm reaching out in search of this enormous **choir** I could hear!

†

I turned from my left, my soul still having senses of sound, hearing a multitude of people singing the most beautiful music, unlike any I had ever heard on earth. (I sometimes remember the sound but I am unable to hum the music or write it down.) I could not understand the many languages, but I understood that it was a song of glory! I looked and looked, trying to see far off into the space of light where the multitude of voices were coming from. I have never heard the words or the sound of this music on earth. I felt joy and peace! I was so happy! "Happy" and "joy" are small words and no words can describe the peace.

♦ ♦

65

Soon three *beings* came forward from the left, as if floating on white mist. The being on the left was a man with white skin, wearing a white robe. For a man, he was "pretty." The man on the right with darker skin, appeared he might have been Asian, and was robed in white as well. Both beings had pure eyes, but no light shining from them like the beautiful lady I had seen.

<p style="text-align:center">†</p>

The *being* in the *center* was of a color I have never seen, a sort of brass/bronze color—as if he had been in the center of the sun—a burned and golden tone, right down to his bare feet. His white beard was full, with tight curls at the edge. His blue eyes were very *soft* and *pure*. His white robe was trimmed in gold along the neckline and sleeves. He wore a single jewel on the middle finger of his right hand and he held in his right hand, a jeweled golden staff, rolled at the top. His left hand moved as he spoke to me. He was not frightening. He seemed to me to be in his sixties, with clear skin. His voice was slow and strong, like an echo. When he spoke it was as if there were mountains surrounding him; his voice echoed. He spoke with *power*! *Majestically!* He said to me: **"You Must Go Back. You Have MORE To Do."**

<p style="text-align:center">†</p>

But I did not want to come back. I was still trying to see where the beautiful voices were coming from. My eyes searched and as I raised my left arm, again I real-

ized, like the beings, I had eyes and could see the woman beyond the funnel of light and I had also seen the three men who had come forward in a never-ending light. I remember speaking, for I answered the man in the center, saying, *"I want to hear the music. I don't want to go back."*

†

The bronze man replied in a stronger echoing voice: **"You Must Go Back. You have M O R E To Do!"** And the "more" was longer than the "to do," because at the "more," I began to go back by his power of instructions.

It was as if I was being pushed back through the light quickly with force.

I could feel a current of air as I was sent back through the light. I gently went downward. I remember seeing my body **below** me; however, I do not remember a *body* in the funnel of light. I did not realize that I was slipping back into my body. The three nurses who were present at my death, later reported seeing a film of mist above my bed. One of the nurses became so frightened that she left the room and did not return.

♦ ♦ ♦ ♦

67

Affirmation of the Vision Beyond

†

THE FIRST SENSE I EXPERIENCED as I entered my body was that of smell. I remember the fragrance of flowers, particularly, roses. I asked the nurse who was preparing my body: *"Where are my flowers?"* at the same time the nurse across the room asked, "Who's bringing in flowers?" But there were no flowers. I believe that the fragrance must have been a gas form, one that I received after going through the light, and, possibly, brought back with me. (I feel I have knowledge of this. I'm sure the gas has a floral fragrance.) The nurse near my bed was shocked that I spoke and called for help.

♦ ♦ ♦

I also had the knowledge that my soul was energy, spiritually reflecting God's light. I believe that this form of energy had intellect as well as senses, such as sight and hearing. I believe, too, that I returned with other knowledge and gifts. It is interesting how everything stopped functioning in my earthly body, so that I was referred to as "dead." When the energy, the soul, returned to my body, I could see below, my body began to function once again! I now have knowledge that we have three senses: our **soul** has **sight, thought**

and **hearing**.

<center>♦ ♦ ♦</center>

I've been asked, "Before you entered the funnel of light after leaving your body, do you feel that you had a choice as to where you traveled? Or, did you simply zip there?"

I don't know about making a total decision myself, but I do believe that I did not just find myself somewhere. I remember traveling down the hall in the hospital, though I do not recall a body. I recall going to my parent's home to say goodbye, though they did not know I was there. I believe that my form of energy that traveled was still me and still able to understand and to think. Yes, our light, our energy, our soul, has *senses* without a body. I did not have constraints, for I was above my parents' roof, then, quickly, inside their home and then in the kitchen.

<center>†</center>

As for the three beings, their identities were not revealed to me, nor, if they ever lived on earth before my time. Perhaps, one day, I will be led to know who they were; especially, the one in the center who spoke to me and *sent* me back to my mortal body.

<center>♦ ♦ ♦</center>

In 1960, I did not know who the beautiful woman was who appeared at the top of the funnel of light. I had an *idea* of who she might be, but I wasn't certain,

because she didn't speak to me. I never told others, including priests, who I thought she was.

However, in 1993, I became certain of her identity. She has come to me many times and said, *"I Am Your Mother."* Without a doubt, the beautiful, illuminating woman who met me at the top of the funnel of light is my Heavenly Mother.

Recently, I told a priest: *"Yes, I now have her name. She was and is our Blessed Mother."*

<div align="center">†</div>

As a child, I was taught the promises made to Lucia, one of the visionary children of Fatima, by our Blessed Mother. I wore a scapular and remembered those promises. I was wearing a scapular when I died. Our Mother **did** keep her word. She was with me as she promised.

<div align="center">♦ ♦ ♦</div>

I use the word "energy," for life is a form of energy. I believe that this energy is our soul. Many people refer to God as energy. I believe that what or who we are, is a reflection of that Eternal Energy, Light of His Light, God! I believe that my soul is connected to my Eternal Father in light and energy, as I am connected to my worldly father through blood. This is what I experienced when I was given what I refer to as **a glimpse of Heaven.**

<div align="center">†</div>

I also believe that hell and purgatory exist, though I

have never been taken to these places. I believe by faith in these teachings, **for the burning desire of God and the waiting to see God is *purgatory*.**

Do I believe there is a *place* such as Heaven? I have no idea about a *place*. I believe it is all a timeless span called Eternity and it is something that we cannot comprehend. I do believe God's *words* in Scripture.

◆◆

I do know that the purpose I was shown the beings was to bring *back* the knowledge that I had been in that space of light. I will remember forever. I went on a *journey* as a gift from the Eternal Father, so I could share it with others. The three beings looked like men, or perhaps, they were men. Regardless, they had the features and forms of men. Were they given these forms so that I would understand and not be frightened? Their arms moved. They had voices. They were *like* me, for I, too, after going through the light, was given a body!

◆◆

I've been asked if the funnel of light cleanses us? No. I believe we judge ourselves before we go through the light. Our state of grace, or our lack of grace, reveals to us our true selves. If our souls are in need of purification, we go to purgatory before Heaven. Purgatory? Yes, that space of **burning desire** for God.

◆◆

Is it true that we are a *likeness* of God? The forms of the men and the women were like us, and the form that *sent* me back was of a man. Is God's Breath our soul? Is the Eternal Father in the form of a man? Was He *seen* by visionaries and prophets? Scripture tells us of the fiery chariot that came for the prophet Elijah, and Moses heard the voice of God speaking to him from the midst of a burning bush.

◆ ◆

I have also been asked if it is possible that my energy will return forever to the light to which we are connected. Yes, I believe this is our destiny desired by God.

†

Who has control of our life? In my case, our God has assigned me a heavenly being? Remember that the center **Being** stopped me and said, **"You must go back. You have more to do,"** and he sent me back. I did not come back willingly on my own. My energy, my soul, was returned into my earthly body because *someone* God assigned sent me back. This is why I believe that experience was meant for me to bring back knowledge to others.

◆ ◆ ◆

I have been very careful to whom I give this information. It is now in print and I do not want the facts distorted in any way or confused with someone else's experience. So far, I have never spoken to *another*

who shared with me on this subject—only doctors, psychologists, priests, and educated persons who appreciate the facts.

Some ask, "Do you believe the man in the center was God." I answer no, but I do believe that he was a being of authority. I do not believe he was God because there was no light from the *inside* outward, as I've seen when I look upon Jesus. Also, I did not feel *humbled*, as I did in the presence of Jesus. Looking back up at Jesus I could only exclaim, *"My God! My Majesty! The exulting joy! The peace!"* **I did not feel any of those feelings before the being who ordered me to return.**

♦ ♦

Distinguish and remember, I said no light generated from the center of this being. Jesus has both human and divine natures. He has a human body, sanctified, purified, and with an illuminating light radiating around the outside of Him, as well as from the inside out. His skin is translucent because He is glorified with the light within. When before Jesus, you are drawn into Him and you are one with His light!

♦ ♦

This was not so with the center being. With Jesus, you are calm and in peace. I did not become humble or obedient to the **center being**. He had to **take charge of me** and *send* me back.

♦ ♦

The beautiful, young woman in the never-ending light had light within radiating outward with purity. I also was drawn into her light and given a deeper love and emotion of desire for the Eternal Father.

◆◆

The three men did not have light coming forth from the inside, though a light did radiate all around the outside of them. They were more like the angel that came to me in later years. (He did not have a light inside, only a radiant light outside his form).

◆◆◆

I am often asked, "What medical condition were you in?" According to my doctor and the medical technology available, I experienced a total loss of physical function. Later the testimony given to me: You died; yet, because of a miraculous healing, I lived! There is another miraculous wonder involved here. I was carrying a child. For weeks after my energy, and soul, returned to my body, the medical technology did not pick up the heartbeat of my baby. Nor was there any movement; my baby did not kick. There was concern that they might have to take my baby. But I would not let them, replying, *"God will take care of this."* I believe that if God had taken my baby (his energy, his soul) home, I would miscarry naturally. I told them that I came back because I had more to do. This is what the being had said. I told them, ***"I believed this baby would live."***

†

This baby went more than full term and was born July 5th. He was our fourth son. I prayed to our God that if this baby was born healthy and a boy, we would name him Joseph. If a girl, she would be named Mary. Our son Joseph had nothing seriously wrong with him, other than a heart murmur.

†

How did this baby live without *my* energy in me? I believe that he had his *own* energy of life, **his own soul**, and did not need my total support. For whatever oxygen he needed from me, enough must have been stored in me for this baby to hold on during the time my soul was outside my body. Surely, Baby Joseph had his *own* source of energy. It must be that our bodies can function, even without life as known in our cells. Possibly the brains energy continues, even after all other functions of our bodies stop? Regardless, we both lived; miraculous and a mystery.

♦♦

Another interesting question that arises about my glimpse of Heaven is, "Did I walk?" No, I moved forward after I was given a body. However, my arm moved upward, so this left me believing I could have walked.

†

What about the three men? As you will recall, I stated, *"The three men came forth."* They did not walk

They moved closer, though the center man's arm moved upward when he spoke.

Could we have walked? I'm sure we could have. The man in the center had feet and a staff. However, the men glided to me. We were all in *a space of light*. The *substance* below us moved us.

<center>♦ ♦ ♦</center>

In those days, I was a young, twenty-one-year-old woman, a spiritual young mother, loving our Holy Eucharist, belonging to the Legion of Mary, wearing my scapular, and praying my rosary. I read Scripture often, but after my glimpse into heaven experience, I also realized that I knew things that I had never read or heard before. I felt very close to Jesus, even closer than before, and I had a *hunger* to return to Heaven. I found myself praying *often* to God to *take* me *back* through the light where I will graduate to my next life! Eternity!

<center>♦ ♦ ♦</center>

I think my life changed a lot from this encounter! I do believe that my faith increased! If there is any major change, it is the *understanding* of how wonderful death is! For me, it is to be *born.* I desire the day when my job, my destiny according to God's plan, is completed. My perception of death was changed. Remembering the joy! I also changed, I wanted even more to be in the state of Grace, I remembered often my burning hunger to be with God! And I tried very

hard not to separate myself from Him, for fear of this hunger again.

◆◆◆

Today my life is *lifted* by God's words! Today, thirty-two years later, I am more spiritual and have grown. Life's mountains have **strengthened** me. Today, I am charged in faith! At fifty-five, I am awaiting His glorious return, for our peace and total happiness! I await my energy, my soul, my life, to be **cleansed** and given a new eternal life, a new birth to live in peaceful Eternal Space! Possibly on this peaceful earth, possibly in peaceful space. Given a space where everything that is beautiful and peaceful to us is desired. One thing I do know, whether we are eternally on this earth or in time, *We Will Exalt And Glorify Our Eternal Father! Our Creator! The Light Of The World! Light Of All Light!*

†

You are Light in my darkness.
You are my great I AM!
But this has no meaning until
I convert myself to only You.
You are my only God.
I give myself totally,
Undesirable as I am.
Mold me, Heavenly Father,
To be one with You in Your Heavenly Light!
Amen.
(Little Olive Branch)

Knock...No Doors Open

A FTER A FIFTH SON WAS BORN and time raced on we moved to Rockford, Illinois, a clean, friendly city, where we now were living. One day, the children and I made our way north to Wisconsin to follow my husband.

<div align="center">†</div>

Coming into town by way of Milwaukee, one must stop off at the famous zoo, especially, if you are traveling with children. In my case, I was following my children's father. He had gone ahead to line up a job, and found himself an inexpensive room with a twin bed. Our arrival was unexpected and no home had been set up for us.

<div align="center">†</div>

Grafton, Wisconsin is a small village divided by the Mississippi River. As far as family life is concerned, this village offers industrial growth potential, dedicated officials, churches scattered throughout the town, medium-sized schools, a couple of motels, a two mile stretch of businesses, a popular village park complete with a gazebo and bandstand—everything anyone who wanted to raise the "all American family" could desire.

We arrived in town with little money and no credit cards. My savings were quickly depleted with the expense of motels and restaurants for a week. I began to buy our food from grocery stores in order to have picnics, trying to make a vacation out of a serious situation for the sake of the children.

I searched for a job, though I had no phone number where I could be reached, and a day care center, so that I would have a place for my five children to stay when I did stumble onto work.

<p style="text-align:center">†</p>

My first priority, however, was to find us housing. (The hotel rules would allow us only to visit my husband in the lobby.) When you are not established in a small community as a known resident, it's impossible to find a real estate service to take you seriously. Late in the afternoons I would play with my children, helping them to scrounge for worms and to bait hooks so that they could experience the thrill of fishing, their lines rippling in the flow of the current.

<p style="text-align:center">♦♦</p>

I tried everything I could to keep smiles on our children's faces. How could they understand why we were facing hard times? Most of their lives I had worked and given them a very nice home with all the luxuries most American children take for granted. Most of their beloved toys and possessions were now in stor-

age, so the fishing poles and a few books were the event of the day.

♦♦

To stretch the little money I carried with me, we began to sleep in our car on country roads. A police officer shined his flashlight into our car one night, and I asked that he please not wake the boys. He listened to my story and looked sympathetic. I asked him not to take the children from me. He suggested that I find housing soon. I was so grateful to our Blessed Mother for protecting us that night.

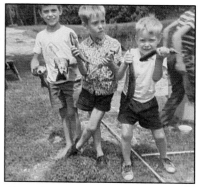

My children in the park in Wisconsin. From left to right, Ken, Joe & Patrick.

Patrick fishing along the bank of the Mississippi River in Grafton.

♦♦

We made our way through town to a Catholic church, next door to a vacant school and convent. Surely, the Church would help us. We are a faithful Catholic family. We should be family, not just back home, but all over the world. I knocked at the rectory door, waited awhile, then rapped again. Finally a priest opened the door and said, "You must call for appointments."

I asked him, *"Please, my children and I are in need of a place to stay for the night. I'm too short of cash. Please, may we stay in your home or in one of the vacant buildings?"*

"No, I can't allow that," he responded, "I can't let anyone stay here."

I repeated, *"Father, we need housing. Could we stay in the convent? Please, will the Church help?"*

Once again he said, "No. Just go. We don't have insurance to cover strangers in the vacant house." He then closed the door.

"Jesus, understand, he's being practical. It's I whom discomforts him."

<div align="center">†</div>

I returned to the car, where the boys were getting hot and testy with one another. By now they figured out that we were in trouble, and they wanted to stop this "vacation." I went to a motel and asked if they could rent us a room for ten dollars—*"Please, just one night."* I was trying to make our little bit of cash stretch, so that we would not be vagrants before I could get monies from Michigan transferred to me. The person who would transfer these funds was out of town on business, and I was at everyone's mercy until he returned and wired me my funds. For now, what little we had was the bridge between starvation and survival. This lifeline called "money" is horrible.

◆◆

I went to the park again and let the children wear off their kinks while I prayed the rosary and read prayers. I turned us over to Divine Jesus. I handed my children's needs over to St. Joseph, and dearest Mother Mary would have to work hard to help us find a home while we had little money.

◆◆

It was after eleven p.m. We drove to the hotel to let my children be with their father and talk things over with him. However, he could not help us until payday. I reminded him that by then we might not need his help because surely the monies would be wired to me by then. He had been on his new job only a few weeks and didn't want his boss to know we were here. He did not want to ask for an early draw on his paycheck, which was understandable. We said good night.

◆◆

I took the children back to a country road, where we tried to settle down for the rest of the night in the crowded car. We just could not sleep under the stars. If you have never been in Wisconsin, then you may not know about summer nights made up of clammy humidity and herds of mosquitoes. We kept the windows rolled up and were soaked in perspiration.

†

About one a.m. thunder began to rumble and the

breeze picked up. We stepped out of the car to cool off and remained outside in the sprinkle of rain. Fun changed to fear, however, as bolts of lightning hit the ground in front of the car. The thunder sounded like bombing, and the lightning was so constant that it remained light.

I feared for the children, so we drove back into town. On impulse I pulled into a driveway, went up to the door, and knocked. A man came to the door and flicked on the light. *"Please,"* I asked him, *"Could my children and I have shelter in your garage for the night? Please?"*

His response was, "Get out of here," as if we were dogs.

<p align="center">†</p>

I went a few doors down and pulled up to a very nice home where the lights were on and knocked. A girl answered, and I asked if her mother was at home. She said her dad was coming. He flung open the door and said, "What's going on?" When he saw me he said, "I saw you at the park with your kids today."

I said, *"Probably so. Sir, could you please give us housing for just one night? My children are afraid of the storm and I'm too low on money right now."*

He was angry now, shouting and swearing at us to get out of his yard before he called the police. So, we took the hint and left.

<p align="center">†</p>

I saw a home with a statue of Mary in the center of some flowers. The lightning lit up the little shrine. Surely, Catholics would help. I knocked but no one came to the door, even though the lights were on in a back room. I rang the doorbell. Still no one came. Then I knocked at another door.

Finally the door opened slowly and a woman asked, "What do you want?"

I responded, *"Please, please, I've run out of money and my children are afraid of the storm. Will you please take us in for the night? Just one night. Please?"*

She quickly answered, "No, no. My husband may be home soon, and if you're here, I'm in trouble." Her face showed more fear than my children's. I could see that she had more trouble than we did, so we left quickly. I did not want her to get hurt by our being there. I prayed for her, though her fear of man was more than her fear of God.

<div align="center">†</div>

The storm did not let up. I kept turning to St. Joseph: *"You showed me enough. I will never forget again how terrible it must have been for you, St. Joseph, when you tried to find housing for your wife and coming child, and the other times when you had to flee, and you had no housing. O dearest St. Joseph, you know my concerns, for you have lived this same trial. Help me. Intercede for me.*

♦♦

We made our way across town back to the Catholic church. Once again, I went up to the rectory and knocked on the door. It was nearly two a.m. When no one answered, I rang the bell, then went back to the car, out of the storm.

Finally, a light flicked on. I jumped out of the car and ran to the door before it closed. Startling the priest, I said, *"Father please, Jesus is in us; Jesus and we are asking for a place to stay. Will you turn away Jesus?"* I also said, *"St. Joseph must have had a difficult time getting a place for Blessed Mary to bring forth Jesus."*

Father looked in awe and opened the door wider. The rain was like a waterfall; the humidity was high. *"Father,"* I continued, *"the children are suffocating in the car with the windows up. Please, they need a drink. Could you give them a drink?"*

He told me to go to the back door, so I sent the children to the back door for a drink. Upon seeing their little faces full of fear, Father took pity. Covering himself with a raincoat, he walked us to the vacant convent where his heart melted enough to let us stay the rest of the night. "You must be out before Mass starts. The committee cannot know you are here," he said. He really looked worried.

When Father left I thought, *"He is in as much trouble as the woman, who is scared for her husband to*

come home."

I settled the boys down on the bare floor and we all said our prayers. One by one they fell asleep. I remember feeling so helpless, so overworked with the **concern** and **stress** of getting the children out of the storm.

<div align="center">✝</div>

I thought, *"Jesus, I know why there was this storm. You gave all those people a chance to give water when we were thirsty; to give food when we were hungry; to give a bed when we needed shelter. They failed to see you, Jesus. Forgive them. I do. And, please, help the priest, and the woman who live in fear. You wanted us homeless, so that we never forget the loneliness and hurt, humiliation and anxiety, grumbling belly and weariness, rejection and misunderstanding, ridicule and resentments of feeling like outcasts.*

"Jesus, thank You for letting me be one of the homeless if only for a while. Let us never forget that even You and Your foster father and Mother were, also, at one time homeless. Let us never forget all the people who have no work, no homes, and, no more friends. No one wants to know you when you are poor and out. Thank You for tonight's shelter. Thank you for my legs, that I may find work, and my eyes, that I may see. Oh how very good You are to us for our experiences."

<div align="center">✝</div>

There were no curtains on the convent windows, and

the following morning the room was bright. I remembered what the priest said. I didn't want **him** fearful because he had taken pity on us and helped. So I hurriedly took the boys to the car, locking the house behind us.

Pondering, *"Should I lock it or leave a way for us to get back in if we need to for one more night?"* But then I decided, *"No, Divine Jesus will give us another shelter. Be good to the priest, for he trusted me."*

<p style="text-align:center">†</p>

Complying with the boys needs a gas station was in order, and I purchased a dollar's worth of gas while they cleaned up. We went back to the church for Mass, and Father nodded when he gave me Communion. Money was even slimmer now, but with care, I was certain we could get through till Friday.

<p style="text-align:center">♦ ♦</p>

Being serious about making a life in Grafton, I went to another real estate firm and asked to see "option to buy" homes. The woman was snobbish and very rude. I asked to fill out an application, but she claimed that she couldn't find one in the office. I asked to see the Multiple Listing System's book of homes.

She replied, "Please leave. Come back when you have money enough to make my time with you worthwhile."

Responding to her with, *"You'll regret your attitude,*

for you don't know me, and I will not come back to you when my monies are transferred." (Having a sizable amount in a Michigan credit union). I tried to walk away with some dignity and not to be angry with such an ignorant person.

◆ ◆

We went to another firm and told them that if they showed us some houses, I would see to it that the money was in Wisconsin within a week.

But the foul-mouthed sales woman rudely said, "Come back with money. I don't have time now." She didn't even offer me an application.

†

I will never forget my impression of this popular real estate chain. If only I knew the home owners, possibly we would have gone to them ourselves and worked out a sale. Today, however, I see that it was not in God's plan that we stay in Grafton.

◆ ◆

Later that day, the children were listening to some singers in the park gazebo. I walked to a nearby phone and was finally able to reach the person who could transfer my monies. Excitedly knowing we would have monies by three p.m. the next day.

◆ ◆

We went to my husband's place of employment and asked if I could speak to him. His boss came out instead and asked what I wanted. Telling him the

story—how we had come unexpectedly, that I would have some money the following day, but that we were homeless for one more night.

His boss went to my husband and brought him out. He invited us to stay one night in his home, and suggested that we all go back to Michigan, as this town lacked housing for families at this time.

♦ ♦

That night we went back to the side roads. We ate bread, peanut butter, orange juice, and apples. After swimming in a small park down the road, I told the boys that their vacation was almost over. We were going back to Michigan the next day, although not to our old home, it was gone. They were glad we were leaving but sad that they couldn't go back to our house. For tonight, we would be guests in a home and by the next day we would stay in a motel with a pool until we could find a house to buy. We had decided that this town of selfish people was not the place we wanted to call "home."

♦ ♦ ♦

The next day, after the money arrived, and my husband received his check, we moved on.

†

Following his car with three of the children, I could see that the two boys with me were happy just to have their daddy. We stopped and fished at a bridge and

made the trip back to Michigan seem like a real vacation. I had plenty of time for praying and thinking, and we had enough money now to live in a motel until we could arrange a start.

<div align="center">†</div>

Only days later, as I sat by the pool in Ann Arbor, Michigan, listening to the children laugh, could I not help but remember how easy it is for one to live in two worlds in one week: from poverty, fear, and rejection; to an elaborate decor with chandeliers and maid service. Money made the difference. How sad!

<div align="center">†</div>

The children did not seem affected by our homeless adventure. In fact, living rough seemed to appeal to these five boys. One of my sons came over with a magazine showing a picture of a family camp out. Oh, yes, the children had decided that camping would be fun. As for myself, I had enough. But then Mom caved in. So off to Ward's we went for all the equipment we needed. We found a state park on Sugarloaf Lake, and their father found a job at Ward's in nearby Ann Arbor.

<div align="center">†</div>

In the meantime, I phoned to make arrangements to receive a check that was owed to me. All was well.

In one month, I found a cottage on SugarLoaf Lake, and as summer came to a close, we decided to settle in the small community of Chelsea, Michigan. At this

point, I decided it was time to stop living to please all others. It was time to take charge of my life through my own free will.

<div align="center">†</div>

The boys did have their father close by, rather than being a split up family, but sadly, our marriage was beginning to show signs of strain. We were close blood cousins, yet became strangers in the wind. We did not know each other like a married couple should, we were playing a part, a most unhappy role. After our son Joseph's First Communion day, we separated.

<div align="center">♦ ♦ ♦</div>

I began to watch the streets for others in need. It was as though we went through the homeless time, in order to appreciate a warm home more, taking nothing for granted. I did find another woman who was having a difficult time alone with her children and it felt good to help her. I was working in a spring factory and had finances to help others.

<div align="center">♦ ♦ ♦</div>

We parted as friends, he even drove us back to Muskegon where our family lived. He returned to Chelsea, Michigan.

<div align="center">♦ ♦ ♦ ♦</div>

†

Do not fear
what may happen tomorrow.

The same loving Father
Who cares for you today,
will care for you tomorrow
and everyday.

Either He will shield you
from suffering
or He will give you
unfailing strength
to bear it.

Be at peace, then,
and put aside all
anxious thoughts
and imaginings.
(St. Francis de Sales)

Going My Way

A FTER MANY VISITS with the priest and a long soul search, I am peaceful with the separation of what never should have been.

Many marriages do grow in mutal respect and sanctity. However, many do not. Consent for marriage includes a full knowledge and responsibility of an inseparable union. At sixteen, I was hardly an adult with this understanding to accept a vow. Because of our youthfulness and immaturity, we did not foresee how our lives would grow in opposite directions. My consent was motivated because of obedience to my father. I had such a minimal understanding of this covenant, how could I know truly what I was accepting?

If this were not enough to see the enormous error of those who were leading my life, let's view the fact that *we were two close cousins.*

My cousin and I both agreed to dissolve our many years of a strained union. We remained respectful and at peace.

♦ ♦ ♦

Mom and Dad were not supportive of my civil

divorce. Their lack of compassion and understanding was very hurtful.

Upon hearing of my legal separation, Dad said, "If you become crippled again, don't think you are coming home with all those kids."

<center>†</center>

Mom said, "Your bed's made; now lie in it. Maybe he should not have done some of the things he did, but you shouldn't divorce! That's a Catholic law. Everyone's ashamed!"

<center>♦ ♦ ♦</center>

The world had become so judgmental and mean through this treatment, that it quickly made me very strong and bold. One day I decided that I had done everything to please others including obeying my father's wishes, only to find it hurt me in a devastating way for years. I was still in my late twenties with five children, and decided from there on I was *"Going My Way."*

<center>♦ ♦ ♦</center>

We were the first couple, to my knowledge, to acquire a civil divorce in our family. Some of my aunts said, "This separation was inevitable. The marriage should never have taken place."

<center>†</center>

My childhood had been controlled by others, especially by my father's persistence that I marry. To add to this, my doctors were certain that two conditions

caused my problems during pregnancy: our close relationship as cousins and my illness. My aunts and friends helped me through the adjustment time while the annulment was being processed.

Did I understand *annulment* in those days? No, nor did anyone guide me to a good priest. The most *painful* part of my civil divorce and my annulment from the church was when a priest in my diocese cut me off from receiving Holy Communion. Today they do not punish you in this way. He stated, "You are breaking a vow of not being subject to your husband. Marriage is forever. Now go back with him, or you may not have my absolution, and do not go to Communion." It was *crushing* to go to Mass weekly and *not* be able to receive my most hungry desire–my Eucharist! Would it have been better to live a lie all my life?

I obeyed the priest. To be separated from my Eucharist gave me a broken heart. But I was sure the priest was wrong and less than compassionate and understanding. So I drove to the town my husband lived in, and talked with him, but he said, "No, it's too late." He said that he wanted to be free to love another. From there, I decided that no priest in his misjudgment was ruling my life. I wanted to be happy too. How could I correct the error of my life.

This was the fourth time in my life I had received very poor direction from a priest, with me to pay the

price forever.

<center>†</center>

This was the most hellish time of my life. I felt empty as a woman, rejected by condemning, embarrassed parents, and rejected by my church.

<center>†</center>

I loved my Jesus the same. I leaned on the Blessed Mother to help me with my children. I fulfilled obligations within my church in all other ways. Yet, I was unable to receive my Jesus in our mystical Consecration. I would kneel with tears soaking my face because I could not receive. I became even more certain that I was the lowliest of the low.

<center>†</center>

Some priests ignore the rule of the church that requires the annulment of a previous marriage before a new marriage can be blessed. The law still remains divorced Catholics must obtain annulments through the tribunal of the church to control a sacramental marriage. There is a place for both annulments and **internal forum–sacramental confession**. Internal forum is **not** to be considered a replacement for an annulment. However, taking the situation through the confessional **helps** the **wounded soul** to **heal**. The internal forum–confession, allows couples to examine their consciences, and review the things they may have done to create this breaking of their marriage vows. Couples need to **feel sorrow** for their part in

hurting one another. They need **forgiveness** from God for their actions. Their soul needs **change** through **learning** and **growing**. They need to tell one another that they are sorry. Each must **repent** and allow graces of confession to heal their wounds. If internal forum is used wisely, *entwined* with an annulment and encouraged by priests, souls will not carry anger into new relationships. They will avoid repeating their mistakes. A piece of paper from a tribunal will neither cure the wounds, nor cleanse the soul. It will only show the world that one had a **valid reason** for an annulment and that one is free to make a new life with blessings. The **real healing** comes from internal forum–confession.

Those who leave their previous vows, not forgiving and with hatred, hurt righteousness, and a mean streak against the person they divorced and annulled, can not be cured without both annulment and internal forum.

Children from a divorced and annulled marriage often find their feelings exposed. Many parents teach their children to sin against the fourth commandment (Honor your father and mother), by teaching disrespect and hatred. These parents who a priest did not take through internal forum, hand their hurt feelings onto their children, causing the child mental cruelty which is then blamed on one's ex-spouse. Many are also guilty of trying to replace the God-given biological parent with a step-parent by bulleting the reputa-

tion of the other parent out of their own hate.

Together parents can share in the responsibility God originally gave to both parents. They become respected friends and teach their children to live by God's commandments.

Children who say, "I don't recall my parents divorce hurting me," come from such a **resolved** annulment.

For those who were coerced, threatened, sold by means of dowry or indebtedness, or trapped into marriage, for those who were immature, mentally incompetent, or caught up in infatuation at too early an age, and were totally mentally unaware or willingly married, I say to you, "Do not place your **souls** into the hands of just any priest or a minister. Search for a priest who is knowledgeable in annulment counseling, then your soul and future will be under the guidance of God.

Some feel the church is wrong in the matter of annulments. Some may state, they are not necessary. Our Pope is guided in **moral matters** by Our Holy Spirit. What the Pope binds on earth is bound in Heaven. We **must** believe this.

Do not be judgmental. It is not difficult for me to believe that His Holiness, our Pope, was and is **inspired** by God, **to create another means of correcting souls.**

Knowing Gentle Jesus' mercy as I do, it is most fitting that His Holiness is led to give souls a way to cor-

rect sin. To live a lie, is a sin.

<center>†</center>

Your priest owes you the truth and he is bound to obey the church rulings. Be thankful for all prudence given to you by your priest. Encourage obedience to The Pope, do not ask special favors. Your conscience knows if you have presented all the facts correctly to the priest.

<center>♦♦♦</center>

I believe all that I have learned is a part of who I am, as my faith is much of my biography.

<center>♦♦</center>

Allow me, at this time, to help one recognize *conscience*, before one acts.

A *correct conscience:* means that a person lives by the Ten Commandments, and therefore acts without fear of committing sin.

A *certain conscience:* is the certainty one has that he or she may act without fear of committing sin, that their act is without error.

An *erroneous conscience:* approves that which is opposite or contrary to the Ten Commandments. It is corrected when a priest explains that the action is not according to the teaching of the Church, and the person, through prayer, accepts this teaching.

One must act according to his conscience. If one says, "Yes, Father, I know that this is the official

teaching of the Church, but I **studied and prayed** about what the Pope has written, and I still cannot believe it is a sin," then this person truly believes his action is not a sin and his ignorance is called **invincible**. Although he may commit a sin, God does not hold the person accountable for the evil of the sin. However, the individual **must** continue to work towards correcting the errors of his conscience.

In the case of a **doubtful conscience**, a person **may not act**. Only after he comes to an absolute decision of conscience, may he act.

A **perplexed conscience:** involves the fear of sin when following either of two alternative moral laws. After talking to a priest, the person will come to a **certain conscience**. He will then act on the lesser sin or not act at all.

A **tender conscience:** belongs to those who live their lives easily in all matters, according to the teachings of the Church.

A person with a **lax conscience** acts with insufficient knowledge, believing to be lawful, that which is sinful. This person also may believe a mortal sin to be only a venial sin.

Those, who for purely imaginary reasons, dread sin where there is no sin, or see all sins as mortal, when some are truly venial, have **scrupulous consciences**.

Although you may be told not to confess venial sin, it is best to use wisdom, to have true sorrow and to make a firm decision to change. Today, one must carefully select a confessor. When you find a confessor who explains things, then you leave the confessional healed and at peace.

If you leave the confessional feeling crucified or persecuted, it may be one of two things. Either you are stubborn, clinging to your own opinion; or, you refuse to change the action and repent, or were not given Absolution or the confessor himself is acting as an interrogate rather than showing compassion as Jesus would listen and help. If Confession leaves you worse than when you went in, don't give up. You must find another priest, and work at resolving this action until you are at peace; this is your soul to rest.

◆◆◆

In preparing my future, I knew only one thing: I needed to take control of my own life, as long as we both tried to keep respect for each other. And I would do all I could to keep the boys close to their Dad, as well as teaching them the fourth commandment, to honor your father and mother. He taught them to respect and obey me, and I taught the boys to admire the wisdom of their Dad.

Our petition to the church for a declaration of nulli-

ty was ultimately granted.

<center>♦ ♦ ♦</center>

The annulment did not mean that either of us intended to give up our deep Catholic faith, or our love and hunger for God. Annulments are a source of correction and peace for the soul, it is a statement that a marriage had not existed.

<center>♦ ♦ ♦</center>

There is a reason why our church requires those preparing for marriage to attend six months of pre-Cana classes. This reason goes beyond the letter of canon law. A priest primarily is concerned with the couple's compatibility–common interests, and beliefs shared by the couple. I recommend that you respect the responsibility of the priest as he follows certain guidelines. Even if after five months, the rental hall, the wedding is planned and paid for, and the priest in his skilled guidance, states "I will not marry you," do not become angry with this priest. The cost of his decision is worth far more than the financial loss. Your soul's peace is worth more than a carat of gold. The prudence of the priest may save you from damnation. Sometimes, the intent of the couple is misunderstood. This can be traumatic. Before your marriage, be totally honest with your priest; this is for your soul, not for the glamourous day. In our case, I wish that the priest had better insight on our marriage and had been **prudent** and said "NO" to us, and to my father. How I wish for the sake of both of our souls, we had been

mature and prudent as well.

<div align="center">†</div>

I am grateful to Our Lord for the hurting experiences of my life, especially shared with you, I hope in some way I can help to save you grief.

<div align="center">♦ ♦ ♦</div>

During the years ahead, and still "Going My Way", I was being selective in the area of relationships. If I were ever to love a man, he would not only need to love me and show it, but he would need to prove he loved my five children even more.

<div align="center">♦ ♦ ♦ ♦</div>

104

The Silent Cry

C ONSCIENCE IS AN ISSUE I speak on often as it is a gift from God to guide our soul.

†

As life rolled by, I made time to work nine years with Right to Life and continued counseling.

We refer to the natural loss of a baby as a still birth, spontaneous abortion, or a miscarriage.

I firmly believe that deliberately ending a pregnancy is an abortion—an induced abortion. The circumstances under which a baby is conceived is not for my judgement. As for the loss of a baby through abortion, most mothers, regardless of a cold heart at the time, feel a twinge of responsibility. I have spoken to angry mothers who really hated their babies. Some were even confused by the issue of "tissue versus human," but still admitted to a *feeling* of responsibility, if not love.

The majority of mothers, pregnant by choice or by force, agree that their baby is still a part of them.

Those who are pregnant by insemination have made a conscious choice to change a natural plan, though

the result is to **aid God in creation!** Let's leave out moral judgements at this time. Let's speak about God's *plan*.

<div align="center">†</div>

Each woman who has deliberately chosen to change her body, to prevent pregnancy for selfish reasons, is arranging her life according to her plan, not God's plan.

Every man who has had a vasectomy by choice, has deliberately changed his body to prevent the responsibility of another child, while still enjoying an active sex life. In most cases, his plan is irreversible. He has rejected God's plan for his life.

Some persons believe birth control to be a common-sense measure for temporarily preventing an addition to a family, avoiding fear, mental anguish, or financial unreadiness, while providing time to make peace or to "grow up" before accepting such an awesome responsibility. Regardless of the decisions made for millions of reasons, the questions remain the same:

> 1. Do we have the right to change the course of God's plan in order to live our lives our way?
>
> 2. Do women who choose not to marry, have the right to change the natural course of God's plan by pregnancy through artificial insemination?
>
> 3. Do couples who are unable to have children have the right to alter God's plan through surrogate mothers?

106

Man has taken so much control of his own destiny, that it seems man believes, as though babies are rarely conceived through love and according to the natural plan instituted by God.

Are all *babies* God's choice? I believe so. Each one is *known by God before birth*, for in Jeremiah 1: 4-5 we read:

> *The Lord said to me, "I knew you before you were formed within your mother's womb; before you were born I sanctified you and appointed you as my spokesman to the world."*

<div align="center">†</div>

How a child is conceived is not the issue here. All children are created of love—not by a love act alone—but **by God's love** and **design!** He knows each soul *before* it is in the mother's womb, because each baby is *consecrated* in the mother's womb. This child has been loved and blessed by God, *before* the parents even knew this child existed. This is the reason I ask how a pregnancy can be considered merely tissue, when God *knew* the soul *before*?

<div align="center">♦♦</div>

Recently, a child was judged to be not "all human" by a bragging Christian, no less: "That kid was born of sin. That is not natural and not all human. Insemination is not human. I don't want that kid near my children."

"Forgive him, Lord," I said, *"he does not know what he is saying. He is confused, Lord. Give him Your Mercy. How quickly one falls into the sin of judgement."*

This innocent child was **known** and **chosen** by God when given a **soul**. This child was blessed before he was born. What a loss, his children were denied a friendship with this innocent child.

Is the act of artificial insemination a natural act? No. But the sperm of the man, naturally collected or not, is still human sperm. A woman's egg, naturally implanted or not, is still human. Logically, joined together may they become a human being, a baby, **chosen by God** to be **created** and to be given life, by a soul. (By no means am I implying that I condone artificial insemination.) What must be remembered always is God has the power to **not allow** His creation of life. God is the Creator, **God controls conception!**

<center>†</center>

When did God decide to show mercy? Since He alone allowed the conception of life, do you dare to second guess God's creation? Would we commit a larger sin with our own judgement?

<center>†</center>

Women do not own their bodies. God does! We do not own our husbands. We do not own our children. What are we? We are flesh and spirit, a light reflecting God's Light. God lends us this mortal shell of a body

108

for His light to live in and calls us life. Our bodies are God's tabernacles. We are to take care of these tabernacles, these bodies, *lent* to us by God.

◆◆

Our wombs? Our wombs are *tabernacles*. They hold the precious *gift* of *God's plan*. We women, with God's help, care for the tabernacle and the baby within. In God's plan, if a baby is to be an innocent soul in Heaven, never having to suffer on earth, then *He* will take this baby from the womb, by means of a miscarriage or *spontaneous* abortion. The parents have *completed* the plan God *intended* for them, according to *His* choice. When a stillbirth or miscarriage occurs, it is only because God has taken the life growing inside the womb, this soul, to Heaven!

What a wonderful privilege for a woman to be *chosen by God* to carry in her womb, her tabernacle, God's creation! In God's plan, the baby is born into life, and that life continues on this earth in a mortal body. God has a plan for this human:

> "I have appointed you as my spokesman/ spokeswoman to the world." (Jeremiah 1: 5)

◆◆

When a mother's decision snuffs out the life of the baby; one of God's plan, through abortion, then the *soul* of this baby, *already* known by God, already consecrated by God, is with God! But what about the mother? In *His* timing, God will offer this mother

mercy or His judgement.

♦♦

When God gives us a plan and we say no to it, we disobey God. We try to control our own destiny, and the destiny of another, by selfishness. Still, God shows His Mercy. Humans might not forgive, but God does.

♦♦

What about rape or force, in or out of marriage? No one owns their own body, and surely a woman's body is not owned by any man. For a man to force himself upon a woman is against God's **loving** plan.

♦♦

When God created woman, He took a rib from man, close to his heart, and said, "Let there be a *companion* for man." (Genesis 2: 18) (God did not create man for man, or woman for woman.) God created a *companion* for man! God said, *"Love this woman,"* as He brought her to man. God also said in Genesis 3: 16:

> . . . *"You shall bear children in intense pain and suffering; yet even so, you shall welcome your husband's affections, and he shall be your master meaning; one you admire."*

Well, ladies, this is God's Will. We shall *welcome affection.* But what if it is *not affection,* but brutal meanness and force? This is not an action *designed* by God. God said *love.* Nor does the church expect a women to live in brutality.

†

A *person chooses* to sin. What is sin? It is when we do that which, we are taught by God's law, is wrong and chooses to do it anyway. Actions which are not done out of love actually break the wedding vow.

It is even possible to sin when a priest gives one permission to do something beyond God's teaching and that of the Church. For example, if someone *tells* you to steal, does that justify the sin of stealing? Be very careful when making these choices.

In certain circumstances a priest may give permission for an action (this may never be for the *purpose* of breaking Natural Law) after he has spent much time in contemplation.

†

When the **priest and you truly see no sin,** and he has given you his blessing and granted you absolution for all other sins, you must then trust in your own conscience and in God's promise:

> *"I will give you the keys to the kingdom of heaven. Whatever you bind on earth shall be bound in heaven; and whatever you loose on earth shall be loosed in heaven."* (Matthew 16: 19)

†

Surely, the priest has weighed everything very carefully in leading the soul before him, agreeing with this

111

person that there is a need for surgery or treatment to bring one back to health. The reason must **never** be to prevent procreation.

When may a priest refuse absolution?

When a person refuses to recognize his sin and make a change in his life to sin no more and truly repent.

What if a person, after much soul searching and research, finds in his conscience, total peace in a decision to do something that is contrary to what a priest says? Is this soul truly innocent with no reservation at all?

To commit a sin, one must know and believe that an action is sinful. For example, a non Catholic may not know Catholic teachings and after becoming Catholic, learn these teachings. Was he sinning before he knew? No. Though one could carry the sin of omission.

<center>†</center>

If one has even a touch of doubt, one *may not act* on *doubtful conscience.* To disobey his priest is a sin.

There are times when one must choose the lesser of two evils. For example, an immature husband who is out of grace with God, comes home drunk from a topless bar. He wishes his wife to perform a sex act, knowing the wife could die if she were to become pregnant with a child, but his sense and self-control are lost in liquor. May the wife deny her husband's affection, which is lust through force?

112

1. It is a grave sin to deny the husband his rightful duty.

2. God gave this wife her body and mind as His temple; in what ways must she oblige God to stay alive? She cares for herself by not taking poisons into her body, by eating the right foods, and by not putting herself in danger.

3. By denying her husband's affection and not submitting to force, has she caused him to seek another woman for comfort? If the answer is yes, is the wife guilty for her husband's adultery? Yes. By not receiving her husband's affections, she may now be taking upon her own soul the sin against God's law in marriage and any adultery she may have forced her husband into.

4. To save her life and her health, this woman has been advised by several physicians to use birth control. However, this is against Natural Law. Once again she commits a sin if she uses birth control.

So, what choice does this wife have? To which "lesser of the evils" does she resort: allow herself to die; be responsible for the sins of her husband's actions; go against the natural law and Canon law? Or, does she make the choice to separate from her husband, so as not to make any of these other choices? Which may a priest, having graduated in moral

theology decide? How would a priest with great compassion as Jesus does, comply?

<div align="center">†</div>

This type of case was referred by a priest, as a "hard call," or "tough love." It is the sort of *dilemma* that should be taken *only* to a *priest* who holds a *degree* in *moral theology* and who possesses the gifts of **wisdom** and **compassion.**

Only a priest and the individual can arrive at a decision that is best for her life, health of the marriage, and **peace in the soul**. But it requires much prayer, a well informed conscience, common sense and a knowledge of moral theology; God's Laws.

<div align="center">†</div>

I do not have the answer, for I hold no degree in moral theology. To be a priest and to be responsible for others souls and lives, is a great surrender to God and His judgement. I would not want this responsibility. However, I must say that many times throughout my life, I have found myself counseling a crying soul. Each time, I turn it over to Jesus. I pray for this tormented, confused soul and always recommend a priest and confession. Sometimes I will come across the answer in Scripture that very day to help them.

<div align="center">♦ ♦ ♦</div>

The only answer I have for my own soul is: what makes sense; what sacrifice must I make to do what is

right. I rely on God's graces to lead me to wisdom. I do know one thing: doubts and arguments about what is right, do not come from God.

Surely, we must not judge another. To gossip is to sin. Only the individual knows his sins. Who are we to cast stones?

◆◆◆

If a child comes from force, is this child God's creation? Yes. The action by which this child was conceived is not of God's plan, but the soul, the life given by God, is God's plan. (Growth means life.) God, alone, gives life. God can take the ugly and make it beautiful!

Force or rape is ugly. The victim is the woman. *The baby becomes the victim when the mother kills this life which God has created.* If a mother kills her baby at any time during its development, she is going against God's plan.

†

God, and hopefully the law, will deal with the man for his cruelty. God tells us in the Old Testament, that if we sin with our eye, we should cut out that eye. Would it not be a good law, if a man sins against a woman, that he should be cut off from the sex act? But to abort a baby is murder by God's Law. To satisfy the emotional pain of the mother by aborting the child, is to inflict the father's punishment on to the innocent child.

115

<center>♦ ♦ ♦</center>

Now you may ask, "What does this have to do with your life, Carol?" If I were forced upon and became pregnant, I would not go against God's plan by murdering God's child as a means of punishment against the man who defiled me. I would be hurt if a man thought so little of me that he could do this. In such a case, all possible love would indeed become fear. A woman raped by her own husband loses all of her self-respect.

<center>♦ ♦</center>

A silent cry is the dilemma a women is in when she is damned if she does and damned if she doesn't.

<center>♦ ♦</center>

As years raced past me, I realized that separation from less than a loved union-ship marriage is the sensible step, not to be guilty of all the other rules by God and by the church. To be alone avoids injury and a choice to sin. However, to be alone, is to create the conscious of other sins, such as a forgotten sin by some called fornication. Therefore, be careful to think or judge others, you may not be aware of the true reasoning of their conscious choice.

116

When You Recognize Love

IN MY MID-TWENTIES, I was growing in my ability to reason; maturing into womanhood.

<center>†</center>

I met a pleasant, intellectual man, who for the first time, made me feel that I was intelligent.

He understood my dream of an education and did what he could to help me achieve it. He also inspired me to be all I could be.

He would say he was in awe that I was the sweetest girl he had ever met. We dated for a long time, and then we got engaged.

<center>†</center>

He was of German descent and very wealthy. He did make one request of me and that was to go to court, to legally obtain sole custody of my children. He didn't want them to be allowed to see their father again. This was never a consideration for me.

<center>♦ ♦ ♦</center>

We broke up, but eventually we reconciled. I wanted this man's admiration more than I ever wanted any person's admiration in my life; yet, I would ***not***

let my children go, and I could **not** deprive the five boys of their Dad. This man was certain that he could arrange for me to have the children to myself. Financially, he probably could have, but I was not a vindictive person. This would not make my children happy, nor would this be moral.

<div align="center">†</div>

I did decide that if he changed his mind about keeping the kids from their Dad, I would consider marriage.

<div align="center">♦ ♦ ♦</div>

Then I went through a very painful soul searching experience. I knew that God would not want me to choose a **love for me** over the love my children had for their daddy. So, I let go of **my** dream man. He was tall, handsome, distinguished, educated and respected by the world, wealthy, but not yet a man of God. He lacked the one credential that would make our marriage whole.

<div align="center">♦ ♦ ♦</div>

Years later he was still in and out of my life. He begged me again to marry him. He offered me all he had. His wealth would be mine—no prenuptial agreement of monies. He offered to share the kids with their Dad. But it was all too late; by this time, **God** had **sent** someone else, not rich, but more supportive in my life. I made a choice, **My Way**, to put him behind me.

When You Recognize Love

As time went on, and I became even more independent, friends thought I would need help to find a partner.

One Rose For One Love

Meaningful Love Can Be Friendship

I WAS LONELY AND OVERWORKED. I met a man through a friend. My family did not really understand. This young man fell in love with me, almost to the point of obsession. He quit his pro-hockey team to follow me.

I was attracted to this handsome, personable man. He accepted my independent attitude, and loved me anyway.

He was Catholic and believed in a sacramental marriage. We shared the *same beliefs* and attended Mass together regularly.

†

He loved all five of my sons, and admired me for raising the boys to honor their father, regardless of our differences.

†

How could any woman resist his proposal? "Marry me, honor me by being my wife. I'll care for you and be good to you. I won't leave you if ever you are ill. I'll even take care of your parents someday. Mostly, I'll be so proud to be your husband, chere."

Although I was still close in prayer to Jesus and Blessed Mary, and going to Bible study classes, I still was "Going My Way," making **choices** that seemed best for me and for my sons and not leaving everything up to God's design. I slowly fell in love with this man. I loved his parents, Dad August and Mother Audora, and they loved me. Our new priest welcomed me back to Communion when we married.

♦ ♦ ♦

My husband believed, from a doctor's report, that he could not have children of his own. He used to kid me that he married me for my children—that I came along with the package.

†

He also had a ritual. He was a romantic and gave me a rose a day. He would sign the little card: *"One rose for one love."*

As a devout Catholic, he saw to it that my sons received their sacraments. His mother was the Catholic choir director. She arranged her own children's choir, with our five sons singing weekly at Our Lady of Grace.

♦ ♦ ♦

He kept his promise and often drove the boys across state to visit their Dad. The world seemed

good at that time. He helped give my life dignity and love. All was well for awhile.

◆ ◆ ◆

As he and the children were playing on the beach one afternoon, I reflected on what a good father he was, not only to his stepsons (teaching them sports and helping with their homework). He would be a good father to his own children, if only he could have them. We married believing he could never have children of his own from provided medical reports. Knowing I was fertile and that he was the last of his family blood line from this generation, I called his doctor. He suggested a special diet for him.

†

Three months later, I went to our doctor and was so proud to be with child! His parents were so thrilled when JeanMichael was born. Two years later, we had another son.

◆ ◆ ◆

During my last pregnancy, I was in a severe auto accident which triggered my multiple sclerosis. My legs collapsed and became numb. Soon I was back on crutches and a walker. My health was failing, but worse than this, was the trauma of other things going on in my life.

My husband worshiped the ground I walked on, but I discovered too late that he was an alcoholic. He suf-

One Rose For One Love

fered physical pain due to injuries he received as a hockey player. (Love does not change because of an illness). He coped with my disabilities and I tried to cope with his alcoholism. In time, I saw this marriage was of *my will*, and I had not waited for God's lead, or choice, for me.

♦♦

However, God did not intend for him to raise these children. He could no longer work, and became depressed. He would take it out on us, then apologize **and beg God to heal him or take him**. While his children were still tiny, God heard him.

One winter, his resistance was down and he developed pneumonia. Within three days, he died, at the young age of thirty-five.

♦♦♦

It was traumatic to tell children that their Daddy died. I remember how the boys were crushed, losing the Daddy they adored.

✝

I placed my sons in therapy to help them through this crucial change in their lives. Mother Audora lost her youngest son, which crushed her. I lost my close friend, the father of two precious little sons.

The incense during his Catholic burial made it all so final.

✝

After his funeral, someone said to me, "You look

like you lost your best friend."

I replied, *"Yes, I did. I'll pray for his soul, and I know he will pray for me."*

◆ ◆ ◆ ◆

A Quiet Cry

A Season of My Life

D ID I EVER NEED TO make a choice for abortion? During a pregnancy with my second husband, now deceased, I was faced with the decision to save my life by aborting our baby after an auto accident. I awoke prior to being taken to surgery and immediately requested Mother Audora to stop the procedure. Even though the doctor gave me a frightening argument, I insisted that my baby was alive and that God would care for us. I wept a "Quiet Cry" and prayed often through our Blessed Mother.

My husband cherished me and it was a hurtful decision that he had signed to save my life when he so wanted this child as well. Pleading that we must trust in God's choice of creation, I did not fear death; I feared more not trusting in God's plan.

Only by trusting God's Will is this 'Life' Ryan; able to give another generation.

†

My son, Ryan was born and he was beautiful. To my doctor, this was a miracle. To me, this was *trust* in my Jesus.

<div align="center">♦♦♦</div>

Men have told me that women don't think of the pregnancy as a baby, until they feel movement. **Nonsense!** Once I was **aware** that I was with child, no matter how early, I began to **prepare** for my baby's coming. I would wash and fold belly bands and receiving blankets, clean and press the lace covering of our bassinet, and take better care of my self immediately! I was **attached** physically and emotionally (maternally). When a child is lost through spontaneous abortion or miscarriage, the parents lose so much–they lose a child that is loved.

<div align="center">†</div>

I recall the physical and emotional suffering of my many miscarriages. I especially recall one occasion, when I saw a nurse carrying a bag. As I stood in the doorway of my hospital room, I instinctively felt that the bundle could be my baby, and I asked the nurse. She said that it was my baby, and that it was being taken to be incinerated.

"What," I said, "I didn't know they did that!" Another "quiet cry."

<div align="center">†</div>

After another miscarriage, I called our parish to see if my baby could be buried in our town's Catholic cemetery. The priest said no, **that my baby must be born first and then die**. He added, "Even if the baby is born prematurely, but dies at more than six months

of term, we can't bury it." Another "quiet cry."

Later, I asked another priest, and he told me that in some states, babies less than six months of term can be buried in another relative's grave.

I was shocked. How could this be? **The Catholic Church teaches that life begins at the time of conception,** and yet it did **not** have enough **respect** for my baby, to give my baby a proper Christian burial.

I believe a soul is given during conception, not after "breath of air."

Our Church must come to a clear consideration on the issue of "life after breath."

The dignity of my babies' lives, overlooked by my Church? In years past I wrote to the Bishop on the issue.

<center>†</center>

Recently I wrote to Rome and requested further investigation on this issue by Cardinal Joseph Ratzinger.

<center>†</center>

At this time I wish to pay tribute to the memory of my children, whom God chose to take to Heaven before breath and before me: Heidi, Candy, Theresa, Bridgett, Mary, James, Dominic Paul, Julie, Carolyn, Bernadette, and Robert.

Though I was not allowed to have proper burials for my children in those days, my grieving mother's heart was pierced just the same. Although I could accept

God's plan and feel that my babies are saints, I still took a mother's time to heal emotionally and physically, in my "Quiet Cry."

<center>†</center>

As a woman with medical problems at the time, my doctors often recommended birth control. However, once again this would *alter* God's plan.

Our Church does believe in Natural Family Planning (once called Rhythm), but this is only effective when *two consenting, married adults are willing to show consideration* for each other and to *sacrifice.* My husband was immature and unwilling to observe Church teaching. I trusted God will decide which of our children survived through birth.

To fulfill God's plan in marriage, I continued to obey God and the laws of my Church. I continued to procreate. I learned that quantity of children does not lessen the quality of children.

<center>†</center>

In the midst of sorrow, came a mother's crown! For God chose to bless my life with seven living sons from oldest to youngest: Francis, Randy, Kenneth, Joseph, Patrick, JeanMichael, and Ryan!

<center>♦♦♦</center>

Recently, my present husband, Bob and I attended a healing service for parents of deceased children at our church. Bishop Rose, of our diocese, has inspired our

priests to celebrate Mass, whereby parents and other loved ones can relieve, grieve, and say a real good-bye to those children, whom God, in *His plan*, carried home! It was meant, also, to be a healing time for those parents whose children were aborted, not by God's plan, but by the mother's conscience choice. Fathers were not excluded from this healing. My husband says that each child is a new hope, a new dream, a new plan; a new generation. But that God has His reasons, and we trust that He has a special place for our son, Robert.

As Bob collected eleven carnations from a vase in the church, one for each child I had lost, it was the first time in all those years, that we felt our parish really cared and acknowledged what our married love gives back to God! Thanks to the bishop of our diocese, this wonderful healing became available in our parish through our parish priest!

<div align="center">✝</div>

I spent nine years working with "Right to Life." I have spent many more years praying for the Choice issue to be overturned. Why? Because we women do not need a written law to allow us to choose. God gave us this right with His "Tree of Conscience" in Genesis 2: 9 and 17. God gave us choice! So why do we argue over an issue which God has provided us with the knowledge? God gave us Commandments through the great prophet, Moses. So, why do we hate, hurt, and

argue about an issue? Moses told us so clearly of God's laws. If our country was governed by God's teachings and we obeyed God's laws, we would not hurt others. Peace and joy would reign.

Do not be judgmental of those who sin; do not be hateful toward those who follow God's laws, rather than human law. Do we, as God's children, have a *right* to protect the unborn? Yes. In fact, we have a *duty*. We are to *uphold* the laws of God. To side with another for convenience sake is a foolish act. To avoid the destruction of America, we must *pray, pray, pray*, for respect for life, respect for marriage, respect for choice of religion and care for your brothers' and sisters' needs.

<div align="center">†</div>

What about unmarried mothers? Yes, it is *ideal* to have two *adult parents* to raise children and surely this was part of God's original plan. But, what if one is immature and very foolish, or mean, abusive, and dangerous to the wife and child?

<div align="center">†</div>

Does God ever decide to give a child to a single mother? All the time? *God chooses life*. What about the thousands of children who lose a parent after birth? Does this lessen the quality of the child's life?

Surely it is *wonderful* when two *adults* marry and raise children under a Christian roof. But if in God's plan *one* parent is left to raise this child alone, do we

have the right to judge God's decision?

So many judge problems as stemming from divorce or illegitimacy. Do you really know more than God in His infinite plan? Should we not be more concerned with **compassion**, and the **willingness** to help those parents **chosen by God** to help aid Him in creation, possibly raise children alone or given later another parent as a gift to help raise this child. Give God the lead. His plan will be perfect.

<div align="center">†</div>

Oh how wonderful it must have been for Blessed Mary to be **chosen**, a girl of fourteen, **to be with child before** she was betrothed to a *chaste, loving, saintly,* dependable, trusting fiance. What a perfect *foster* father and spouse was Saint Joseph when he listened to an angel and said yes to God's plan.

<div align="center">†</div>

I have been asked many times, to speak with confused girls and women who are contemplating abortion, because of their fear of an unknown future. I become so excited when I am called! I love to be near all pregnant women! This brings me closer to God! For in each of these women lives Jesus!

From the moment God allows conception, He has given life within. God knew this baby before He placed this life in the womb. He chose this woman. She can say *yes* to Jesus, trusting in Him and accepting the baby He has asked her to carry.

I become excited when I *honor* a woman during her pregnancy. God didn't choose me; He chose her! Her womb has become a tabernacle for God's plan! Wow! Even if that plan is only for a while, this *special* woman has been chosen by *God!*

All pregnant women should be honored. Motherhood is to be **honored**.

If God does not want a pregnancy, **He has the power over life**, the **power** to **prevent** conception. But when He chooses you, He allows you to trust in Him. When you let God control your life, using you for His plan, all will be well. (Psalm 23) In saying *yes* to God's plan, you will live a joyful life on this earth and in Eternity! A strong woman is a godly woman.

<center>†</center>

The Blessed Mother, the godliest, purest woman of all, is the perfect model of motherhood. In her many apparitions all over the world, She spreads God's Word, enforcing His Commandment: Thou shalt not kill.

In 1531, when Our Lady appeared to the Aztec Indian, Juan Diego, she wore a dark colored sash and a cloak of blue green, which are Aztec symbols and colors of pregnancy and motherhood.

In private locutions that are known to Mexico's Catholic Hierarchy, Our Blessed Mother, Herself, called abortion the "horrible evil" and compared it to the bloody human sacrifices of the pagan Aztecs.

Under the title of Our Lady of Guadalupe, she has promised to lend her protection and help to the pro-life movement. Our Lady's intercession, combined with the prayers and sacrifices, Masses and Communions of her children, can bring to an end this "slaughter of the innocents." The ultimate Quiet Cry for all of us.

Jesus, the Physician of all healing,
Wrap me in grace, within Your Presence,
So I may feel Your Strength.

Jesus, You know my heart was broken,
When You lifted my child to Your home.
I felt so empty.
My head was heavy in piercing pain;
My heart was choked in my grief.

Gentle Jesus, You understand my hurts.
You understand my need for healing.

Lift me above my grief and memories.
Heal me and bless me
With Your graces.

Jesus, I gave to You all of me.
Work a miracle in me, Jesus;
Restore me to joy!
Hold me in Your arms,
And carry me everlasting.
Amen.
(Little Olive Branch)

CHAPTER 15

See Me As God Sees Me

FROM BIRTH TO THE MID-SEVENTIES, I lived my life by the standards of others who arranged and led my life: *"Going My Way."*

♦ ♦ ♦

From this point, I began to take charge of my life and its destiny. I supported and raised my seven children, ran my own business, taught catechism in the church, and participated in civic and private associations.

†

The mountains of my life have been a series of avalanches, more with let downs than with stability. Even society fled each time a crisis entered my life. I learned at an early age to expect to carry life's crosses alone.

♦ ♦ ♦

Some traumatic events in my life, such as childhood polio became a *blessing*. I gained the strength to be a better mother as I dealt with these hardships.

♦ ♦ ♦

Two sons joined the service. We were in the midst of building a new home, along with building a business in retail, I was busily juggling my hours and still had

time to manage to keep up with Cub Scouts and a variety of sports which my other three sons were actively balancing their lives with. Plus, I had the two little tykes still underfoot, Ryan and JeanMichael.

†

Sound familiar, Moms? You bet, in today's fast-moving world, we try our best to become super-Moms!

♦ ♦

The younger children's father, who has since deceased, was very helpful with all the assistance needed to get the boys to games, or take them on outings or just taking the babies to the harbor to feed the ducks, even though he was very ill.

†

This time other personal problems arose. In addition, my health had begun to fail again. However, I just did not have time to slow down.

♦ ♦ ♦

Before Christmas 1974, my life was uncertain, and I was not sleeping well.

♦ ♦

The building of our new home was delayed, so we had to rent a house for awhile. The landlord wrote a letter one week stating that they wanted to sell the home and we must leave. Our new home was still not complete.

♦ ♦ ♦

Early one morning, before we moved, I had a dream. I awoke, frightened. The next two mornings I had a sequence of the same dream. Each day I told several persons about my consecutive dreams *"that someone would be shot, this I was sure of; I felt I knew the person and they were close to me, but I could not see the face of the person in my vision-dreams."* Bewildered, I began to pray about these three dreams that woke me.

†

I was concerned that these visions could be a pre-warning to me as a mother, of my two sons who were now in the armed service. Francis was in the Marines and Randy was in the Army. However, **as I reveal the true story**, you will see that God is so loving that he even tells us sometimes about the future through awareness in a dream.

♦ ♦ ♦

After Christmas, we moved into the loving home of Mom Audora, the only person willing to take us all in on such short notice. She had an apartment upstairs which we could temporarily borrow until the new house was completed.

♦ ♦

I now give you this season of my life as part of my autobiography.

♦ ♦ ♦ ♦

137

"Told by the Person
Who Lived It All the Way
His Mother — me."

Avalanche
Little Hands & Big Courage
*Told By the Person
Who Lived It All the Way–His Mother*

I HAD WORKED PRACTICALLY my entire life, from the celery beds at age seven, to working crippled as an elevator operator, as a waitress, industrial worker, supervisor, inspector, in retail management, a secretary and later as a licensed real estate broker. Until I was twenty-seven years old, I lived my life by standards others had set for me. At that time I set out to be an independent person, to "go my way" with my five children to raise.

I was now a mother of seven children. All my life, I knew it was important for me to do my very best in climbing my mountains, my mountains of multiple trauma. But nothing in life prepared me for life's tragedies nor did I ever anticipate the avalanche that awaited me.

It was on January 17, 1962, that we were presented with a joyful bundle of love. Our fifth son was born. I remember saying, *"Another soldier! His name will go on for generations."* As I looked at his small stubby legs, wide fists, and bald head, I

thought, *"How very beautiful he is. Thank You, Jesus, for two hands with all his fingers, two feet with all his toes, two eyes like light blue petals, his stub nose, and sweet baby's breath."* He was normal and chubby.

<div align="center">†</div>

I had carried this son ten months. This child, I was sure, would be my last, for I had angels in heaven and my health was not good. These five sons would be enough for my joyous heart. When they handed me this small bundle in the hospital, I felt he would be mine forever. I did not think about the possibility of ever losing my child. That always happens to someone else. I never dreamed that I could know this pain.

After hours of cuddling my baby, and his father sharing in the holding, we talked of his light features, "the Irish side of my family, for sure!" I looked at his father and said, *"His name shall be Patrick James!"*

<div align="center">†</div>

When we arrived home, his other four brothers fussed over him. None seemed to be jealous, although very close in age with sons Francis, six years old; Randy, five years old; Ken, four years old; Joseph, two years old, and now our fifth son, Patrick!

<div align="center">†</div>

After Patrick's baptism, my health declined. The

Avalanche: Little Hands & Big Courage

doctors did not know what the diagnosis was. While I was hospitalized for two weeks, our friends Joe and Donna took Patrick with them (as I trusted my baby to their care).

<p style="text-align:center">†</p>

Later it was discovered, when my body would become very weak and my legs would go numb, these were symptoms of multiple sclerosis (forever I also retained crippling of my polio in areas of my body.) But at the time of handling five babies at once, I was misunderstood, and far overworked for my condition. To this day, I believe that the angels must have helped me with this little family.

<p style="text-align:center">†</p>

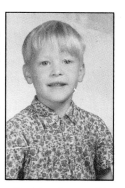

Patrick was nearly three before he grew blond hair! He was the shortest of my sons at this age. Patrick was bright, always with a smile, and a most gentle child and easy to care for. He was very special. For ten years, he was my youngest, my baby.

Patrick at 5 years old.

<p style="text-align:center">†</p>

Life was good, though many rough times came our way. However, the future would be the roughest. In December of 1974, I took the boys, with their new sleds, out to the Blockhouse Runs. They spent hours sliding down hills and falling in the snow, their playful laughter ringing in the air.

January 17, 1975 was Patrick's thirteenth birthday. I was hoping to make it special because Patrick and his brother were leaving that afternoon by Greyhound bus for a Christmas vacation, with the family while we settled into another house.

<div align="center">†</div>

We spent the morning in church, followed by a pancake breakfast. During that afternoon, we went sledding down the Blockhouse Runs. We all tumbled in the glistening snowdrifts. Laughter filled the air.

I remember so clearly going down the run with Patrick. We were both snow owls by the time we reached the turn. As I brushed the snow from Patrick's round face, *the sun radiated in a sparkle from his petal blue eyes, a sight I'll always remember.* He started brushing snow off me and said, "You're pretty, Mom." We romped in the snow until his brother tumbled in, and then we made snow angels in the drifts with our bodies. As my sons frolicked, I made my way up to play with the two smaller babies.

Later at home we hustled with the suitcases in order to get the two boys to the bus on schedule. (How I wish they had missed that bus!) It was painful to place those two boys on that southbound bus. They were close in age and close buddies. I saw no reason to be concerned; though as a mother, *I felt the loss before the bus even pulled away. I cried as I saw*

them wave. Patrick's face pressed against the window as he gave a big smile. They were so excited over their first adventure alone.

<div align="center">♦ ♦ ♦</div>

They arrived safely. The next day I spoke with my sons. They were happy and having fun. All seemed well.

A few days later my sons were left alone due to an emergency. A shotgun was sent to their house through the mail as a Christmas present. One of the boys picked-up the gun, and from that moment in time, both of them were thrown into a life long trauma when the shotgun automatically discharged due to a malfunction. The shell had been left in the chamber and could have gone off at anytime during shipment as was reported by expert investigators.

The shotgun blast tore through a sofa and kitchen cabinet. It proceeded to hit Patrick, in the next room, as he was reaching in the cabinet to get a can of dog food. Then it continued through the range and lodged into the wall. Unknown to my son, was the fact his brother had just knelt down to get a can of dog food. He saw his little brother Patrick slumped to the floor next to the cupboard with his head severely injured. He went into shock but somehow managed to call emergency number 911, while cradling his brother in his arms until the ambulance arrived. The police had arrived and handcuffed my

little son and put him in the squad car. They followed the ambulance to the hospital and put him in a room where they handcuffed him to a bar while they continued their investigation. He was scared and alone not knowing of his brother's condition. He was in shock and being interrogated by police without his parents or any other adults present.

◆◆◆

Meanwhile, back home in Muskegon, I was having a good day. I redecorated a restaurant and fulfilled a contract. Grandma Audora watched the other children. She was a woman of *grace*, who was always there for anyone who needed help. I always said that her kindness was an image of Blessed Mary.

I had just slipped off my boots and was about to pour tea when she called me to the telephone for a long distance call. She fell into a sofa as the phone dropped to the sofa beside her. I had grabbed the phone barely said hello when a voice yelled, **"Pat's been shot! Get to Ann Arbor NOW; they can't operate until you get here!"**

Oh my God! I stood horrified for a second. Relaying the message to my family, I ran for my purse, sweater, and coat. My niece, Chris, and her husband insisted on driving us across state.

Within three minutes we were on our way to Motts Children's Hospital, Ann Arbor, Michigan, a one-hundred and eighty-five mile **race against death,**

during a snow storm in which you could not see more than a few feet ahead. I remember snow, grey sky, and fear. Would we get to the hospital in time? Was my little boy dead? Why was fate touching the bud of life this way? The drive took an eternity. My son Ken and I prayed one rosary after another. His close support will long be remembered.

Son, Ken, rode with me to Ann Arbor when Patrick was shot.

†

Arriving at the hospital, in panic, I demanded to see Patrick. I rushed down a long, grey hall followed by several doctors and nurses.

Someone pointed out the cart on the next turn. His body was so tiny compared to the size of the cart. They pushed the cart to meet me. I gripped the side rail and then rolled back the blood soaked cloth from his head.

My child's face lay open from the back of his ear across his nose, a mass of raw skin and blood. I looked on in horror while a surgeon explained where his eye should be.

Someone said, "Sign these papers; they're waiting in surgery for him."

I signed as Patrick was moved onto an elevator. My arms stretched out in shock. Only the grey walls sup-

145

ported me. I don't remember how long I stood there, frozen and alone. the names Jesus and Mary were repeatedly on my mind. I twisted my rosary beads from one hand to the other.

<p style="text-align:center">†</p>

As the hours went by a police officer, in his quick judgement, gave me his theory of what had happened. When he told me that my other son was being questioned I shouted, *"You fools! Who is with my son? He is one of my gentlest sons. How can anyone even consider questioning him in this shooting?"*

I ran to a pay phone and called the Muskegon police, asking them to recommend an attorney with whom other attorneys and judges did not care to deal with. This was the attorney I used.

I called him and asked that someone go to Jackson, Michigan immediately, to help my other son. I was torn between two sons who both needed me, one on an operating table facing death, the other in a police station, being questioned without my permission or the presence of an attorney.

Ballistics experts later found that the manufacturer of the gun was at fault. In fact, several guns in the same series had the same defect.

<p style="text-align:center">†</p>

Feeling so bewildered. How could this happen? While waiting to hear about Patrick, I had hours to

wonder and recall how special my seven children were to me. Remembering Blessed Mary would know my agony: the stabbing through my heart; the pounds of hurt that crushed my chest, with every breath pain sank deeper into my own body.

I am considered to be a strong woman. Even in devastating situations like this, I have never been known to panic and can sort through thoughts and make decisions. Normally, I weep silently and clutch only my rosary for comfort. Multiple sclerosis, however, reacts to trauma. My legs became weak, and numbness was setting in.

During the trauma, little did I know I would need all my strength for after the surgery. Our family had not come to Ann Arbor yet. Many had not heard. Thank God, I had my sixteen year old son Ken with me for the first few hours.

<div align="center">†</div>

During the surgery, the fearless Muskegon attorney sent for my other son, to be rescued from torment and taken up North in Michigan until the investigation had been completed. This relieved me from being torn between the needs of both sons.

<div align="center">†</div>

After the surgery Patrick remained in a coma. A sack of blood swayed above his frail body in the intensive care unit. Bottles and tubes did little to ease my fright. In this case, a transfusion was not routine.

Complications set in. As my little boy lay motionless, I turned to take his hand in mine, but the nurse said my five minutes out of this hour were up.

The gloomy waiting room contained crying parents and people continually talking about their children's hopeless cases. I kept my sanity by staring out the window and visiting the chapel frequently. I let myself go back in time and remembered our last day together and the fun we had playing in the snow.

We needed Patrick in our lives. He always found so many pleasures in life. Day and night I waited alone for a sound or movement, letting us know he could respond. The thought of his dying was so intolerable, that I could almost feel my whole body leaping to defend him.

How could I help him to survive? I learned the hard way in life about strength and will power, because of the polio at fifteen and the multiple sclerosis at twenty-two. But it seemed so different now that it was my little boy.

Discipline and limitation were necessary for successful rehabilitation. As I spoke with a doctor about his chances for survival, it became clear to me what my future would be as his mom. ***It gave reason to why I had been through so much. I was being prepared for this day***. I remembered when a nun once said that someday, I would understand how these experiences would give me necessary strength and

148

tolerance. No way could I have known about the hurt that lay ahead.

Patrick had lost most of the right side of his face, including his right eye and total orbit area. He would have major facial deformities. There is a dent in the right side of the cheek, where the cheek bone floats. He was totally deaf in the right ear, and blind in the left eye. Many fragments remained in the wounds and in the orbit or socket area of the left side of the face, and his jaws were wired together.

<div align="center">†</div>

The flow of people hardly allowed me time with Patrick after the news was out. People came from in and out of state. But I was alone inside, except for my dearest Mother Mary. I knew she shared my hurt, for hadn't she seen her Son's bleeding wounds as He died? Surely, she knew my anguish. She understood. At times, I thought I felt her hands hold my shoulders or my head.

<div align="center">†</div>

Behind double doors at the far end of the room, doctors and nurses worked in an area containing fourteen beds and monitors. It was a scary room. For a mother it was "death row." A child with head covered had been wheeled out just before I was signaled by a nurse. They had just examined Patrick, and I was to try communicating with him again.

As I looked over at my little boy, my eyes filled

149

with tears for the hundredth time. My mind had been so tormented that all I could do was to put his limp hand in mine, and begin the short speech I had prepared to say each time I approached his bedside: *"Hi Patrick. Guess who? It's Mommy. I love you and need you to wake up, Patrick. We are ready to leave for a hockey game. Come on, wake up, or you will miss the game."* (Patrick loved all sports but baseball and hockey were his favorites.) I was trying to reach him through some pleasant thought. I thought I saw his fingers twitch; then he moved them as if writing. Excitedly, I asked a nurse for paper.

Unable to move or communicate in any other way, Patrick scribbled, "I'm thirsty."

I shouted joyfully: *"Water! Get some water,"* ordering nurses around as if I were head nurse. All we could do for Patrick was squeeze trickles of water between his lips, hoping some of the water would make its way through the wired teeth and jaws, down his throat. This was the moment we prayed for, a sign of life, a response to our voices! After three more days I slumped exhausted into a chair.

I did not care at this point about what was happening around me. I just needed a good night's sleep. My friend Karen, who arrived from Lansing came in and tried to get me to leave the hospital for a shower and food. I was wrapped in fatigue. Let the experts go on without me. An enormous burden hung over

me. Though Patrick had moved his fingers, there was a long way to go before he could be moved out of ICU to a room upstairs.

When everyone left to return to Muskegon that day, I was alone with no one to commiserate. I just slept on and off in a chair. Within a few days Patrick was stabilized and out of immediate danger. He was moved upstairs. After he was settled, I pulled a chair close to his bed, took his hand in mine, and softly sang a song he liked, **How Much Is That Doggy In The Window**. Then resting my head on the edge of the bed, I dozed, comforted so close to my son.

I awoke to the sound of: "Mom, is it you?"

"Oh, yes, honey, I've been here right along."

It was his first real effort to communicate sensibly. He could barely speak through his wired jaws and he was blind in the only eye he had left. He clung to me with a frightened grip.

The next day a doctor came in and told Patrick that he had lost an eye in the gun blast. Patrick reached for his bandages. I took his hand away. He let out a sound I had never heard before, and hope never to hear again. We made it painfully through one day at a time.

†

On the sixth day, I got Patrick to leave his room and to sit in a wheelchair in an art class with other children. Though he could not see them, he could sense

life around him. I was hopeful that he would enjoy life as he had only weeks before.

As the children decoupage a picture to a board, Patrick did his picture blindly. He selected a picture of Blessed Mary and her Child, even though he couldn't see, dabbed glue onto the back, and pasted it onto a tongue depressor box that was handed to him. I still have that box and picture that he made for me while he was blind.

"Rehabilitation" they called it. Only the cruel world began a number on him his first day out of his room. A child about eight years old started laughing at Patrick. Another asked him: "Will you get another eye that you can see with?"

Patrick realized that the others knew. He panicked and felt the bandages around his head with one hand, while he gripped me hard with his other fist. I took his hand away from his face and pushed him back to his room, where we were safe from laughter and questions. This was not a good first day.

<center>†</center>

I remember the day Patrick first saw a glimpse of light out of his remaining eye. I held his hand tightly, feeling the fear that raged within him. We were hopeful that even a part of his sight would return. What could we expect next?

A doctor sat down and discussed how sight can come back little by little, while reminding Patrick

that he was missing a right eye, socket, cheek bone, and some jaw bones in the right orbit area. He explained that surgery was being planned to restore part of his hearing and the balance of his face.

Patrick accepted the doctor's shattering diagnosis, living with severe pain. Each groan tore my insides as well. Patrick was weak from loss of blood. He had lost a lot of weight and could not eat solids with his jaws wired.

<div align="center">†</div>

Today was to be a big day. The stitches were being removed and Patrick could go home in a couple of days. When you are waiting for doctors to pop in, your watch is an essential item. I saw and felt seconds in the pulse of my wrist, but they refused to add up, and the hours refused to complete the day.

By the time the hands finally crept to three p.m., I located an aide and asked if the doctor would be in soon. I was concerned with Patrick's suffering.

The nurse was preparing her tray of utensils for the doctor to remove the stitches. I asked if they would put Patrick to sleep. She said, "No, it won't take that long. For goodness sake, surely Patrick has been through more than stitches being removed." I witnessed his suffering. He yelled out between his wired teeth: "Oh God, help! Please, help!"

The muscle and blood seeped out as the stitches were pulled. The procedure seemed endless and

153

Patrick was exhausted by the time they had reached behind his right ear. It was impossible to numb myself to his pain. I seemed to feel it as intensely as he.

Before he was released, I spent two days learning how to care for Patrick. Scissors, gauze, swabs, rubber gloves, mask over mouth, proceed: go in on left side of cavity; swirl softly with gauze to the left; softly dab; pat. I suddenly flinched. The doctor had touched a nerve ending in the open wound with its raw meat and muscle. The air alone made Patrick's hands grip the chair until his veins stood out. The cavity looked almost as grotesque as the first day when his face was laid open.

I could not relive that torment again. The gruesome job of cleansing the orbit cavity was just too much to ask of a mom. I could not imagine myself going through this procedure. How could they expect so much from me? Didn't they know I felt every pain that my son felt? Couldn't they realize that I had suffered even more than he had at certain points? How could they ask me to open his wound? It was eleven inches in length.

I guess they thought I would harden to it, but I never did. Each time a stitch was cut off, I flinched as I opened the wound from his eyebrow, down his face, to behind his ear. I cleaned it out twice daily and stitched it with "butterfly" stitching. Sometimes the solution I used burned nerve endings.

154

How many times I wanted to toss my responsibility to someone else, but since I would have to continue this care after we were home, I had better learn how to do the job correctly.

Cleaning the raw meat was emotionally painful for me as well. The physical suffering was too much for either of us to endure, but we knew we had to. People make big deals over hangnails and cut fingers. A little hot water makes us withdraw our hands in a hurry. How did Patrick ever endure the pain of the solution down the entire right side of his face? Oh, what our Blessed Lady must have felt when vinegar touched the wounded lips of her Son. As Patrick healed, the pain and the itching intensified.

<center>†</center>

Patrick left the hospital on February 16, 1975 and returned to Muskegon in grand style, riding in a motor home. At first everyone came to see, to care, to offer help.

Only they didn't live up to their empty promises of help. All too soon my calls for help became a nuisance. No one from my parish responded. Family avoided calling. Pat's daddy had to work. So, I was left to fend and Patrick to mend, alone. Everyday was booked with doctors' appointments.

<center>†</center>

The public wasn't satisfied. Cruel telephone calls

were made to me by strangers. People demanded to know what kind of a mother I was to let my kids have a gun. The newspaper played it up without facts, misinforming the public about **where** and **how** this had happened.

The public forms opinions from what it reads and then adds to it. The "righteous" cornered and tore my life to pieces with wrong gossip, giving no thought to the hell I was enduring through no fault of my own, other than allowing my sons to spend their Christmas vacation with more family in Southern Michigan.

♦ ♦ ♦

Twice I made weekly runs between Muskegon and Ann Arbor, nearly a four hundred mile round trip. I was forced to cover the cost of a licensed sitter for my other children while I was away. Family became less and less available and the mere mention of financial aid sent relatives into hiding.

The medical costs soared with outrageous amounts for supplies, appointment fees, and the hospital insisted that I make regular payments.

The tires were worn bald from the unusual amount of traveling, and the car broke down several times, probably as exhausted as we were with so many runs.

†

By the third day at home, I refused to open the door to just anyone, so they called the Health Department.

All I wanted was a little rest and peace. It turned out okay. The Health Department sent out several different investigators, who asked the same questions over and over again. They soon discovered that our home was orderly.

So called "concerned" people did nothing to help. Instead, they invaded our privacy with their "tittle tattle." I explained over and over again that it was *no* accident, but *negligence*, on the part of the gun manufacturer. Certainly, ballistics experts knew more than the public. Surely, professional investigators knew more than gossips. Had our family not been through enough?

Some were concerned because I was suturing my son. They had heard only half the story. They did not know that I was *trained* and *instructed* in this procedure for his safety. Otherwise, his hospital stay would have been longer.

<div align="center">†</div>

It was February 20, 1975—one month to the day that Patrick was shot. I had another disaster on my door step. We found that it was hard to relive these events for other people, and we had real difficulty facing so many strangers. I devoted each day to only Patrick and closed the business. I was so glad Patrick was still alive! I would not have entrusted him into the hands of anyone else.

<div align="center">♦ ♦ ♦</div>

Our new house was about ready to move into, and we were staying with my parents for a few days. We all were anxious to be settled as a family again. Then we had another emergency.

On that particular day I had a very hard time cleaning Pat's wounds. He kept jerking, first a hand, then a leg. At first I thought he was coming out of the initial shock at last. An hour later, however, when I brought him his supper, Patrick's arms were jerking in mid-air. Then his legs kicked out and he sounded delirious. No one had prepared me for this.

Dear Lord, what was going on with my little boy now? Patrick had no fever. Dearest Mary, what was wrong? I thought, *"Why did they let him out of the hospital so soon?"*

I rushed to the phone to call Ann Arbor. The doctor diagnosed probable epilepsy and said that Patrick had received some "temporal lobe damage" from the gun blast. Why hadn't they told me this before?

The doctor continued, "Take your son immediately to Blodgett Hospital in Grand Rapids. Doctors will be waiting."

I dialed the helicopter service number but the pilot was not available. So I called an ambulance and they asked what insurance I had and when I replied, they told me that I needed to pay six hundred dollars above the coverage, four hundred dollars now and the rest in fifteen days.

158

I didn't have this amount of money available, so I hung up the phone and carried my son to the car. I could hear Patrick gagging. I was afraid he was swallowing his tongue, but I could do nothing, except turn him onto his stomach, because his jaws and teeth were still wired.

Starting out for Grand Rapids, I realized I was nearly out of gas. I had no cash with me, but thankfully I knew the station attendant, who gave me five dollars worth of gas on credit. He could see through the car windows that Patrick was in trouble.

Before the gas cap was on tight I sped away, blasting the horn nearly the entire forty miles to Blodgett Hospital, while Patrick's arms and legs jerked all about. I could depend only on dearest Mother Mary and Divine Jesus, to help hold my son until we reached help **in this new race against death**. I knew time was precious. Had I come this far only to have him die in my arms?

I had never been to this hospital, so I asked my guardian angel to lead us. I had no map and saw no signs, yet somehow my car ended up in sight of the hospital. I thanked Divine Jesus, Blessed Mary, and my angel as I pulled into Emergency.

We were met at the emergency room door. Pat was still flinching, but felt some relief just knowing that he was in the care of experts. His one eye wandered to where I was standing.

He was put through many tests while I signed a dozen papers again. Then there was the reliving of the whole traumatic injury: which hospital, doctors' diagnoses, all the treatments I could recall, names, dates, etc. To this day, I cannot speak about it without flashbacks of the horror.

Patrick quieted down after being given phenobarbital and was released back to me, but he had to return to the seizure clinic once a week after that.

<center>†</center>

Things began to settle down. Pat's inner ear was healing and his seizures were becoming controlled.

On February 25, however, he ran a fever of 105° degrees. I took him to Muskegon Mercy Hospital. They would not keep him because they had no records.

Because his treatment was delayed, he developed an infection in the orbit and right ear area. In his condition, everyone was surprised that he was not kept for observation. Due to the long drive ahead of us to Ann Arbor, fever medication could not be given. I had medication for infection but that would not control his fever. Besides, with wired jaws, how much was getting into his system anyway? I felt so helpless.

<center>†</center>

We were back in Ann Arbor for treatments and tests. We stayed in a motel room on my credit card, and I

160

gave Pat his proper dosages with the special instruments given to me.

The real problem was finding Patrick restaurant food for his wired mouth. Finally, I convinced the motel kitchen to purchase a blender and to bring my son meals that he could take through a straw. It was difficult for Patrick to be in public with his head totally bandaged. People gawked, so I asked the motel to serve him in our room.

<div align="center">†</div>

Returning home, I tried to arrange for a tutor to come to our house, to help Patrick keep up with his school work. *None* ever came. Determined that he would not fall behind, I became his tutor. On our next trip to Ann Arbor we acquired a written guide for the completion of his studies, eliminating, of course, gym, shop, sports, and cafeteria lunch. I now became his teacher.

Eventually, Patrick did return to school, though for only three days a week. I tutored him the other two days.

It was suggested that Patrick go to a rehabilitation school, but I insisted that he remain in a normal school environment. He had not lost his brain power; he was only damaged. I knew Pat could keep up with my help.

It was not easy for him to adjust to cruel stares and idiotic questions. (I, too, had lived with being crip-

161

pled and rejected. No one fought for me to have an education at age fifteen. History would not repeat itself.) I was determined that this would not happen to my son.

After a number of schools rejected Patrick, I held firm to give him his American right. We found a school that agreed to accept Patrick as a student, based on the advice of my attorney, the head of public schools, and myself. I had to bring him his prescribed medications daily; they could not be kept on school property. The days ahead would be tough. This was the job in store for me. I gave up my own career to care for my son daily.

It was a struggle, but Patrick kept up with his level in school. In fact, during a conference his English teacher commented, "Patrick has an electrifying effect on people. He should be a politician someday."

As he began to adjust normally to his friends at school, I knew that firmness instead of coddling had paid off for my son. I remember saying often, *"Put your head up and ignore them. No one said this would be easy. Besides, you have made new friends already."*

When a couple of young men asked him to join them in a game of pool, I looked up with a grin to God and said, *"Thank You, Lord, for giving me the endurance to be firm with him."* It made my day to see and hear him laugh with friends instead of hiding

behind closed doors or, God help us, pondering suicide. No hibernation in our home! I went on with life and expected no less from my son.

<div align="center">†</div>

Patrick began calling his brothers ugly. He was daring them to call him ugly in return. It seemed he was doing this to draw out others. At that I said to Patrick: *"Patrick, it's not your face that's ugly; it's your personality that's changing."* He stared at me, a bitter glow in his only eye. I knew he was hurting inside. Then he twitched around and looked at me and I saw tears swell. I reached out, holding him close, and we both cried. We shared many such tender moments together as time passed. Patrick started accepting himself, except for the idea of one eye.

When we returned to Ann Arbor, the doctors suggested a prosthesis. But Patrick had convinced himself: *"**No** patch and **no** prosthesis. If I can look at it—so can the world."*

His doctor told him that he should wear one for others because they were not as brave as he. Others, especially children, expected two arms, two legs, and two eyes.

Patrick finally agreed, not for himself but for them. He said, "It bothers them more than me." How much of that he honestly believed, we were not sure. Had I really done that good a job of building up his self-esteem and self-confidence, or was he covering up?

Hopefully, he had learned that *being himself* was his best asset.

<center>†</center>

On April 20, 1975, we returned to the hospital once again. Patrick was to undergo a series of operations in which his ear canal would be enlarged and then replaced, to enhance his hearing in his right ear. The ear could not drain by itself, so from now on he would need to continue with unlimited visits to keep the ear clean and free of infection.

<center>†</center>

By May 21st, my little Patrick underwent delicate surgery. He drifted into a second coma. Meanwhile, my mind raced to the summer before when Patrick spent every day at the park playing ball. He was a natural athlete, putting everything he had into whatever game he was playing. I thought about the letter his coach had just sent:

> **Hi Pat. You are still my favorite ball player and I often think about how hard you played. Well, Pat, you are in a different ball game now and I know you have the courage and the patience to WIN. Some of your team called about your tragic injury. We want to let you know we are all pulling for you.**

If only Patrick could read it. It was read to him, even though he was in a coma. I was told that possibly he could hear us.

164

When he miraculously awoke from his coma, it meant another long week of hemorrhaging and vomiting (a mess with wired jaws).

Because Patrick could choke, the wires were removed early. He suffered with this operation, but he felt that he had a worthy goal—a good old American hamburger! However, his dream was just that, a dream. After one's mouth has been closed tightly for three months, it's like having lockjaw. Forcing in the tip of a spoon, much less a hamburger, is impossible at first.

Each visit ended with a bad report. We came to dread each long, tedious round-trip drive to Ann Arbor, the continuous infections, the daily changing of dressings which was my responsibility. I wasn't sure what to look for, but I knew enough to be frightened by such responsibility.

<div align="center">†</div>

It was near the end of the school year and we had worked hard to keep up Patrick's grades, in spite of spending only one third of the school year in the classroom. I was his nurse, surgeon, and teacher, but Patrick passed and that meant a lot to us. I was appalled, however, that several students received perfect attendance awards, but no notice was taken of Patrick's exhausting struggle to pass with his class. Patrick should have received a scholarship for *endurance*!

†

A new experience awaited us on June 10. On this day a mold was made of the right side of Patrick's face, to form a plastic replica of his cheek and orbit area, with an ocular in the center called a prosthesis.

I could not imagine anyone being good enough to copy God's work of art in painting an eye. Patrick's eye was special. We often kidded over the years that he was our "flower child," because of the "petals" that encircled the pupil, a mixture of azure blue, sky blue, and sprinkles of green, violet, and brown—"daisy" eyes. How could mere man capture that?

Each morning we sat as he formed an ocular by hand. He steadily stroked and dotted colors together, coming up with an ocular very close to Patrick's remaining eye. I shopped for eyelashes to match Patrick's, and took them to be fitted onto the prosthesis.

The prosthesis was not cheap, but Patrick had both a cosmetic and mental need for it. I paid for it by selling precious jewelry and a bond. It lasted for about five months, when the process of ordering a new prosthesis (another twelve hundred dollars plus fifty dollars for each visit) began again.

I remember one night in the motel, while Patrick, now thirteen, slept, I walked the floor, holding the ocular between my fingers and thinking back to January 17, 1974 when we played in the snow and

166

the sun glistened on Patrick's two eyes. It's so painful to remember! On this night I went outside by the pool and let it all out to God, so that I could put on a brave positive face the next day for Patrick's sake.

The torments of the year left me feeling haunted. The suffering was merciless. Many times I drove off the road, during the long trips back and forth. There were constant disappointments and overwhelming decisions about further surgery to be made during these visits.

<center>†</center>

By June, Patrick began to have terrible headaches. More tests were ordered and it was found that blood was building up. It was decided not to risk another operation so soon. Instead we would pray that the blood would break up and the headaches disappear.

This worry nearly drove me crazy; just one more complication! I wanted to save Pat, but each operation only seemed to encourage another. I had already turned down three operations. How could he live through so many? He was trying to be brave, even though it looked as if he might have only months to live.

I sat at a consultation table with five doctors, the chief of staff of the hospital, and Patrick. One of the doctors said, "Mom, it's up to you. Which risk do you want to take?" (Earlier his doctor told me that he

167

had a thirty percent chance of successfully coming through the surgery.)

I recall looking at the grey checkered ceiling and weighing Patrick's life against my decision. I took a few moments to turn to my Mother Mary and prayed, *"Ask your Son quickly to give me the wisdom for this decision, O Mother. Use your heart. Remember the pain if I lose my son. Your Son knows Pat's future. Tell me."*

Deep inside I heard, ***"WAIT."***

Looking at Patrick I said, *"We'll wait."*

Another doctor reminded me, after we left the room, that Patrick might only have a few months to live.

I said, *"No, the fact that we have come this far and he is still alive is a great reason to keep going. Besides, I've been helped in this decision by God."*

The doctor walked away disgusted.

Patrick had much to bear given that the odds were not good. Given the choice between life and death, he chose to live, regardless of the suffering ahead.

Patrick's headaches continued for some time. He ran fevers and I watched closely for infections. His health was poor, but he had his sense of humor and the ***will*** to live, to dream, and to plan.

<div align="center">†</div>

Once again it became a time of run, run, run, from

Avalanche: Little Hands & Big Courage

one doctor to another, from one city to another. I was forced to ask myself the question, *"Could a blood clot **kill** my son?"* Would my decision keep him suffering? Would postponing the surgery shorten his life, and would he die during the next surgery because of the delicate site of the operation? Were there any guarantees if I allowed another surgery? *NO!*

I trusted our God to leave word deep in my soul for guidance. I prayed so often: *"Lead me, guide me along life's ways."*

<div align="center">†</div>

I drove home in a state of shock, moving like a robot in and out of traffic. As my tears poured I said to myself: *"No, you are not a robot. You're a mother and you've just come from saving or killing your little boy."* It seemed astonishing that life was going on out there while we were driving.

This family had been through such a traumatic blow. It was years before we adjusted. I have dealt strongly with heartbreak because of faith. It seemed that as soon as we grounded ourselves in an area, another problem would arise. I realize now that I did my duty as a mother, loving my child and leaving much in the hands of God and our Mother Mary. I also went in prayer to Jesus' grandmother, St. Ann. My best friend, Gentle Jesus, was my director.

<div align="center">†</div>

Back home, flashbacks of that first day, seeing the gross damage done to nerves, muscle, and brain as the bloody gauze was lifted, became frequent. We suffered many nights of heartbroken sobbing. I always thought "heartbreak" was a word in a lover's song, but now I felt the worst of heartbreaks. The crack inside of me was so real, I was afraid I'd never mend.

<div align="center">†</div>

Patrick returned to school again, staring right back with one eye at people, head held high, full of good nature, never telling anyone what he had been told. I asked Patrick, at one point, if he wanted to wear a black patch like a local attorney did. He answered, "No way." I knew then that Patrick was wearing his prosthesis for his own self image. Soon I would need to find funds for another.

<div align="center">†</div>

The next visit was disappointing. We were told that Patrick had glaucoma in his left eye, his only eye. It would be only a matter of time before they knew if it had progressed, remised, or produced total blindness.

<div align="center">†</div>

Childhood went on for him even though we lived another threat now. Patrick begged for a bike. I feared debris might cause an infection, stones might harm him, or a fall could force the blood clot to move to a danger point. After much prayer, I decided to allow

Avalanche: Little Hands & Big Courage

Patrick to have a life while he lived. So he got his own new bike.

Then Pat was eager to play ball, and so week after week we practiced batting and catching. At one point Pat threw a ball at me so hard that when it struck my head, I fell to the ground. When I sat up, he was crying, "Mom, I need you okay." I held him tightly and we talked. I pointed out that if the ball had hit him instead of me, I would feel badly too. He understood.

Though he gave up baseball for a while, he did not give up fishing. This summer he won first prize at the festival for the largest fish.

Everything Patrick did took strength from me to let go; nearly everything added risk. I would say, *"We will have **faith**; you will be okay and prayed for his guardian angel to protect him."*

◆ ◆ ◆

In August, I took a badly needed trip to California, looking for a mountain about which I had dreamt. I was certain God wanted me to find this mountain, but, gee, hadn't I already climbed many mountains?

I remember how free and at peace I was when I stood upon a cliff, free of decisions, free of heartache for a few days. Spending time getting back in touch with just Jesus and me, among the high pines and the blue waters of Mt. Shasta. I fell in love with northern California.

When I was about to land back home, I wanted to run. I knew the future would be as the past, but I also knew that our children needed me. I had been weak for some time and was facing serious surgery myself when I returned.

<div align="center">†</div>

In October of 1975 I was approached by a woman who said that she represented an organization for banning guns. I was furious, feeling that she was using us as a ploy. I told her that I would not support her idea; I would not ban cars if my child were killed in a faulty car. I had no intention of helping her disarm the nation because a manufacturer had made faulty equipment.

I told her that my sons had been taught well to respect guns. They had been trained in gun laws and the cleaning and handling of guns, just as they had been taught to swim for their own safety. I would agree to speak about stern laws for *inspecting* and licensing firearms only. I knew she did not care about Patrick, but only about *her* cause.

That fall all my sons, including Patrick, went deer hunting. Pat shot his first deer, which we used for future meals, just as God intended—deer, fish, and gardening. Destroying guns, knives, bats, cars, or anything people choose to use as weapons will not stop crime. After all its not the instrument, commonsense, says it is the hands of a criminal and the mind

and will of the criminal. Teaching **respect** and love of neighbor and promoting peace is the only way to rid ourselves of crime.

<div align="center">†</div>

The whole year was critical. I decided it might be best if I sold our home in Muskegon and moved to Ann Arbor to avoid being away so much. After all, my other children needed me too. I placed the plan in the hands of God (after all, He was going to be up all night anyway) and went to sleep. Next morning something happened to make me aware that God did not wish me to move. Not yet.

<div align="center">†</div>

On my drive back to Ann Arbor, I was deep in prayer. This was a serious trip. I was consenting to surgery. They had to operate or infection would move to the brain and kill Patrick. There was no time to weigh the odds; I had to consent. I stopped at a filling station on this April day in 1976. The attendant, whom I knew, smiled and said, "Hi," and with a searching glance added, "Trouble at home or with Patrick?"

"Yes somethings wrong," I snapped, *"I'm taking Patrick in for more surgery. The doctor says he may not pull through this one but they have to try to save him. This infection will set in worse and he will die. Either way, I've had it."*

I guess I wanted him to see me angry. Now news

could travel and others would take notice—all those who were not helping as they said they would.

I said, *"I'm tired of hurting alone. Tell my friends I'm tired out,"* and sped away. As I had just spent days calling family and friends for help to share in the driving.

I began to feel guilty, leaving such gloom on what had been a happy face until I came along. I was so angry and shouldn't be driving, but what real choice did I have? Others knew but no one offered to drive us.

My speedometer read seventy and I said to myself, *"Okay, Carol, take it easy. You're not exactly in great shape to drive."* (I often talked to myself to control my senses.)

The trip had become a boring habit and I was sleepy. Tension built up and I felt my eyes burn with tears. My hands went limp and I ran off the road into a ravine. My face hit the steering wheel. My right arm grasped for Patrick, who woke up suddenly.

I felt guilty about what happened. I knew it was a mixture of weariness and exhaustion; maybe even a way of not facing the hell ahead. Then I saw my rosary on the dash and prayed, *"Dearest Mother, come to me. Visit me. Give me patience."* I took control of the car and drove safely, the peace of my prayers guiding me.

†

No operation could be done until the infection cleared. His doctor had already ordered surgery for April 18. However, everything was failing, so a medication was used that gave Pat side effects. His belly was inflamed with a rash and he felt a burning inside, as though poisoned. His eye was swollen. He looked beaten and bruised. He was weak with fever, suffering terribly, Patrick was slipping away.

The chief of staff feared meningitis in the brain. The attending physician said he would try another drug which also could have a side effect. I signed for this drug, and I carry a secret to this day of its possible side effects. However, the risk was necessary; the infection had to be brought under control.

On April 21, his doctor ordered surgery in the orbit area, even though it was still hot with infection, caused either by foreign fragments of the shell or a growth, tumor, or cyst.

It was an ugly time of pain, fear, nausea, nose bleeds, and hemorrhaging. Patrick lived nightmares of occasional total blackness, and loud noises made him flinch. After surgery, he didn't know if he was blind again. The darkness scared him. Pat kept looking for ways out of the darkness, trying not to panic, trying to find a crack of light behind all the bandages. He woke up this time after shaking and sweating from fear of blindness.

My visits to the hospital chapel were many. I don't

know how we could have gotten through these times without the continuing mantle of Blessed Mary's love for us.

<div align="center">†</div>

Going home was a joyful event. We held a party for Pat's return. We tried laughing and making light of tomorrow. One day at a time.

But, by the end of the horrendous year of 1975, with it's tragic events, I was living in a forest of loneliness, trying hard to accept the fate of the new realities of my life, through the Grace of God.

Alone, I faced a new road with my sons. The new year began without a husband at my side. It was my expectation that I would have to climb this treacherous mountain alone.

<div align="center">†</div>

In July of 1976, we went back and forth to Ann Arbor. Still more surgery was necessary, with the chances of infection spreading to the brain extremely high. We worried constantly about infection over the last three years. I had to leave Patrick in the hospital for treatment until this infection cleared up. However, his doctor felt he would have to operate again in spite of the infection. Patrick's chances would be much less than before.

I was numb mentally and physically. My brain felt pierced, my throat choked off, my chest crushed, and my heart broken. Lord, the mountains of my life have been many—but this mountain with all of its

avalanches!

Yet, Divine Jesus was right there to lift the boulders and Blessed Mary, to mend my wounds and give me the strength to show strength for little Patrick.

Each visit gave us less hope; each doctor's report said tomorrow was trouble. Patrick's childhood had been tossed aside and the doctors constantly set me up for a loss. But I would not give in; I was sure that God had a larger picture in mind for Patrick!

My Gentle Jesus didn't desert me. I was led into a new friendship with a caring man, who provided help for me and my sons. This friendship grew to a great admiration for him, and his good care of my sons while I was away with Patrick. He later became my husband, Bob.

†

As another year rolled on, Bob was so supportive; caring for the children at home plus working. He was generous about my being away most of the time. It was always wonderful to come home to the other children and this saintly man. I have always said, *"Next to St. Joseph, Bob is the best!"* He sets an example of what a man should be, especially before our boys.

†

In August, the orbit area was swelling again; this time, out beyond his nose. Pat couldn't wear his prosthesis and the pain in his head was excruciating. Bob and I rushed him back to Ann Arbor where he was

treated for a week for infection and sent home.

People were tired of asking and hearing bad news. Prayer groups were adding his name like a new bead to a rosary. The family spent years, living in a world of confusion and anxiety. I remember the one person I leaned on was my dearest, closest friend, Divine Jesus. I talked with Him day and night.

Blessed Mary and I were so close, for I knew that she understood what I was going through. She knew the torture of watching a son's suffering and contemplating the joy of seeing it all over, with.

As I was reading Scripture into the night, I read verse after verse that described my own feelings.

<div align="center">†</div>

A cry came from Patrick's bedroom, not his usual deep, low voice, but a plea two pitches higher, "Mom! Mom, come here! Mom!" A stab of fear went through my heart. I knew by his tone that something was severely wrong.

Patrick's pillow was soaked with blood and mucus. It was not coming from the nose, as one would expect, but from his left ear.

I phoned Ann Arbor and told them we were on our way. It took us six hours to find a ride, for my car was still in a garage being repaired, and Bob was out of town. Once again, the helicopter we had on stand by was tied up. I also called an ambulance, but now they

wanted twelve hundred dollars cash up front to take off across state. Those I called to borrow money were unable to lend any, because they were saving for trips or taxes.

Praise Jesus for the one friend, a living angel, who dropped everything and took off work to take us to Ann Arbor.

<div align="center">†</div>

When we arrived at Motts, Patrick was treated for infection and placed in ICU for four days, in pediatrics for three days, and then released. As an out patient, he saw doctors daily for one week. We stayed in a motel the last two nights.

On August 11, 1977, Patrick's doctor checked him but could not give us much hope. I was told to treat the problem at home with a prescription, and in three weeks time, the doctor would operate.

The responsibility of decisions was so powerful, I could only hand over my son daily to Divine Jesus. I had to trust in His mercy. I had to believe. I felt alone for so long, but finally I reached out to my husband, Bob, and said, *"Forgive me for being so absorbed in Patrick. I do appreciate you as a gift from God, too."* He understood.

<div align="center">†</div>

Pat's fevers continued. All too soon we had to face another emergency run back to Ann Arbor. Patrick was admitted again.

179

The doctors were afraid of meningitis developing in his brain. Surgery in the new ear canal was dangerous and painful. Patrick was extremely ill and I felt his pain. One moment I cooled down his fever and the next, he was conscious and chilled. He was released in nine days.

<p style="text-align:center">†</p>

On August 30, 1977, he suffered an infection in the cavity area, where an eye had once been. Each moment was an anguish. Once again he was admitted and on September 2nd, we waited anxiously for an operating room, for the orbit area surgery.

This all took its toll on Patrick. Half way through the operation two doctors with grim faces walked towards me from off the elevator.

I froze, thinking, *"Oh God, No!"* Always a nurse had come to the waiting room to say that Patrick was in recovery. If a doctor approached, it was a sure sign to any parent that something was seriously wrong, and that usually meant death.

The two doctors tossed medical jargon at me. They said, "Patrick is still in surgery, but we need your permission to *go back in* again." Hours had passed and they were already beyond the time allowed to keep him safely under. However, they assured me it was absolutely necessary to remove some bone from the nose, in order to close up the cavity to prevent future infection in that area. It was no guarantee, but

the possibility of future infection was as dangerous as the surgery itself.

I quickly needed to make a decision. I heard inside: *"Continue."* I signed more papers, and a compassionate doctor quickly hugged me.

<div align="center">†</div>

Staring out a window at the sky, I remembered that Patrick laughed before the surgery, because the nurses wanted to take everything off him.

He told them, "You can have my undershorts, but not my scapular." (A scapular is two small square pieces of cloth with pictures and prayers. Joined by two pieces of string, it is worn over the shoulders. According to tradition, Our Lady appeared to St. Simon Stock in 1251 and gave him the Brown Scapular. She promised that those who died wearing the Brown Scapular would not go to hell.)

As Patrick held that scapular tightly in his hand, I asked, *"Please, may he keep it with him?"*

The nurse agreed to it, and we all laughed as a nurse said to him: "Well, you're not naked, are you?"

<div align="center">†</div>

Six hours had passed since Patrick was wheeled away from me. Pacing the floor, I again looked out the window and across the field, seeing boys playing in a park. My heart grieved with a terrible pain, remembering Pat's athletic years. If only Patrick

would live through this operation, so that we could enjoy him a little longer and take him to a ball game. He was always so excited to go to a Detroit game, and one time I took him and his brothers to a game in Chicago. Oh how Patrick dreamed that one day he would be a big-time player. Memories overwhelmed me of Patrick's Little League and All Star years. Surely, we all were in a different ball park now.

It was hours before we saw a nurse. She told another parent that her child's surgery had been delayed because a little boy was hemorrhaging in the operating room. The words spread quickly in that little hell of a confined area. Was the child Patrick? My heart seemed to stop momentarily.

Listening to others speak again quietly among themselves about their problems I thought, *"It's astonishing how life goes on."* I remember praying for the other suffering mother and then saying another couple of rosaries for Patrick.

Word was brought to me when Patrick finally was taken to the recovery room. My husband Bob, had gone back to Muskegon, to work and to care for the other children, after admitting Pat. My mother Maude, who had made this trip with us was not a person to be compassionate, though her small talk filled the hours that would have otherwise been empty and lonely. I began the usual ritual of telephoning concerned relatives and friends.

Avalanche: Little Hands & Big Courage

Patrick had lost too much blood, and two operations within three weeks made him extremely weak. He took a turn for the worse towards night. I was summoned to the nurses station. Nurses and doctors rushed in and out, hooking up bottles and giving shots. Finally they pulled the apparatus away. A doctor held my shoulders as he said, "They did all they could." We would just have to wait for the outcome.

A short time later, Patrick's doctor came out of his room, unable to fight back tears that flowed down his cheeks. He looked dazed. You could see he really cared.

Another doctor, also in tears, came out of the room. Taking my hands he said, **"He is gone. I'm so sorry. He is gone. We did all we could."**

I went to Patrick's bedside. He was grey, like death warmed over, and his skin was cold. I thought he was alive, as his body twitched from shock. "Nerve twitches," the nearby doctor said. He shook his head from side to side, tears filling his eyes like little pools, hiding the color of those eyes. I felt a wrenching at my heart as I looked at him, and the words of the other doctor rang in my head: "He is gone."

I rushed to my little boys side, leaning over I pressed my face against Pat's cheek and then motioned for a nurse to cover him. I pressed the scapular hanging

183

down Patrick's chest between my fingers and prostrated myself half on the bed, weeping and pleading with Divine Jesus to show His mercy now: *"Now, right now, O Lord, I know you are the greatest of healers. You can, at Your will, let my baby complete his life. I believe, Lord, that You intended more from his soul. As you raised me, Lord, raise my son. Give him back to me, if only for a little while longer."*

I then pleaded with Blessed Mary: *"O Mary, please, you know the persecution of a mother in the loss of her child. Please, ask your Son to have mercy."*

Once again I cried: *"Lord, I call on You now for a miracle. I call on Your healing of life. Now, God, now."*

I remember clutching Patrick's small frame, then I placed his scapular to his grey-tinged lips and cool clammy skin. He was lifeless, **but I believed I could grab back his life**.

I pleaded with Divine Jesus: *"Hear me, hear me! I don't believe his work is complete. Please, give him back, if only for awhile. Just as You healed me and sent me back because I had more to do, send back my little boy, Jesus. Hear this weeping mother.*

"O Mother Mary, you know the depth of my suffering. Intercede with a mother's compassion.

*"O Jesus, I believe, I believe. Now, **right this minute, You CAN give life back. Now, Jesus, Now."***

184

I saw the scapular move on Patrick's lips and I spoke to the nurse immediately: *"He's alive. He is, he is! I saw the scapular move.* ***Jesus breathed His sweet breath on him. I tell you, my little boy is alive.*** *"*

A nurse tried to pull me away, believing I was just a grieving mother, but I insisted, *"Look! Look at this scapular."*

The nurse must have seen it move for she yelled for help. I was hustled out. The two doctors hurried in.

I twirled joyfully in a little dance, a smile from ear to ear, and tears of joy and thanksgiving to God. I was praising, ***praising*** Divine Jesus and Blessed Mary.

The doctor came out crying again. He said, "I've seen it all. I must call my mother." He went into the nurses' station and called his mother, having the nurse dial the number because he was shaking and wiping his face with a towel. I could hear him clearly say, **"Mom, I just saw a real doctor at work. I've seen a miracle. A boy was gone but his mother was praying and now he is alive. His mother used a scapular. Remember how we used to wear scapulars? You always had me wear a scapular. I'm going to wear one again. Mom. I love you,"** and then he hung up. In his joy he had stopped to call his own mom. This doctor came over to me and hugged me. He asked, "Can you get me a scapular?"

I responded, *"Sure, next trip back I'll bring one.* **God** *alone is the Greatest Healer. Doctor, my son, when can we take him home?"*

The doctor smiled and said, "As soon as possible, Mommy."

I knew without a doubt that God had spared my little boy again.

<div align="center">†</div>

And some women, through faith, received their loved ones back again from death. (Hebrews 11: 35)

<div align="center">†</div>

I truly believed, however, that when Merciful Jesus restored Patrick's life, He healed him of infections as well, for no further operations were ever needed for infections.

Some felt the physiological damage was severe, but combining neurosurgery and cranial facial surgery at this time seemed useless. His face would grow some, and that which is replaced by plastic surgery would not. Thinking it over and praying made me decide. Grafting bone from the hips and ribs is a very painful procedure and slow to heal. Also, working below the cheekbone can damage developing and existing teeth. So, I weighed everything and stopped all talk of surgery. Yes, this was to be Patrick's last surgery as long as I had a say.

†

I allowed an Ann Arbor doctor to speak of Patrick's case on television, and allowed his prosthesis to be shown on TV with the hopes of helping others.

After three prosthesis, Patrick grew tired of the doctor's enthusiasm and made a decision on his own to wear a black patch. At first the kids teased him. Pat laughed it off, pretending to be a pirate, but it hurt inside. Soon the children at school became used to seeing the patch. Patrick's friendly character made him a popular young man.

†

For the first time in years, we knew stability at home and in our future. I limited our son's visits to doctors and clinics by praying before agreeing to an appointment. To many doctors I said, "No." I was determined to return to a normal life style. The trips to Ann Arbor became once a month; every three months; every six months.

†

Patrick, now seventeen, refused to be held back. Sometimes he took on extra homework to gain extra credit. His goal was to get a degree in law and eventually work in politics. Though Patrick was small in stature, he was so big in courage.

†

At eighteen, Patrick was still on medication to control his epilepsy. However, he did graduate with his

Patrick's 1980 high school graduation picture.

high school class in 1980, and entered Michigan State University in the fall.

♦ ♦ ♦

In 1975, I left my business to be with my son. God provided, but we were left with huge medical debts to pay.

By 1978 I had a new career in real estate. Sizable commissions helped to pay the medical bills which had occurred between January, 1975 and July, 1980. It took eight years to pay them in full.

♦ ♦ ♦

Patrick grew to have a witty personality. He was bright and had common sense.

Years have passed from college days to now. He is now a husband and father of four children! A good citizen! A son of which any parents could be proud!

Patrick plays baseball with a men's group. He also enjoys coaching. He holds a good job in management. Along with investments that I set up for his future, he is a good provider.

Patrick avoided additional surgery after adulthood. He is good looking, and his character reminds people of the **COMMISH** (a TV personality.) His facial structure is about the same, but he is strong.

188

God had much more planned for Patrick. I believe when someone has others *to pull hard for them, hang onto their life, call them back, and plead with God to show mercy*, He will. Don't give in. Expect a miracle. Remind God to see His first plan for this soul. Ask, "Is his work really done? Has Your will been fulfilled, Jesus?"

†

I've been laying on hands since I was fifteen. I've learned to feel deep compassion for other's sufferings and needs, to *feel* so deeply and pray so deeply, that Divine Jesus feels mercy for our prayers.

I've witnessed Him restoring life; curing diseases that were hopeless; lifting up bodies that were to be stiff or limp forever! I've seen the bewilderment when one wakes from a coma; witnessed fingers near severed from a hand and miraculously attached without medical stitching! I've witnessed so many of Gods' healings, that it would take another chapter to tell about them.

†

I know that the strength I gained from these past "mountains," *prepared* me for Our Lady calling me in 1993, to help the soldiers and refugees in Bosnia, Herzegovina. Our past trials mold, teach, and help us to grow stronger and wiser, believing that miracles *do* happen! Could this be what Our Lady meant when she said to me on November 1, 1993: *"Your*

Fruits Are Bearing. Your Sacrifices Were Many. You Are My Daughter. I Am Your Mother"?

To date, I still am blessed with these precious gifts. Come join me in sharing the celebration of the Mass! Come share His Presence with me!

♦ ♦ ♦

†

Jesus, my Friend, my Brother,
I pray You will touch my life.
Forgive my weakness.
I confess with my inner heart and lips,
That You, alone, are my Savior.
Take away my burdened heart.
Lift me up in joy.
Cleanse me, mold me to Your Gentleness.
I receive You, right now;
I feel Your warm Light.
Mend my soul, my mind, my body.
You know my needs; meet and heal me
By Your Mercy.
Fill me with Your Presence.
Give me a nature benefitting of Heaven.
I believe in miracles of Your Power.
I expect my healing in Your Name.
I expect a miracle for those I pray for
in Your Name.
*Jesus, **I adore you**.*
Amen
(Little Olive Branch)

CHAPTER 17

Blending My Will With His Plan

DURING THE TIME TRAVELED from Muskegon to Ann Arbor and back, it became apparent to me that I would have to sell my house, get a job and relocate my family there. Before leaving town I secured a home and was offered a new job. It would be great to have all my children with me. En route home, I was beginning to see that I could make decisions and get things done *my way*. When I arrived home, I placed this total plan into the hands of Jesus. I said to Him before going to bed, *"You will be up all night anyway, Jesus, you think about it."* I fell into bed totally exhausted.

♦ ♦ ♦

By morning, I was sure that I could continue with *my way*. I opened the phone book, searching for a real estate firm to handle the listing of my home. The secretary answering the phone stated that the broker, whom I knew from grade school, was not in at the moment.

I explained my urgency of needing someone before 3:00 p.m. I answered her, *"Who else do you have?"*

She gave me several names. I said, *"One of the names is familiar. I may know him. I went to school*

with a Bob Ross. Please send by someone."

◆ ◆

About 11:00 a.m., there was a knock at the door. When I opened it, I was surprised to see it was the man I had known since childhood!

"What brings you here?" I asked.

"You called for a realtor?" he responded.

"Yes" I said, *"but I didn't know they would send you! Come on into my humble home, Bobby Ross!"*

†

Bob explained to me how he came about getting this listing.

"Upon arriving at the office this morning, I found a woman's name in my message book. At the end of the day, we always put our message books in a slot. This morning, the secretary put in your name to have a home listed. When I first saw the name, I didn't recognize the last name. I'll never know why, but for some reason, I kind of thought it was *you*."

†

When I told him that I was concerned about my children being on one side of the state when I needed to be on the other, he responded with wisdom: "Let's go another way first. You can always sell later. Let me take care of your children while you have to be away."

Then he said, "I'll even take you out for dinner

when you come back to town!"

"Really?" I answered.

After all, the problem was my fear of various sitters, rather than one firm adult to keep the boys in line. I was in too much of a hurry to think about this new plan, so I agreed with Bob. Besides, what a deal! Just have dinner with the nicest boy I went through school with, in exchange for my children's security while I am away.

◆ ◆ ◆

En route to Ann Arbor, I prayed my rosary and hummed hymns when a light went on in my mind. *"Oh, no, Jesus! This doesn't mean that You intend to put another man into my life, does it? I'm doing fine with just You and me. (You never leave me; man does. I don't want emotional pain.) Though, I'm not surprised that You took care of us again by sending this nice Catholic man to my home. I'll bet You even picked him out to be a new friend because he will be a good example to the boys. Jesus, show me if you want me to list the house and move later."*

◆ ◆ ◆

When I arrived at my new-promised job, the firm said that I needed to wait four weeks, and I could not have time off to move after starting work. I went back to secure rental of the house. The woman said that the current tenants would not be out for thirty-five days. I pulled into a nearby Catholic church, went into the chapel, and turned it back to Jesus. *"Okay, what's going*

on here? Everything was settled. Now none of my plans are working out."

Now prayerfully inside my mind and heart I heard the words:

"See My Will."

I answered, *"Your will? What's Your will?"* But I heard no more.

<center>†</center>

I was baffled. What did God mean by *His will*? How would I know? How could I see His will? I was still in my thirties.

<center>♦ ♦ ♦</center>

Returning home from Ann Arbor, I found that Bob had made friends with the children. They liked him and trusted him. The house was in order, and he had arranged for a sitter for the children while he took me out for a hamburger and a drive to the beach.

<center>†</center>

Shortly afterwards, he asked me not to date any other men while I was dating him.

Bob and I agreed to meet for a date at a festival in the city park. I wore a long blue floral dress, and carried a sun parasol. As I walked up the walkway through the park, I saw Bob in the distance. He was like a young man excited about his first date, shy and cute. I was touched by his innocent ways. We spent the day at the art fair in the park. As I returned to my

car, he said in a sweet, shy voice, "May I kiss you?"

I replied, "If you wish." There was a twinkle in his eyes. Bobby leaned over and kissed only the side of my face. His face lit up with a wide smile. "He is such a tender, sweet man," I thought.

We began to court. The arrangement for him to care for the children while I was away, stayed the same, except that Bobby was falling in love with me, and I was fighting the relationship.

♦ ♦

Slowly, I came to know this wonderful man, and his sweetness grew on me. During the second year, without notice, I found myself in love with Bob.

At Christmas, he asked his mother and his aunt to my home for dinner, making sure that the children were there as well. Then, in front of everyone, he asked, "Will you marry me?" He showed me a beautiful parquet engagement diamond.

I was surprised, but I did not want to embarrass Bobby. I accepted his engagement ring. We discussed the matter a little later and Bob said, "I don't think you want to disobey God, and I know God has planned you for my wife."

†

I asked him, *"Can we wait five years?"*

He answered, "No, I know the time is right, now."

We went through an innocent and slow courtship.

196

When I too was led to see that honorable Bobby was right for me and my children, I was also given confirmation that Bob was part of God's plan.

♦ ♦

One evening while considering all avenues of this coming marriage. I asked Bob, *"Can you live with the fact that I will always love another man more than you?"*

"Who?" Bob questioned with a concerned expression.

"My Jesus," I replied.

Bobby grinned and said, "I think I can live with that."

♦ ♦ ♦

By February, we went to visit my parish priest. After a one-hour visit, and having seen us regularly at church, Father said, "Anyone can see that you two should be together. Blessed is a marriage designed by God. I'll make arrangements, and you listen to Bob, you and the boys need him. God's looking out for you, Carol."

♦ ♦ ♦

We took three more classes. Our wedding was sooner than I had planned for, but Bob was eager to marry. Our parish priest advised us and we listened, and **followed** all his advice. We did each step by the instructions given to us. By now, my will had *"Blended with God's Plan."*

♦ ♦ ♦

Our honeymoon was a real experience in "sharing". Bob rented a chalet up in northern Michigan for a week.

Our first night was spent getting settled in. The next day, we went fishing. About mid-afternoon, Bob said that we had better stop and get a few groceries as he had invited our families. Unknown to me, he had invited his mother, Olive, his aunt, and my parents, Sylvester and Maude, to join us. I thought he was teasing, but when he rowed the rental boat to shore, I could see he meant it. I chuckled for being married to a man who wanted our families to know one another, and share in our happiness on our honey moon!

†

We laughed as Bob's mom and aunt took our wedding bed, and my Dad, Sylvester, tossed down pillows and blankets from the loft bedroom, for Bob to make up our bed on the livingroom floor below. With Dad and Mom hysterically laughing from the upper loft, along with more laughter coming from Mother Olive and Auntie in the master bedroom. We were the joke of the day.

†

The day after my wedding, on our honeymoon, I was not upset as I cooked a full fish meal for Bob's guests. While this may not have been romantic, it certainly was hilarious.

198

The years passing were a struggle as always. But I did not have to climb the mountains ahead of me alone. Bob was an excellent foster father to the children and a most honorable husband. Bob was eager for the boys to honor their natural fathers, living and deceased. Bob even went with me and the two younger boys to their daddy's grave to trim weeds and clean his gravestone.

I often say, *"Next to St. Joseph, my Bobby is the holiest."*

♦ ♦

It's no wonder to me that Bob, too, has his full share of miraculous wonders. It is also no wonder that he is a cherished and beloved father of the boys, who continue to show their love and appreciation of him each year. Father's Day had become important to Bob.

♦ ♦ ♦

Having listened to Bob and our priest, I learned that going God's way, by His plan, I did not make mistakes.

His plan is right. When I was *going my way*, I made poor choices and created problems for myself. I hurt others, though I didn't mean to, and I was not at peace in my mind.

♦ ♦ ♦

Today, we feel we have a sacramental marriage. A blessed marriage with God focused between us.

As time rolled on, I became tired, burned out physically. Though I may seem strong, I needed someone to be home with the children, especially the teenagers. An occasion came up for me to travel to California.

Jesus, I've messed up,
Going my Way.

†

I didn't feel worthy to call You my Friend.

†

You enabled me to rise,
You suffered to save Me.
It doesn't matter how I've
Been hurt by others or hurt myself.

†

You are SOVEREIGN.
For You alone can deliver me.
Blending my Way
To be
In Your Way

†

Give graces to me, O Lord.
I need Your healing.

†

You created and set in motion
You are miracle multiplier.
†
You, God, are my Source.

My abundant Eternal Life.

†

I'm listening, Jesus.
Yes, I'll give You my soul, my life.

†

Suddenly, through you, my Jesus,
I know. Rejoice!
Amen.
(Little Olive Branch)

Real Estate

A FTER I ENJOYED TRAVELING by truck through various states with my Uncle Jim, who I was visiting with in California, I had a pleasant visit with my Aunt Bea, Aunt Mary and Uncle Bill. A well needed vacation after my years of stress and heartbreak over my son.

♦ ♦ ♦

I returned back to Michigan. Later we moved to Fruitport, about eight miles east of Muskegon. We settled into a normal lifestyle with family dinners and playtimes with our children meant laughter and contentment. I realized though, that soon I must get back to work. Now I would need to find a new profession to cover the accumulated medical debts from our son, Patrick's, injury.

†

I carefully selected a new career. Bob was sure I would do well in real estate, as I had been in sales for much of my life. Surely I would also see more of my husband while working, since he was already a realtor. This however would mean returning to study, which was a delight for me. Because of my handi-

caps I always needed to prove myself. So, I put my whole self into my new goal. My M.S. was in remission, I was able to get my state sales license on performance of my exams, rather than judgement on my inability to walk well.

<p style="text-align:center">†</p>

I'm sure the attitude I held about doing my best, came more from proving that my mind was not paralyzed. (Even if my legs were to go out again.) Praise Jesus for the blessing of having had polio. and having learned to become strong with determination that a mere part of my body would not separate me from being a self-sufficient person. After all, God gave me many children to care for and support. He knew me first, and He knew I would be able to handle the illness and the responsibility of providing for them. When you become weak in one area of your body, God gives you strength, sometimes wisdom. The one thing I knew, was when I chose real estate, I would be fair and would remember to treat all clients with dignity. I do my best to help people to prosper through sound investments.

Soon I found myself less and less at home, as Bob encouraged my career. Having worked some twenty-four years and learning that when I was at home, my schedule included homemaking, mothering, budgeting, church, devotions, and most of all, trying to make my marriage as solid and trustful as I could.

204

Balancing personal life with ambitions and dreams means, juggling time. My family soon learned to work "appointments" into the controlled hours of my week.

<div align="center">†</div>

I enrolled in continuing education classes to better my position in a strained profession. I fit in yearly classes, as well as courses in Real Estate I, II, and III, Appraisal I and II, Commercial I, Marketing and Management. Courses also in fundamental business skills, bookkeeping, accounting, and office equipment, and extensive sales and real estate training.

<div align="center">†</div>

In a business sense, it was felt to be advantageous to belong to the Board of Realtors. I never could see an advantage to being a board member. But this was a title that realtors and the public had been schooled to expect after one's name. If anything, I found that it limited rather than helped success in some cases for me. Remember, this was *our* town not the normal in the countrytown. I investigated another board and it was operated quite differently.

<div align="center">†</div>

One of the most irritating issues I had with the Board of Realtors, was its mindless determination to remain on the second floor with no lift chair or elevator access. This **prevented** me from obtaining immediate and updated material; or accepting a

board position, since most meetings were held in the board conference room, up three flights of stairs. On several occasions, submitting paperwork to the board, or even to work as a business women, I had to scoot step by step up the stairs and had to brush myself off when I got to the top. At that time, no lower level drop-off box was provided. There were times this inconsideration cost me much suffering.

†

Belonging to the Board of Realtors also required meetings and lots of extra paper and computer work. Although, in our town, I had little respect for this organization, with its laughable ethics committee and arbitration board that took eleven months and numerous letters to investigate a case, the little "slap on the hand" for offenders. Along with an outdated, incorrect Multiple Listing System (MLS). For me it was a waste of monies. Its service was more for the seller; happiness for the performance it gave to me. In most towns, it is good business sense to belong to a protective member board.

†

There were times when I had to use a cane or wheel chair, and in this era of equal opportunity, it made it humorous to be a member of the board. At one point I requested a chair lift to be included in the projected remodeling of the Real Estate Board Building. It was voted down by most members. (It would have

cost less than $1,500.) I surely was not the only person with a need. There were those with knees, hips, back problems and heart problems.

<center>†</center>

I received a letter from an "ignorant" co-broker who stated, "You were handicapped for years. Why did you choose a profession in which your legs would limit you? Go find something else to do."

I am sorry for never telling him that I forgave him immediately. I'm not immune to ignorance, and it gives me another chance to turn an injustice into prayer.

<center>♦ ♦ ♦</center>

Because of these injustices, I was especially concerned for the welfare of the handicapped and minorities. I offered my services to fair housing organizations, community development associations, I served as chairperson for the Mortgage Review Board and worked with senators for **bills** and funds for the homeless, veterans and the handicapped. Praise Jesus, for my mountains to climb and the **strength** I gained; and His compassion in me, built a desire in me to help others. Each effort we do for others is a prayer.

<center>♦ ♦ ♦</center>

After ten years in real estate, I decided to become a real estate broker and open my own firm. I possibly could have more influence in board policy, as

well as run an orderly office and extensive training program. I could offer the public, previously unheard of services and develop a commercial real estate system to really get the job done.

<p style="text-align:center">†</p>

Due to my physical handicap, it took many months to obtain my real estate brokers license. Certain unique conditions were being placed upon getting my license by the State of Michigan Licensing Board. I fought back. Still believing this was a singular, personal injustice.

<p style="text-align:center">†</p>

With optimism and faith, I leased office space and purchased equipment. Still, I could not open my new company, having to remain under another firm pending my own broker's licensing.

<p style="text-align:center">†</p>

In a final attempt to obtain the licensing, I traveled to Lansing with a witness and insisted, cane in hand, that I walk out with my license. Notifying the state employee that my hand recorder was on, I asked the woman, *"Would you like to explain again why you feel that my brain might not operate the same as another broker's brain, because my legs lack good movement?"* We were eager to hear her reply.

This state employee gave a couple of excuses: my application was being reviewed and they were backlogged.

I had passed my exams. I had a proven ten year record of successes. I never had a grievance filed against me. I supplied them with letters from credible realtors as well as clients and business people with whom I dealt.

Even then she hesitated.

I found an empty chair and stated that we would not leave without my license.

She said something about security.

<p style="text-align:center">†</p>

It was then that my witness stepped forward with his briefcase, and I turned on my tape recorder, holding it up for her to view.

She took one more look, lips pouting and twisting, and said, "I'll try to find time this week."

<p style="text-align:center">♦ ♦ ♦</p>

If you recall, when I was fifteen, I was rejected from the parochial and public school systems due to my handicapped legs. Out of ignorance of the day, no school would accept me as a student. The principal stated, "You must accept that you cannot learn as you used to." I recalled my answer to the principle, *"My legs are paralyzed, not my brain."*

As a child, I did not know how to fight back in those days and demand my right to an education as an American. **Time** and a **tough life** taught me **immeasurable strength** and **persistence**. Today, I

would not be rejected.

<center>†</center>

Our persistence on this day caused the state worker to go to her desk and find my file. Within twenty minutes we walked out with the license! Personally, I think Jesus had a lot to do with it, by answering my prayers.

<center>♦ ♦ ♦</center>

After opening my business, I brought into my firm licensed professional residential salespersons and one licensed commercial trainee. I remember the resume of one of them. He had been turned down by other firms and told over and over: "We will call you." No one ever did. He had to leave his license in state escrow for sometime because no firm would hire him.

After our first interview, I circled one sentence that troubled me: "I want to work for Fun and Money." I was bothered by these words, though his past record on his resume, showed that if given a chance, he was a motivator.

So, I called him back for a second interview. I explained that in this profession, "fun" was the last expectation, as the work required long hours, stress, and much frustration. It takes many deals to make money.

"What does 'I want to work for Fun and Money' mean to you," I asked him.

To my surprise, Quincy pulled a folder from his briefcase. The cover was entitled, *Fun & Money*. It seemed that over and above his state-required courses, he had taken an additional course by an adventurous spokesperson at the community college.

I laughed and told him, *"God is on your side, young man. I liked everything about you. Your potential is great, but that one sentence had the sound of insincerity to me."*

He assured me that he was sincere. He listened and he put in long hours **learning**.

<div align="center">†</div>

Within six months, Quincy was our top producer and the top commercial listing agent at that time!

Quincy's life's goal is to one day be governor. He has graduated from college. I expected much from this good man. I took my first commercial realtor on and insisted that he learn the skills of marketing, tax, and procedures for coordinating and closing. His integrity surpassed that of most of the men I knew. After all as Sweet Jesus taught me long ago to give everyone a second chance, especially minorities.

<div align="center">†</div>

I suggested that Quincy consider real estate. In my firm there were those who chose to be property managers or listing agents, excelling in marketing. Also, there were those who were best at counseling buyers,

those who were advanced in alternative financing and sales skills. Some succeeded in marketing open houses and of development, area skills, another preferred appraising.

Personally, it was the professional who selected a single title who usually performed the best. We had an assistant manager and one person who regulated meetings and scheduled training hours for all realtors in the firm. The commercial department separated from the residential department.

◆ ◆ ◆

Just as good doctors are needed, and those who specialize are well paid because they are more knowledgeable in their fields, so good, fair realtors are needed too, especially those who specialize. It's worth the investment to have a specialist. In fact, it's my belief that if a broker is experienced in only one area of real estate, then he should hold only a limited license with his firm, or be required to hold a limited license for each study and category their firm represents.

◆ ◆ ◆

Many *old timers* from outside the board, are as capable as realtors who only have access to an MLS book.

†

Is MLS (Multiple Listing Service) a good system? Yes, especially if it is by state rather than county.

And a national computer system is a must! Detrimental, is too many separate real estate boards, that are unwilling to cooperate with each other in sister cities.

◆ ◆ ◆

Because our area was confined, we were rapidly losing businesses and industry, and we were left with many vacant buildings. Our local board MLS, did little to aid us in marketing these businesses, and the commercial real estate industry.

†

For this reason, I branched out to incorporate a new business and organization. After seven months, one hundred and eighty-six licensed commercial realtors, developers and industrial giants joined! I had printed, out of state, our own *MLS Commercial and Industrial Business Opportunity Book*, for a one time modest fee. I also held monthly meetings in different cities across Michigan, whereby multi-million dollar connections were agreed on, nearly like a low-key, exchange. With my new business to receive only a half percent of all finalized closings.

◆ ◆ ◆

Floor duty was heavy with opportunity with our location in a bank, this also made us accessible to business investors, including those who were handicapped. Although our firm was primarily residential sales, we were growing quickly in management as

well. This being another area the MLS did not aid the firms with.

<div align="center">♦ ♦ ♦</div>

My firm grew and prospered! We expanded, occupying half of the fourth floor of the bank building within two years.

Two of my sons had joined the firm, Ken and Joe, and eventually branched off to their own.

<div align="center">† </div>

I worked long hours and my mind would not stop working. Bob would call to interrupt and invite me home. The list of clients and customers increased. God was allowing success! My husband was **patient** as well as my children. He was in real estate also and understood the demands of the field.

<div align="center">♦ ♦ ♦</div>

Making it Go

†

IT WAS EXCITING TO SEE commercial real estate finally turn over. Our firm alone jumped forty-seven percent in commercial sales that first year. Praise to Jesus for my health to carry on!

◆ ◆ ◆

Later, my concept was adopted by other boards and by our state association. I was requested to give them information about needs, and how they could help the commercial market. It is all part of fairness. Since other states, having heard, also wrote me to help them in this concept. I did not sell my idea because I was happy to share it with others to help them prosper. Today, our state has adopted part of this concept. This I hope will help other professionals as well as the fairness to the client.

◆ ◆ ◆

Some fifteen years before it was popular to use a form called a *seller disclosure*, I created, with the help of an honest attorney, a form to protect the *owner* (seller) from law suits after closing. We also complied with federal regulations, as well as balanced fairness of practice to the investor in residential real estate. Today our state has designed it's own *mandatory*

215

disclosure for all residential sales.

<div align="center">♦ ♦ ♦</div>

At the buyer's expense, both parties agreed to an *attorney's certificate*, a third-party document signed by an attorney, that stated that all is well on both sides prior to closing.

I enjoyed the presence of an attorney at closing. I provided him with a check list. He provided the *attorney's certificate.* Often, we had the signed certificate rather than a verbal opinion; the attorney received a check for a job well done. Why should all liability be the responsibility of the broker when an attorney is paid for advising? An *opinion* is not a guarantee. A certificate is a contract guarantee.

<div align="center">†</div>

I always recommended for the buyer an attorney who did not represent us. However, my sellers were protected by our firm's attorney, if they so chose.

<div align="center">♦ ♦ ♦</div>

We recommend seeking buyer broker agencies. As an investor, you require an appraisal of value. Therefore, it makes sense to us a Buyer Broker agency to look out for and protect **your investment.**

In most transactions the realtor is bound to his client; all his loyalty is to his client, the seller, who pays him his commission. However, the buyer who is given to understand that the realtor is looking out for

216

his interests, or who finds himself in a dual-agency situation, can become very upset when he realizes, and feels he has been taken in some way. This is also federally illegal.

<div align="center">†</div>

An investor should add the cost of both a buyer broker agent contract and an attorney's certificate to his initial investment. In most cases, the investor will use less monies and security and will be given full disclosure of past, present, and proposed future conditions of the area, the land itself, and construction. He will be advised and shown how he has built equity into his investment, and a quick term means of paying off the investment with knowledge of the best tax-cut method. First time investors should choose a buyer broker agency very carefully. That first investment will make or break an investor.

<div align="center">♦ ♦ ♦</div>

I remember chuckling one day while in prayer. My chair faced the window, overlooking the city. I was only one block from my elementary parochial school. *"I didn't go far, did I Lord? Only one block!"*

<div align="center">†</div>

I felt as though I had been as successful as any woman could hope to be; especially being limited. I was so blessed! I had a wonderful and understanding husband. I had seven nearly grown children. I had a growing and profitable business that people

respected.

<center>♦ ♦ ♦</center>

I had a lovely home on the lake which was paid for and all the luxuries most people only dream of. Investments and respect!

I looked at the steeple of my childhood church just across the street, into which I often slipped away from the office, for noon Mass and the love of the Eucharist.

<center>†</center>

The greatest moment of any day was my quiet time with God, receiving His total Presence during Mass. All I needed was the Presence of God in my Host: My daily hunger, my daily food, my daily strength!

On days when I could not go to Mass, I would close my door, as on this day, and take a few moments to meditate on my St. Ann's Chaplet and read a little scripture.

<center>♦ ♦ ♦</center>

God had placed me in this profession for more than money. This profession allowed me **to be me**, the person God had molded me to be from all my experiences. I made my own hourly worth, my own reputation by my integrity. I was able to grow in success at the rate I set for myself, with no one to hold me back. I could be involved in as many useful organizations for helping people as I found time. I could offer opportunities to employees that could not be

found in other offices.

Most of all, *God had me right where He wanted me*—in a business where I could aid people who were troubled. And they certainly found their way to my desk, from those already in a financial business to those who did not know where to start with their first home investment. The homeless were also referred to me. I worked with the elderly and their estate properties, their **earned equity** is their last chance **for security**.

♦ ♦ ♦ ♦

219

Trust My Advice

†

FOR THOSE WHO ARE not in real estate and have no knowledge of law, financing, contracts, investments, and titleship, I advise you to consult a knowledgeable licensed realtor, as well as your attorney before you place your signature on an offer to purchase, or accept a contract or counter contract. If your realtor has not advised you on these matters, turn him in to the nearest Board of Realtors or to the government. Just because one wears an "R" pin does not mean that a person is reputable.

Just like doctors, attorneys, or members of any profession, there are duds. Check credible certificates, degrees, and previous employment history, before your lay your life or your investment into their hands. Top sales is not a credential, believe me. Some of the top sales award people are the most sued and least trustworthy. They have sloppy closings. I can list the many times I personally walked out of a closing, refusing to be part of a poor or dishonest transaction. Rescheduling when I was assured every detail was in writing and properly endorsed.

†

Why do I write so negatively about a profession to

which I felt called to? Because I hope that what is written here will *alert* people and result in more *justice*.

♦♦

Many realtors have been known to be *honest* and to help others invest in a business or housing. Sometimes, many will even help from their own pockets. I have known many generous-hearted realtors. I still believe that *integrity* is the first word of all professionals; less than that is criminal.

Never was I forced to return my commission in a law suit. With Jesus' guidance and an honest attorney, I and our clients were safe.

♦♦♦

As chairperson for the Mortgage Review Board, I received some hair-raising complaints. After investigation, only a few were found to be unjustified.

Working in Fair Housing, and once again listening to complaints, I always suggested: get an attorney and file a formal complaint.

Just A Few of My Favorites
Investing in Heaven

†

I RECALL ONE DAY when a man, woman, and child came into my office. With tears in his eyes the man said, "If I had a gun I would shoot myself. Somehow we have become homeless."

I stepped from behind my desk and hugged him, telling him, *"God sent you to me because He has given me the knowledge to help you."* He and his wife broke down and cried.

No job, no money, no home. God had given me the insight and the experience of being homeless; the feeling of being less respected than others, of being shunned, mocked and scorned; the inability to acquire a job because there is no phone number for an employer to call. I, too, experienced the landlord and the realtor who wanted me to get lost because I had no security of deposit many years before.

†

The welfare program for the homeless is set up to accept only applications that show a permanent address. Even church members move away when a family drops their bags, containing all that they own, in the back of the church or in the pew.

222

God allowed me to experience hunger and to listen to my children cry for beds. Tears tear a parent's heart out. *"Thank You, Jesus, for this lesson in my life."*

As I looked at this family in distress before me, I said, *"**Sir,** would you fill out this questionnaire and application. God entrusted you to me. Thank you for coming in. I will do whatever I can."*

The man's face reflected dignity when I referred to him as "sir," and thanked him for coming. I offered them coffee and rolls, and the child, a toy box I always kept in the corner of my office. Afterwards, I handed the man twenty dollars, and asked them to rest at a nearby restaurant and return at four p.m. to see if I had come up with anything.

I put all calls on hold and called in favors from among my Real Estate colleagues. Who had a vacant apartment; who had a listing that required no money down, and so forth.

By one p.m. I had located, through a cross office, a home that the owner wanted to dispose of half furnished. I asked to view it by five p.m. Then I made a few calls to the local County Building to see if any permits had been taken out and if there were any proposed road or business zoning changes. I also called the Health Department to be sure when the last water sample and septic system inspection had been done on the property and if there were any planned rate

changes. I hurriedly went to the courthouse and checked for any obvious liens that could set this family back on the street (this is called "homework"). Finally, I checked the tax record and found a one year back tax that could be included in an offer or affixed to the cost of the home. Any costs the seller would incur, I also included into the total cost. The seller was by now aware of my venture.

Shortly after three forty five p.m., the anxious family returned, washed and full of food. They were smiling and their eyes looked hopeful. I took them to my car and we went to view the home, having arranged for the purchase from the seller at "above listed price" if they liked the house.

I pictured the perfect bedroom for their son and Mom's kitchen, including pantry and a window over the corner sink, overlooking the backyard where once had been a garden and flowers. The living room had registers as well as a wood-burning stove. Though the house needed "TLC," (tender loving care) I knew that from among my Christian friends, we could help them with their needs over this one weekend.

I bought the home on a contract with the written understanding that I could resell on a contract within twenty four hours. The only value received, or put in, was my time, as I had worked the cost and arranged for the realtors from the cross office to be paid their

224

commissions in segments.

Now that the prospective couple had secured *their* home, we needed to find him a job. "Go that extra mile," God would say to my soul. In four days time, I called in a few more favors, and the man had a job with a tree trimming company.

As of three years ago, their home was paid for, added on to, and remodeled. The value has increased three fold. He now holds a job as a superintendent and she drives a school bus. All is well. Praise to Jesus, only.

♦ ♦ ♦

A family was burned out and the woman called, crying, "What will we do? The insurance company says we get no money until the investigation is completed."

I said, *"God has been good to us. You come home with me."* After one year they received a fair settlement check and bought another house. Praise to Jesus, only. My husband and my children were so patient and helpful in these causes.

♦ ♦ ♦

A widow closed the sale of her home, expecting to move into a senior's apartment. However the apartment was given to another person, due to his need for a main floor apartment.

She was left with two choices: use up her equity

from the sale of her home, which she had planned to invest for income, or come to live with us for more than a year until another apartment was available. She was a pleasure to live with. Praise to Jesus, only.

♦ ♦ ♦

Another couple was invited to move to our town and live with their son. A week later, friends of their son did not want Mom and Dad around, so they found themselves homeless. They were low on cash and could not afford to live in a motel for long.

Praise God! He sent them to my firm. I listened and took them home for several months. Eventually he acquired a job. A realtor in my firm helped them to invest in a home.

Did I not owe this to them? They had both spent time in the service, and as retired veterans, they deserved my help. To this day we are great friends. Praise Jesus!

♦ ♦ ♦

A woman with two sons was left homeless when the house she rented was sold. One week before Christmas, they came to live with us.

I encouraged her to start her own business so that she could avoid state aid. Her business grew, and she saved money to buy a home. She developed a new relationship with a Christian man. She began to find dignity and trust in others. She found even more trust in herself. Praise Jesus!

◆ ◆ ◆

In Real Estate we were able to continue a mission of sharing the pillows of our home with others.

Counting Pillows

<center>†</center>

OH, HOW MANY LIVES our home has held, and how many friends we have been blessed with. We still take in homeless and open our doors to pilgrims who need a haven of serenity.

<center>†</center>

Oh, how well I know my mission field was in real estate at that season of my life.

<center>†</center>

Of course, one must limit cases of this sort, or one would not have the hours to help those in need. But to have the knowledge to help a widow take back her home from the state, sell it, and invest in a more secure future; to have the knowledge to help a sinking business relocate and survive, help others in marketing, and see a business prosper is a blessing. Thanks to Jesus for the knowledge of government and to help hard working families and minorities to start businesses and secure their own employment—praise Jesus for the knowledge, experiences, compassion, and insight he has given me.

Each man and woman was as wonderful as a client could be. I treated each client with dignity. Even

Real Estate

when they said they had no money, no one was ever left without help. God gave me the opportunity to be educated and knowledgeable enough to help those in need.

St. Joseph was my "right arm." He found unlisted housing. God worked miracles in melting hearts and making deals come together that others would have given up on. But because I was blessed to know how one can fall into a hard time, I enjoyed helping others.

Most of those difficult cases took time and there was little financial gain. But the wealth was not in the commission check. It was in the tears and the hugs and the excitement, when they found the right home. In some cases, it was the joy that they could just have a home.

♦ ♦ ♦

Bob and I were seldom ever alone, for Bob agreed that I could continue to shelter the homeless. During all these years, my dear husband, Bob, has coped with my bringing home others less fortunate. He did not grumble when, instead of banking my income, I used it to feed and financially help them. Bob accepted who I am. We both complement each other, balanced each other, and did all we can to help one another go to Heaven!

♦ ♦ ♦

"Happiness" is being invited to the blessing of a

marriage. It is a home that unifies a family, open to all, even homeless families (who may be divided without a place to stay).

"Happiness" is when people move their clothes from a junky car into a home that is up to city code.

"Happiness" is being in America where everyone should be guaranteed the "American Dream," and every man is head of his own castle and Mom tucks her children into their beds at night.

"Happiness" is the many blessings God has given me, including a large beautiful home on the lake that has held so many homeless persons over the years. Divine Jesus answered our prayers, helping us to find them housing and jobs.

◆ ◆ ◆

"Homeless" is *not* a word for someone else. Anyone can fall into hard times or find themselves in a temporary situation in which they are grateful for someone to take them in. If every home counted their pillows and invited the homeless in, there would be no hurt, loneliness, or homeless. *I am my brother's keeper.*

This is the reason I love the song, *"Whatsoever You Do To The Least Of My Brothers, That You Do Unto Me."*

†

"Jesus, Sweetest Jesus,
As I go about my business day,
Keep me fair in my dealings,
Helpful to others,
Considerate and wise.
May I prosper only from my investment
Made into Your Eternal Kingdom.
Let Your laws guide me.
Let Your angels watch over me.
May I always remember that I am to please You,
Jesus,
In all my dealings.
As my Bible teaches me,
Let truth and honesty be my character,
Let St. Michael protect me.
May business be only for me,
A place where I am needed by Your plan.
May no award be of importance,
Your cross take its place.
May my deeds of justice offer fruit,
Showing that You live in me.
May I remember You live in my clients
and customers.

Bless them, Jesus, in all that entrust in me.
Amen."
(Little Olive Branch)

Season of My Life

OR MANY YEARS, I pursued my career in real estate and community service work with great zest and vigor. My life was running smoothly, although there were times I felt I was moving at a two-thousand-mile-an-hour clip. I was at the height of my real estate career, active in civic-minded charities, championing the cause of the handicapped, sheltering the homeless, and counseling the weary and the depressed. Then quite suddenly, in 1989, I spun into a 180° turn of fortunes.

◆ ◆ ◆

Bob and I were driving to a business meeting when we were involved in a head-on collision with a hit-and-run drunk driver. I was injured. My heart problems were aggravated.

Tying It Up

†

WHILE IN INTENSIVE CARE, my family and friends were by my side.

†

How I had missed so much time of my life with working, instead of the golden days I could have spent bonding relationships.

†

I guess I spent time thinking along these lines, because I was realizing that within hours, I could possibly turn another degree and tie my life up.

†

While in prayer, I reached out to Divine Jesus for answers. Is my job for you done, Lord? Wonderful, I'm ready, Gentle Jesus, if you call me. But if you have more for me to do, get me off these machines, as you are my healer, and you have given me people to care for. Show me your will. What shall I do?

♦ ♦

Though I was stabilizing, I requested to go home from intensive care by signing myself out. My business was suffering and medical debts were soaring

again.I closed my business and moved forward with my life.

<div align="center">†</div>

The police were unable to turn up the hit-and-run driver. Although my husband did find the correct car that hit us, the police treated his discovery as doubtful just because the man said, "It wasn't me." However, the more than six witnesses who saw the criminal, were never called to identify him as the driver. Doing my share to try to hold down insurance claims, I did not bring any action against the AAA, my insurance firm, except to repair my car.

<div align="center">†</div>

I never recovered. The pain continued for a very long time and I was not up to running the three businesses. There was no one to really take over for any length of time. This was a lesson for a business person to learn: never be without the insurance to cover your time when the support of the business is down.

With my physical suffering and stress, and being unable to continue at the pace and energy level I used to have, rather than risk hurting a client, I gave my remaining strength to those cases remaining.

Being burned out, it just made sense to get on with my remaining life.

<div align="center">♦ ♦ ♦</div>

Lead Me West

†

WE WERE THRUST INTO a major mid-life trauma and adjustment. This alone, in and of itself, took a heavy toll on me. Soon, we were unable to generate the income to meet the standard to which we had become accustomed. Our medical bills soared. What savings we had accumulated, evaporated. Much of our earlier earnings had gone to pay Patrick's medical bills and a good deal of the rest went to feed and care for homeless and hungry people, either in our home or other places. Not to mention the government and its big bite.

♦ ♦ ♦

We began to down-scale our lives in order to cope with the changes. By 1990, due to stress and illness, I had decided to close down my corporations, drop so much volunteer work and move from the house, in which we had raised the children. I was living on nitroglycerin pills as if they were candy, trying to keep away the pain. I had spent many years stressed-out with hard work and concern for the world. Now, it was time to just pack it in. I was now fifty-two years old and **burned out**.

♦ ♦ ♦

Season of My Life

While I slowly closed out the business, I was also closing down life. As I looked at the empty office, our empty house, and my empty future, I felt a deep hole, a void in my very being. I was sure that my life, my job for God, must be about over. I had lost my will. I wasn't needed. Bob would be fine. I asked friends to look out for him, and I took out a sizable insurance policy to care for his needs. I gave my most treasured items to my children. I was not sure how or when God would call me home, I just had a feeling it should be soon.

♦ ♦ ♦

But just as it had always been in the past, during times of suffering and trial, My Divine Jesus was nearby to comfort me. Not working sixteen to twenty hours a day anymore, now only applying about four hours a day to real estate. I found much welcomed time for a fuller prayer life. It was becoming clear that my seasons of life were behind me. Today my award plaques are no longer important. All but my active broker's license are packed away in a box. My wall reflects today's work—working for my Lord by His plan.

I was sure my purpose in life was done. Surely, God would call me home very soon. My heart pained. My left arm pained. My face became numb for moments at a time. In certain positions or when climbing stairs, I had problems breathing. Somehow,

I was certain that my life was about over. A large, empty feeling mounted in me. I have nothing to do but go home to God.

<div align="center">†</div>

In January, I was invited to take a trip for some rest. My son Randy, and I left town to go west towards California. I was looking for a mountain I had dreamt about four times. I felt that I might complete this dream before I die. I went from mountain to mountain. But it was not in God's timing. We did not make it to California, for we were sidetracked to Arizona, where both Randy and I enjoyed our time together, re-establishing a closer mother and son bonding. We both found jobs and made a home and new friends until spring of 1990.

<div align="center">♦ ♦ ♦</div>

We enjoyed the sun of Arizona, the blossoming orange, grapefruit and lemon trees; the palm trees swaying, with mountains cradling this beautiful terrain.

<div align="center">†</div>

One day I drove to the mountains. Jesus and I were alone, deeply in tune. Looking over the plains, I began to feel strength, even though I had been in severe pain due to the high altitude. I was beginning to feel new strength, and new life, as I worked out the answer within my soul and mind.

<div align="center">†</div>

238

It was not God who was done with my life on this earth. It was my will that was lost. I began to review my life, and I really could see how each road had been where God wanted me, for His reasons at that time. I could see that even when I was going my way, making major mistakes in my choices, God made a sweet drink from my lemons. I could see when I feared man more than Him, and made choices to please man, but bringing problems upon myself, God was there to bail me out.

<div align="center">†</div>

As the movie of my life flowed before me on the mountain, I could see that Jesus was always there. *"Thank You, Jesus, for loving me so very much. Thank You, Jesus, for suffering for my poor choices. Thank you, Jesus, for saving a lowly sinner like me."*

<div align="center">♦ ♦ ♦</div>

While out west, I often returned to the mountain tops and the woods, or wherever Jesus, nature, and I could be close. Then after five and a half months, I returned home, refreshed, healthier, younger and hopeful!

<div align="center">†</div>

Jesus had always been there. I didn't just *now* discover His Holy Spirit. I was lifted as a child to know His Spirit. He gave me the next pathway which God would have in His plan for me.

<div align="center">♦ ♦ ♦</div>

239

We had moved out of our home for one year, renting the big house out to make things easier on me.

<center>†</center>

We moved back into our home on the lake in Michigan for three years, while I spent more time making friendships and doing works of mercy. I decided not to go back to making money as stored-up treasure for my old age. I was inspired by Jesus to help people.

<center>†</center>

Now that I have blended my life in a burning desire to go His Way, I have become a worker of harvest! By surrendering my life to God's way, my life is joyful, peaceful and fulfilled!

> *"When the Holy Spirit controls our lives, he will produce this kind of fruit in us: love, joy, peace, patience, kindness, goodness, faithfulness, gentleness, and self-control..." (Galatians 5: 22-23)*

<center>♦ ♦ ♦</center>

About the same time I returned from out west is when it all began–this new life *He* has called me into–from the calling of my name, to the gift of seeing illuminating Light, to being led to Medjugorje by way of the Cross, through Blessed Mary, and through her, into a deeper relationship with her Son, Jesus.

His Holy Spirit moves me in all discernment and decisions. Holy people fill my life in several prayer

240

groups. Many sinners and troubled people come to our home, and I listen to them and beg for God's Mercy and loving healing in their lives.

Now I travel, for God is sending me from state to state, and even to other countries, as my mission field to evangelize in churches.

♦♦

I am not alone in this journey of faith, for He carries me. I am the smallest lamb whose legs are weak. I am the youngest to whom He teaches right. I am the smallest lamb who needs our Holy Trinity to love me and guide me and lift me to eternity.

On my faith journey, God has blessed me with Bob, a holy husband. Day after day, people gather to hear Bob, for he is called to evangelizing, too.

†

Some of our children have married and our grandchildren are beautiful gifts from God. We are so blessed.

My name is not important. I wish I did not need to use it in this book. What is important is the true story and message that these chronicles of my life bring to other souls; that through my failures and struggles, mountains and achievements, and deep love of God, others connect and know of His loving hand and strength in helping me. Surely, He will help you.

O Lord, you alone are my hope;
I've trusted you from childhood.
Yes, you have been with me from birth
And have helped me constantly–
no wonder I am always praising You!
My success–at which so many stand amazed–
is because You are my mighty protector.
All day long I will praise and honor
You, O God, for all
that You have done for me.
(Psalm 71: 5-8)

Our life rolls on with His lead.

Season of My Life

Baptists Are Beautiful

I T WAS THE SPRING OF 1991 and Bob felt like getting away, as I was still under much pressure from closing down two firms and busy organizing my new business. We seldom do this, for God has given us a *haven* to live in each day. We have a lovely lake frontage home with secluded and picturesque views of crystal water and sunsets! When you are spoiled by this retreat spot, you find yourself in permanent comfort.

<div align="center">†</div>

However, it had been sometime since we took a trip north through Michigan. We set out to enjoy a visit to the memorable fifty-five foot redwood "Cross in the Woods," atop a foothill wrapped by shrines. The resort area is along an inland water way once used by Indians. The "Cross in the Woods" was inspired by Blessed Kateri Tekawitha, a young Mohawk convert to Christianity, who often erected crosses to be her prayer chapels in the woods. She was beatified (proclaimed "Blessed," the final step before canonization as a saint) by Pope John Paul II in 1980.

After strolling over the grounds, including the nun doll museum, the stations of the cross, and attending the outdoor Mass, we continued our tour northward, arriving at the Sault Ste. Marie Locks, bridging Canada and the United States. The frontier beauty of this northern terrain gives way to a laid-back life style. We spent a few hours celebrating with others in an Indian Pow Wow.

<div align="center">†</div>

As clouds covered the sun, we started for home. Near Conway, Michigan, about eleven miles north of Petoskey, we noticed a problem with one of our tires. We pulled off the road, across from a house. The owner of the house, who was a Catholic, was a most generous Samaritan. He helped Bob find the problem—a bad tire valve core. We had a new "donut" wheel that did not fit our car properly, and so we called our road service for a tow truck. When the tow truck arrived, the young driver reached underneath the car to lift it. Unknown to us at the time, he accidentally poked a hole into the radiator hose.

A passerby, in good faith, stopped to help in the lift. However, he was drunk and slipped in the mud, rolling down the embankment. We tried to discourage him, but he insisted on working his way back to the car to help. As we passed laughing glances between us, the car was finally lifted, and we were on our way south. I still recall the kindness of the home-

owner who said, "If I had a tire, you could have it."

After the tire was repaired, we continued our drive along Route 131 south, when on came the temperature light. Bob pulled on and off the road, cooling the engine. By now we understood that the tow truck driver had damaged the radiator hose. It had been such a wonderful day, with Mass at Indian River early that morning and the breath-taking scenery of the Sault Ste. Marie Locks and waterways, forests, and rolling green hills! We refused to let the car take away the joy God had given us that day.

Our smoking car came to a stop north of Walloon Lake. Off in the distance, through the woods, we could hear the sound of rock music and loud yelling. It was a dark night on a lonely stretch of road. Bob locked the car doors and we coasted slowly past a farm house. Bob would not let me go up to the house to call the tow truck in Petoskey. Bob was fearful that the farmer might just shoot at us through the closed door. "What has this world become?" I wondered, that one fears to rap on the door of a brother in Christ. We quietly coasted further down the road. In a deserted area, Bob pulled over, saying that we might need to wait until morning. With each car that passed, Bob hoped no one would stop unless it was a state trooper.

With my husband restless with concern, I turned this small crisis over to Jesus. I began to pray for an

angel to come by and help us. I asked God for His protection, and that He arrange for a *peaceful* person to come by. I was deep in meditation and at peace. Bob gets upset with me at times because I do not hold the fears that he does. I am not careless. I just choose not to live without any trust or to be intimidated by "could be."

Bob's deepest fear happened. A car pulled up directly in front of us. The door opened and a man stepped out. I said, *"God sent us help."*

Bob said, "Don't roll down the window!"

The man knocked on the driver's window, gesturing for Bob to communicate *through* the glass. He looked to be in his fifties and had a soft expression.

I said, *"Thank You, Jesus, for sending a safe Samaritan."*

Bob said, "Shhh."

I replied, *"God sent him by. Open the window."*

Our Samaritan identified himself as the Reverend, and asked what he could do to help. With his headlights pointed at our hood, he and Bob checked the car over. Seeing that the car needed water, the Baptist minister, agent sent by God, drove south to Walloon Lake Park, and emptied a garbage basket in the public john. Filling it with water, he borrowed it to bring back the water for our car.

While he was gone, I praised Jesus once again for

sending us a safe person. Imagine! I prayed for a safe person and God sent us *His* own holy one to help. Surely, Jesus was looking over us from the start. Later we learned that this was not the normal route the preacher usually took. That night he had been *led* in this direction with his wife and special son.

After the radiator was filled with water, we followed the preacher south to Walloon Lake Rest Area and parked our car, for it was late and no garages or auto parts stores were open.

The Reverend and his family welcomed Bob and I into their beautiful home.

Also, the preacher returned the basket. This samaritan Reverend invited us to come to his home, 16 miles north back to Petoskey, until morning. He then would bring Bob back to repair our auto the next morning.

We were welcomed into their orderly home. Our guest bedroom had a window looking over the serene beauty of Little Traverse Bay. We had not had supper and the preacher's wife made us a snack. We talked awhile, then retired. In our night prayers, we gave many thanks to Jesus for *His* care of us.

We felt such peace and comfort. Only God's loving hands could have made such a devastating incident into a loving retreat!

We arose about eight a.m. The preacher and his wife were already up and awaiting breakfast for us. How gracious.

After eating, Bob and the Reverend drove twenty four miles south to Boyne City, to an auto parts store for a hose. They drove eight miles back to Walloon Lake, where this preacher, an angel of God, replaced the radiator hose in our car. Bob followed him back north to Petoskey.

En route, Bob smelled something burning under the car's hood. He found that oil had spurted all over the engine. He was afraid the engine was damaged from running hot the night before.

Once they were back, the Reverend put three cans of oil into the engine, and insisted on putting three more cans into the trunk, refusing any money for the oil or labor. He also said to Bob: "And stop every fifty miles on your way back and check the oil level. Call me if you need me, no matter where you are."

Bob answered, "I'm not calling you if I'm fifty miles away." But the preacher, whom God sent to us, replied, "You'd better. No matter where you're at."

I had remained in their home, reading Christian literature while the Reverend's wife took her son to a doctor's appointment. After the preacher washed up, I talked with him while Bob washed up.

This wonderful, holy man sorted out spiritual cassettes and *serenaded* my ears with the rapture of

spiritual music. Bob remembers hearing singing and thinking, "Boy, someone is a good singer." When he came into the living room, he was amazed that the voice he was hearing was that of this Baptist preacher. We sat cuddled, wrapped in contentment, as the preacher serenaded us with many hymns. We realized that God had taken our lemon car and made lemonade for us. We were enjoying this spiritual retreat Jesus had led us on!

When his wife returned, she prepared us a healthy dinner before letting us leave. While preparing us dinner, they both sang hymns we had never heard. We also heard the rough draft of hymns they were recording.

As the preacher led grace, he added to his prayer a healing prayer for our car: "Lord, you can heal anything in Your Name, anything, and we will glorify You alone. Will you heal Bob's car so they can return home safely?"

After laughter and wonderful conversation, hugging, and a promise that they would look us up if they ever came to Muskegon, we departed, driving down the hill overlooking God's beautiful Traverse Bay. We felt God's peace and our eyes captured God's enormous, beautiful world. Bob left with trust and a new outlook. We took 31 South to Traverse City and stopped off to check the oil. *No oil was needed.* We thanked Jesus for *His* generous healing

of our car. (One month later we still did not need oil.)

Bob kept the other three cans of oil into the winter, hoping one day to meet this preacher and his family again. I tried calling the Reverend one day, but their phone had been disconnected. They had stated that they might be transferred to another Baptist church soon. These agents of Jesus have remained in our prayers.

♦ ♦ ♦

I am used to being led to God's mission fields, to be of service to whomever God places in my path. But on this occasion, we were to learn how Jesus sees us as brothers and sisters, and how He does not segregate us by the name of our beliefs: Catholic, or Baptist, however we title ourselves. It reminds me of Peter 4: 10-11:

> *God has given each of you some special abilities; be sure to use them to help each other, passing on to others God's many kinds of blessings. Are you called to preach? Then preach as though God himself were speaking through you. Are you called to help others? Do it with all the strength and energy that God supplies, so that God will be glorified through Jesus Christ—to him be glory and power forever and ever. Amen.*

We must have *respect* for those who preach in His Name. Leave them alone; let them do God's work.

†

I could never put down or injure another of my brothers or sisters of another denomination. Surely we are all part of the one body of God's children. Our testimonies are similar. We both believe in the Word of God—Scripture.

◆◆◆

Our most significant *difference* is found in the priesthood of the Catholic Church. Through the Sacrament of Holy Orders, a man is ordained a priest by a bishop. He receives the powers to forgive sins and to change bread and wine into the Body and Blood of Jesus Christ. These powers were originally given to the Apostles, the first priests and bishops of the Church, by Jesus, Himself. Thus, our bishops and priests are part of an unbroken chain of succession that began with the Apostles of Christ. We remain in love with and sing glory to our same Lord!

†

When we returned home, we shared this incredible journey of faith and inspiration with our prayer partners. What a journey! Our friends reminded us: "What goes around, comes around." They reminded us how we had always opened our doors to the homeless, and this was our pay back! I would still like to believe that God was leading us into an incredible journey of faith with Jesus *in* the home of Baptists!

◆◆◆

I give you this part of my life because I feel these

Samaritans, sent by God in answer to my prayers. Inspired me to love even more, my brother and sisters in Christ.

<div align="center">†</div>

As time flowed on Bob and I found ourselves more involved in church matters and in group prayer time. We also spent more time these days in our home chapel.

Shekinah Visit

IN OCTOBER 1992, a supernatural form in a Shekinah Light, (meaning God manifested in Light). The form of Shekinah were before the sliding doors in the living room. While Bob was seated in his chair, and I seated across the room on the sofa. Bob exclaimed to me, "Do you see that!" I looked up and saw a form in a illuminating light, we were both witnessing, as the form left and the light became a streak, of Shekinah light, shooting across the living room and turning left down the dark hall. Bob leaped up, and began to chase the light, and I hurriedly chased behind Bob, as it took us down the hall. "I saw the light go through a door," Bob said, he was coming to the end of the hall and lost sight of the light. He said to me, "Where did it go?" And I responded, *"Through Ryan's bedroom door."* Bob quickly opened the door the Shekinah light had gone into. We were amazed to find the heavenly beam of light had departed.

What did all this mean? This voice calling me for three years? This supreme light? Where was this leading? We shared our encounter with others,

including our parish priest, in February 1993. Commenting on these and other experiences, Father stated, "These are your gifts; isn't this wonderful." I was also told, "You are being prepared."

<p style="text-align:center">♦ ♦ ♦</p>

What did this mean? In March 1993, we would discover that "the voice" I had been hearing was that of an angel, preparing me for his actual visit when he would give me an assignment. Later, we were to know God intended to make more visits.

Shekinah Visit

God Gives Us His Design
in the Preview of a Dream

W E KNOW THAT THROUGHOUT time, heavenly beings have placed knowledge into the minds of chosen persons. Many have stories to tell about dreams; few ever say that their dreams come true. How I wish to share with you my dream in God's plan. As a child, I remember a picture on my grandmother's wall, of two children on a bridge and an angel hovering over them. As a child, I memorized a prayer to my Guardian Angel. I learned from stories my father told to me, as well as the Bible, about angels coming to our Blessed Mother, Jesus, and St. Joseph, other saints, as well as the prophets and the chosen people.

♦ ♦ ♦

On November 1, 1992 I awoke chuckling from a pleasant dream. I told Bob: *"I talked and laughed with an elderly man (who was he; he wasn't my dad) while he and many other people climbed upward, singing."* I could not recall who the man in my dream was and that bothered me, though I could still remember his face from the dream. At breakfast,

Uncle Bill, who was visiting with us from Oregon, joked about it. Then the dream was brushed off by all.

◆◆◆

Two weeks later my friend, Heather, who was now living with us temporarily, decided to move out West to live with her son. Not understanding why I was doing so, I offered to drive her to New Mexico. The trip became a journey in faith, amidst treacherous road conditions.

En route that first night, we pulled off I-290, near I-294, in Hillside, Illinois. We asked a motel clerk for directions to a nearby Catholic church.

✝

Joseph Reinholtz, the visionary from Hillside, Illinois, who receives messages from Our Lady & Dear Jesus. We shared a private message Joseph had for me.

The following morning of Tuesday, November 17, 1992, we had arrived at Divine Providence Catholic Church in Westchester, just as Mass was about to begin. I noticed an older man in the left front pew of the church. (He was arranging something on the seat and we could see his face.) Turning to Heather I said, *"I know that man in the left front pew; his name is Joseph. I'm sure his name is Joseph. He must be from Muskegon. What's he doing here? I'm sure I know him."*

God Gives Us His Design

♦ ♦ ♦

After Mass I approached him and asked, *"Is your name Joseph?"* "Yes," he answered, "would you like to join us in the prayer room for the rosary?" By now I really was curious, wondering where I knew him.

†

We agreed to join in the rosary, and made our way to the glass enclosed prayer room. Heather took a seat next to a statue of Blessed Mary and I (in my purple sweater coat), feeling like a purple sheep in the flock, made my way to the back row of chairs.

Joseph sat down next to me. During the rosary, he suddenly stopped praying aloud. I glanced sideways at him and was startled, chills running through my body. At that instant I recognized Joseph as the ***man from my dream of November 1, 1992.***

I was unable to focus on the remaining prayers. I began to feel a sort of uncanny feeling. After the rosary, while Joseph remained with a group of people, I asked a nearby woman, *"Who is that man everyone seems to want to talk to him?"*

She replied, "Don't you know? What are you doing here?"

I answered, *"I'm not sure why we are here, other than for Mass. We are passing through on our way out West."*

The woman responded, "That is Joseph. He's a visionary. He makes claim Our Lady gives him

257

messages for the people."

Chills increased within me. Closing my eyes a second, I quietly spoke to Jesus: *"What is going on here? How did I dream of this man, and know his name, and then one day come to this unknown church and **know** him when I first saw him?"*

I was not sure if this was good or evil. I just wanted to get going. Only my companion had begun to talk with other women. Still in the church where I felt safe, I stood looking at the man, and continued to pray for protection and discernment, immediately.

<center>†</center>

Joseph, the visionary, left the others and walked over to me. He told me that he would like to take me to another church, Our Lady of Lebanon, in Hillside. I gave him a questioning look, but in his eyes, I saw peace. I began to feel as though I was being **led** by someone higher.

Heather came over and agreed to go, even though I thought we should get on the highway and put some miles behind us. But time means little to Heather, for she is constantly in a spiritual orbit. Just name a church; she is ready to go to it. Just mention a prayer group; she will stay on, no matter where. I remember saying to her once: *"It is great to be 'high' with your Lord, but remember, even He wants your feet on the ground."*

We agreed to go with this stranger to another church. Following him in our car, I thought at the stop light: *"What am I doing? What is going on here? We are being LED by a dream, to actually drive behind a visionary who had appeared in a dream. This is really weird."* It was as though I was being roped and led, but I felt at ease as I drove.

Heather, in the meantime, was looking up prayer groups for this area. (She has a book that lists prayer groups across the country.) She found one located in a cemetery in Hillside for that very afternoon. I said, *"Heather, we better hit the road after this stop."*

<p align="center">†</p>

Inside Our Lady of Lebanon Church in Hillside, IL, Joseph, the acclaimed visionary, met a priest and asked for the key to a chapel. Then a lady from Poland joined us and asked to go into the chapel, too. Joseph, Heather, the woman from Poland, and I entered the chapel.

As the doors opened, I felt a strange covering of heat, yet all was peaceful. I realized that I was in a *holy place*, in the presence of God. Joseph told me to touch the base of the cross on the altar. He placed his hand on mine, and together we touched

Together we touched the base of the cross & prayed "Our Lady of Lebanon" Hillside, Illinois.

259

the base of the cross and prayed.

He then said, "Kneel on the bottom step. I am to bless you." I knelt in prayer. Joseph was to the left of me, the woman from Poland was to the left of Joseph, and Heather was to the left of her.

Joseph touched my left shoulder to turn me towards him. Taking from his pocket a crucifix, given to him by Vicka of Medjugorje, and placing the crucifix to my forehead, Joseph prayed for perhaps a minute and a half. He then held his crucifix over the other two women.

<div align="center">†</div>

Afterwards Joseph told me secrets of miracles that are happening to him and which are being investigated. To this day I do not speak of them to anyone. I was absorbed in the rapture of the presence of God and our Blessed Mary. Surely, all was holy around us.

<div align="center">†</div>

Outside, in the church parking lot, I said to Joseph, *"This was awesome, Joseph. Thank you. I feel at such peace. Joseph, my friend has this book that tells of prayer groups, and she was considering going over to see this cross where people gather to pray. Do you know how to get there from here?"*

Joseph chuckled aloud (the same chuckle I heard in my dream). He stated, "The cross you are asking about and the prayer group—this is where Our Lady

God Gives Us His Design

comes each day and gives me messages. Come to my car."

We followed him, grinning all the way and shaking my head at Heather. Joseph opened a photo album and showed us photos of unusual phenomena that he had taken at the Cross, the site of his apparitions. How could one not be open to the possibility, after seeing these photos?

He offered to guide us to Queen of Heaven Cemetery, where the Cross is located, but he informed us that he would **not** go in with us—something about obedience on this Tuesday. Outside the gate of the cemetery, Joseph came to our car, and we exchanged private phone numbers and addresses. Then he leaned on my car window and said that he and Mary would like me in Medjugorje over Easter, 1993. Looking at my traveling companion, Heather, I asked, *"Where is Medjugorje?"*

She answered, "Yugoslavia, I think."

"Oh no, Joseph, I can't afford to go out of the country. I'm sure of that."

Joseph responded, "If Our Lady wants you there, money will be the least to keep you from going." Then he said, "When Mary calls, everything comes together. I'll call you in the Spring of 1993." He turned then and stated, "Trust in *her*; she will provide." He smiled his wonderful smile and his pure eyes twinkled as if he knew something we didn't.

♦ ♦ ♦

Continuing our journey West, I mentioned to Heather as we drove out of town: *"This is the last I'll see of the man in my dream."* However, my adventure was just beginning.

†

I did not see or hear from Joseph again until February, 1993, when he called me about the trip to Medjugorje. I was still uncertain and had talked only to my husband about the event. I told Joseph that I must talk to my priest before deciding.

My priest, on hearing the unusual way I was **led** to meet this man, said that others have claimed to have been called or led by Our Lady. He said not to rule out the possibility. He suggested that I go home and *fast*, *pray*, go to Communion, and read Scripture. Then after a week, even two, listen to what God tells me.

After one week of following Father's advice, I began to feel at peace, even though I had just learned that Medjugorje is in the heart of a **war zone**.

Neither my husband nor I were worried about the fierce war that rages in Bosnia. I did have other local concerns, including where the money would come from. But, ultimately, I felt that our Blessed Mother and God were leading me. I was close to consenting to go.

†

God Gives Us His Design

In February 1993, I went to my priest after Mass and said, *"Father, I want to tell you something you may not know. I SEE AN ILLUMINATING LIGHT around the Host and the Chalice during the Consecration. Something very spiritual and wonderful is happening with you. I do not see this in all churches and not with all priests, but YOU are one it happens with most."*

"Wonderful," he stated, *"this is your gift, not mine*. You see the Glow, so it is your gift!"

"My gift? Really?" I said, "This has been happening on and off since 1990."

"That's good," Father responded.

"Father, I always knew the Presence of my God was in the Eucharist and now I can see His Glory! Thank you, Father!"

Father instructed me, "Go tell, especially priests and others if they will listen." And so I did. First I would tell the priests in the churches where I could see the Glow. Later, I began to tell a few friends within our church and family. I would share by telling all who wished to listen. Many priests do not believe and many Catholics today do not believe in the priests power of consecration. And so it began. This maybe only the beginning.

Seeing the glow and knowing it is (my gift) was affirmation God is surely close in my life.

<p style="text-align:center">†</p>

Then Gentle Jesus appearing, was another affirmation, God is calling me closer to Him.

<center>†</center>

Along with the gold layer upon my chaplet was another affirmation Our Lady is calling me.

<center>†</center>

But into what?

<center>♦ ♦ ♦</center>

The money for the trip came suddenly by the first day of March. And on March 20, 1993, just before Mass began, while praying my St. Ann Chaplet Rosary, I stopped and asked Blessed Mother: *"My dearest Mother, I have come too far in my life. Don't let me be lost."*

As I continued my chaplet, I noticed a shiny bead. I handed it to Bob, who was sure that the plastic bead was covered by a layer of gold. A jeweler confirmed this and I consented to answer our Blessed Mother's call. But why me? This was a miraculous sign for me. And I considered it as affirmation

<center>†</center>

Many affirmations showed me that I was to listen to visionary Joseph Reinholtz and go with him to Medjugorje, Bosnia Herzegovina during Easter 1993.

Because of the war in the Balkans and the "ethnic cleansing" ("holocaust" is a better description), some of our seven children were very concerned about me

placing myself in such danger (only a fool would say that there is **no** danger). My husband, Bob, tried to reassure our sons that it was okay, saying, "Where is your faith? When Blessed Mary calls, you go. When you do what she is asking, she will take care of you. Have some faith."

Well, that sounds good, but our son, Ryan, who was twenty at the time, was not buying his dad's words. He was tired of hearing me speak of how I met Joseph as being God's plan. Ryan came into the living room. He looked at his dad in the easy chair and me in a cane chair and said, "I'm *curious* about what's going on down there [at the Cross]. Let's go on Sunday. I'd like to see that *guy* who's taking you half way around the world into a war—and you don't even know him. It's crazy!"

Bob looked at me. I had picked up on the word "curious" and knew that this was God's lead word.

<center>†</center>

On Sunday, March 21, 1993, we drove to Hillside, Illinois. We left home at five a.m., in the rain and the cold, to be on time for the rosary at the Cross in Queen of Heaven Cemetery.

Those who are there for the first time are curious, listening to Joseph, who claims that Blessed Mary, Divine Jesus, St. Michael the Archangel, and many

angels visit the earth at this spot each day, and that one or more of these heavenly beings gives messages to him. The messages that Joseph claims to receive are sometimes for the world and sometimes for individuals.

One need only look into this energetic elderly man's face to see the soft, loving eyes that seem to draw you into his soul and reflect his love for Blessed Mary and Divine Jesus. After he receives a message, he glows and nearly always has a smile and a tenderness for all those around him. One can see that he has a love for children and compassion for those who are afflicted. He has a great reverence for his faith and obedience to his Catholic Church.

<div align="center">†</div>

He is in control. Once in January, 1993, Joseph was grounded, as a test, by the Church. He abstained from visiting the Cross and all the places he was told not to go. He spoke neither about the Cross, nor about the visits and messages from Blessed Mary. Our dear Blessed Mary helped him, he tells, by not appearing during this time. I personally have fasted and prayed, offered Masses, and asked Divine Jesus for the gift of discernment concerning Joseph.

<div align="center">†</div>

As cars were pulling into the apparition site. I asked a woman if she had any photos similar to Joseph's. She showed me what she had and then said,

God Gives Us His Design

"Soon another women will be here and she has a collection. She comes everyday and will show you. I'll let her know you're here from Michigan."

When I saw this woman, I approached her and asked, *"Could you show my husband and son your photos?"*

She was very obliging, as if she *lived* to fill others with what she knew. Because of the bitter cold and rain, she stepped into our car and began to unfold the total story of the phenomena that had taken place. She told of Joseph, Medjugorje, and the messages. Then she showed photos taken at the Cross. She sat beside our son, Ryan. Bob, in the back seat, leaned over to see and to listen. I stepped out of the car, listening to others.

We gathered at the Cross on March 25, 1993, before beginning the rosary. I placed a blanket on the cement to the right, before the cross, and as people came, we began to pray. Bob and Ryan were among the crowd.

<div align="center">†</div>

As we prayed, **a glow illuminated the Cross**. It moved to the left of the cross. Then a form appeared! *Divine Jesus* head faced, and HIS hands moved outward and upward. *HIS* white robe shimmered with the movement. *Divine Jesus*, with His gentle face looking upon us, in all His light and beauty. He was beside the cross. Light came from within and

around Him.

<center>†</center>

This was not the first time I was given to see **Divine Jesus**, so I recognized Him!

Upon seeing His presence, I was lifted up in spirit in a wonderful joy and peace! I felt His warmth and love, and was drawn into His peace. I basked in His Divine Love. I was in such a state of joy and peace, that I forgot all about Joseph.

<center>†</center>

I had knelt beside a woman who also was seeing Divine Jesus. She looked at me when Divine Jesus moved to the side of the Cross. She was a shy lady and she was crying. But we were in communion together in what we could see.

Whispering, I said, *"Jesus is larger than the corpus of the cross."*

She smiled through her tears and nodded yes.

<center>†</center>

Although it was freezing cold, I was veiled in His divine warmth which came from His light, and I pushed back my scarf and coat, unaware at the time of why Divine Jesus wanted me to see Him. After sharing with my priest, I learned I was gifted by God to be a witness to the apparitions as being real for Joseph.

<center>♦ ♦ ♦</center>

Though I did not tell Joseph of my witnessing his

apparitions until after I spoke to my priest of what I had seen.

<div align="center">♦ ♦ ♦</div>

Joseph knew we were there because I had called him the day before. After the Rosary, he blessed the people, then asked me where my husband and son were. I called them over for Joseph's blessing. I could see Ryan's face as he looked into Joseph's eyes while Joseph spoke quietly to him.

<div align="center">†</div>

When we left, Ryan, who was driving, turned to his dad and said, "Did you see his clear eyes? I believe him. I believe Mary is giving him messages. And that woman, who shows those photos, she is doing good. She opens you up before Joseph comes. somethings going on here."

<div align="center">♦ ♦ ♦</div>

Our son asked for his rosary and began to pray it daily. He began to tell others, and encourage others to say the rosary, showing them pamphlets and telling them of Joseph. After two months, the chain of Ryan's rosary began to change to a golden color. Ryan was being called to prayer by Our Blessed Mother.

<div align="center">†</div>

Some people have asked, "I know spirits sometimes come back to families after death, but how can you see Jesus?"

I took this question back to my Divine Jesus. After much prayerful meditation, I went back to my Scripture to look up a passage in "Luke." My Bible fumbled from my hands and opened to Matthew 23. As I began to read, I quickly came upon Matthew 23: 39. There I found affirmation:

> *"For I tell you this, you will never see me again **until** you are ready to **welcome** the one sent to you from God."*

Surely, I welcome Our Savior sent for us. I received peace in this scripture for my present understanding.

God may choose to show Himself to some. He may also choose some to be witnesses of His word.

<div align="center">♦♦♦</div>

Are dreams prophesy? Sometimes. Are dreams preparation? Many times. Do dreams come true? Often times, when there are two or more alike. I have come to believe, that we are living in times such as those described in Job 33: 14-18, and that many *are* coming daily to true conversion:

> *"For God speaks again and again, in dreams, in visions of the night when deep sleep falls on men as they lie on their beds. He opens their ears in times like that, and gives them wisdom and instruction, causing them to change their minds, and keeping them from pride, and warning them of the penalties of sin, and keeping them from falling into some trap."*

God Gives Us His Design

We are all *invited* in Revelation, 22: 17:

". . . 'Come.' Let the thirsty one come—anyone who wants to; let him come and drink the Water of Life without charge."

<div align="center">†</div>

In the past, I have asked Divine Jesus many times, that if there was something He wanted of me, to show me. My daily prayer is:

<div align="center">

ALL FOR THEE

Take my life and let it be

Consecrated, Lord, to Thee

Take my hands, and let them move

At the impulse of Thy Love,

Take my feet, and let them be

Swift and beautiful for Thee,

Take my voice, and let it sing

Always, only for my King.

Take my lips, and let them be

Filled with messages from Thee.

Take my will and make it Thine;

It shall be no longer mine.

Take my heart, it is Thine own;

Let it be Thy royal throne.

Take myself, and I will be

Ever, only, all for Thee.

(Unknown Author)

</div>

271

Even though I was called to Medjugorje, Bosnia-Herzegovina, and returned with a stronger faith and deeper conversion to Jesus, I've learned that people need not run around the world searching for Divine Jesus. Jerusalem, Lourdes, Medjugorje, Hillside, and other such places are an *awareness*. To be with Jesus, one needs only to turn to Holy Scripture, and receive His Presence in the Holy Eucharist, to Love and to look upon his neighbor and within himself. Divine Jesus is present in all of us. We need to remain in the state of grace glorifying Him.

God Gives Us His Design

By Way of the Cross

JOSEPH SHARED WITH ME **this insight of himself.**
As a retired railroad worker, Joseph's idea of
retirement was sports and sleeping in. Instead,
this youthful looking man, who is in his eighties, has
energy that makes me seem like a turtle. He "rises
with the chickens"—sometimes even earlier if he has
a home visit from his Heavenly Mother, Mary.

This man who holds himself out publically, and
has shared some of this life with me and his close
friends, does so that we may all know him better.
Joseph, who attends daily Mass and is an extraordi-
nary minister of the Eucharist, is very reverent. On
Tuesdays, he leads the rosary in his parish church
Divine Providence of Westchester, Illinois, for he
refrains, by obedience, from going to the Cross in
Queen of Heaven Cemetery, Hillside, Illinois, on this
day.

It's only normal at times, for a person to want to
enjoy a favorite activity, but Joseph, obedient to his
instructions, spends his days totally in works of
mercy, visiting nursing homes, listening to the trials
of others, and spiritual works. In addition, there are

many hours dedicated to praying for the release of the souls in purgatory.

<div align="center">†</div>

Who is Joseph? To me he is a man, my brother in Christ, shown to me in a dream in 1991 and then led to in 1992. He is a widower who speaks tenderly of his deceased wife—as if she had been an angel.

<div align="center">†</div>

Joseph was hospitalized in 1980 when he lost his eyesight. He continued to experience severe vision problems over the years.

In the fall of 1987, some of Joseph's friends made a pilgrimage with him to Medjugorje, Bosnia Herzegovina. It was during this trip that Joseph met his dear friend, Vicka Ivankovic, one of the six young visionaries of Medjugorje.

Returning home, Joseph stated he was overwhelmed when his statue of Blessed Mary began to cry tears, which were collected. It was at this time that Joseph's sight was restored. These were signs that something very special was about to happen in Joseph's life. Surely, Blessed Mary was beginning to call him to deeper prayer time.

<div align="center">†</div>

Joseph goes on: In 1989, during another pilgrimage to Medjugorje, **Vicka told him that he was to find a crucifix that was about fifteen feet tall and stood**

274

beside a three-branched tree, a "trinity tree," as the tree is now called. When Joseph found the crucifix and the tree, he was to pray at that spot.

†

Through God's Mercy, Joseph's health greatly improved. He goes on to tell how he searched for and found the crucifix and trinity tree close to his home. They were located in the Queen of Heaven Cemetery, Hillside, Illinois.

†

Joseph prayed daily at the site of the crucifix. Eventually, a handful of friends joined him in prayer, kneeling in snow, rain, and heat, early or late in the day. Some would say, "Who is that nut, freezing in the snow. He'll die of pneumonia." Yet, others kept him company, praying devoutly and meditating. This they tell me with loving memory.

Joseph told me that one day the corpus on the crucifix bled. Joseph climbed a ladder to touch the blood. To his amazement, Jesus spoke to him saying, *"WHY ARE YOU TOUCHING ME?"* Joseph responded, "I didn't know I wasn't supposed to." Blood was collected and Joseph asked Jesus if he could take a picture. Jesus gave His approval. The result was awesome and moving.

On August 15, 1990, our Blessed Lady *appeared*

275

to Joseph under the Cross (as the crucifix is called). **According to friends I spoke with**, Blessed Mary appeared again on November 1, 1990, and some were gifted with wondrous photos of Her next to the trinity tree. Joseph told his prayer partners, "Our Lady is present with angels and St. Michael!" But only Joseph could see and hear.

<div align="center">†</div>

Those who are present take photos before or after, but not during, devout prayer time.

<div align="center">†</div>

I was told that one time, some ten thousand people were at the Cross, and many converted during the apparition. On one rainy feast day, I was present with some twenty five hundred people!

<div align="center">†</div>

This is a place for our Blessed Mother to come and feed her children hope, giving them her blessing. One day while on our visit to the cross, angels were among the children. As one played with a baby girl, we could see the child reaching upward and active with only air. Only Joseph stopped the show of the child by saying, "Our Blessed Mother called the angel back, telling it to leave the children alone." Joseph laughed aloud and then shared with us all of our sweet, Gentle Mother's caring.

<div align="center">†</div>

By Way of the Cross

This cemetery is well cared for by caring persons. Jesus has said, *"THIS IS HOLY GROUND."* Surely this is a wonderful place to rest, with mausoleums that remind one of Rome. Many have told me that they would like to be buried in this holy ground one day, and why not? I have seen Divinc Jesus present over this holy ground, next to the Cross. I have seen Blessed Mary as she hovered among and above the trees and the people, in the sky! Some have seen St. Michael the Archangel, as well as other angels! (No, these are not hallucinations. Many times they are captured in "phenomena" photos.) Even I have looked into a possible resting place in this Holy land. I was informed their are many lots and crypts still available.

<center>†</center>

I, too, have been gifted by God to take photos that revealed unusual phenomena. Pilgrims I've taken to the Cross have also received the gift of taking won-der photos. On September 27, 1993, Gentle Jesus spoke to me, saying: *"THE PHOTOS ARE YOUR GIFT, TO TELL YOU I AM HERE."* Only God could have known the discernment for which I prayed privately.

<center>†</center>

It was on June 18, 1993 that Divine Jesus said to me beside the cross, *"CONTINUE TO DO AS YOU ARE DOING."*

On this same day, I could see Blessed Mother

hovering on the east side. I asked my Blessed Mary: *"What more do you want me to do?"*

To my surprise, Our Lady answered, ***"Continue To Bring Them To My Son."***

"Yes, My Mother, I promise," I replied, in a humble, awed voice.

And so I continue to arrange pilgrimages, caravans of cars from Michigan. We meet in Muskegon, Grand Haven, and Holland, Michigan and we lead them to the Cross in Illinois. It's a wonderful experience! Along the way I share my many photos and tell

Joseph Reinholtz blesses Marty.

of my times with Divine Jesus, Blessed Mary, and the angel. I began with eight trips a month, and then as the weather changed, so did the number of trips. Though no month has passed without at least two trips to the Cross in Hillside. On several pilgrimages my confidant, Marty Miller also lead a caravan of pilgrims for a spiritual uplifting.

<p style="text-align:center">†</p>

Pilgrims gather at the Cross from the time the gate opens until it closes. Though ***Our Lady*** has chosen this place to show her love for her children, pilgrims should be courteous. Drive slowly, speak quietly, and don't roam over the grave sites, except, of course, to look for the graves of loved ones. Remember to

respect the purpose of this place.

A portion of the land is unselfishly set aside, at present, for Our Lady to appear at this time. Your prayers are asked, so that Joseph may continue to go there, and so that the patient and dedicated cemetery staff will continue to welcome the pilgrims with warm hearts, appreciating that our Blessed Mother honors this holy place as the site of her chosen mission.

About nine a.m. daily, except Tuesday, pilgrims begin to find places in a circle around the Cross. At approximately 9:25 a.m. an aisle is opened for Joseph to come to the center to lead the rosary.

Usually someone from the prayer group leads the pilgrims in prayer and song. Children are selected, as well as visiting priests, nuns, and laity, to aid Joseph in praying the rosary and the Divine Mercy Chaplet. After the apparition, Joseph turns to give the daily message, and on the *twenty fifth of the month*, the message for the world! Many of the messages are directed to priests, for our Blessed Mary so loves her priests.

<div align="center">†</div>

Joseph raises a cross, given to him by Vicka of Medjugorje, in the direction of Blessed Mary, and asks for a blessing upon the pilgrims. Many times throughout the apparition, people are gifted to inhale Our Lady's special fragrance, roses. Rosaries often

turn gold before the pilgrims' eyes.

Many, including myself and my friend, Ginny, have been given the gift of *seeing* Our Lady. On August 2, 1993, Ginny came over to me and said, "Our Lady wasn't wearing a crown."

Not fully taking in what Ginny had said, I replied, *"She had no crown today."*

Quietly Ginny responded, "I know. And her hands . . ."

I chimed in, *"And her hands were held outward."*

Again Ginny responded, "I know."

At that time, I looked up at Ginny, whose face was all aglow, and said, *"Ginny, you saw! She gifted you to see too!"* That day, nearly every pilgrim brought to the Cross had some kind of wonderful spiritual experience!

◆ ◆ ◆

On some days, in Divine Jesus' presence, there is another aroma: a beautiful fragrance of incense, floral and spice. Those who are gifted to inhale it, bask in it! One day Gentle Jesus looked down twice over the little children praying.

†

Many times, Gentle Jesus' Divine Mercy flows over the pilgrims. On September 8, 1993, Gloria and John, who are pilgrims from Michigan, were with me at the Cross. One of them said, "Take a picture of Carol touching the feet of Jesus [corpus on the

Cross]." The "phenomenon" photo shows streams of white and red mercy light flowing over all who are gathered at the foot of the Cross, as well as over my blonde hair and my red-sleeved arm. All present that day received His Mercy! This negative was checked, and a professional firm proved this light to be before (not touching) the corpus, another light form also seems to be near the cross.

Mercy flows in light from corpus upon us at Hillside Cemetery.

†

Our Blessed Mother has said that this site will remain a "private shrine."

†

*"Do not come to see great signs of miraculous wonder. Come **only** to join in prayer with others. Come with intentions focused on a deeper **awareness** of Divine Jesus, for a revival in faith, and for **unity** among brothers and sisters in Christ, who join in prayer and song."*

†

There are no speakers or sound system. Cardinal Joseph Bernadine, in a letter to me, explained a sensible reason why Joseph has agreed to be considerate

of the ground rules. We must remember that the first purpose of this land is burial in consecrated ground. In consideration of this holy service, a sound system would be inappropriate, disturbing to those in mourning. Because of this, many bring tape recorders. They arrive early, getting as close to Joseph as they can, to hear clearly the messages he receives. His letter, one of three to me, explains how the Diocese is pleased with Joseph's obedience.

<center>†</center>

If you are looking for the Presence of Gentle Jesus, remember first that you can receive His Presence daily in Holy Mass, in the Eucharist. This is Jesus' direct gift to us through time, from Peter and the Apostles to all the priests of the Catholic Church.

<center>†</center>

When you believe without signs, you are *listening* deep within and following out of love and obedience. You will be given great graces as your gift.

<center>†</center>

If your faith needs reviving, and you are near Chicago, join in the prayer at the Cross in Hillside, just off Route I-294.

I wish to tell you this: before I take a caravan from Michigan to the Cross in Hillside, I often ask a new pilgrim: *"Why are you going? What do you expect to get out of this visit? Will you be joining the rest of us at Mass, following the prayers at the Cross, before returning home?"* Nearly all who have gone to the Cross have a story to tell: ***personal conversions*** that bring them closer to Jesus; ***healings*** in their ***souls*** and ***minds*** that ***bring peace***; physical healings; and for most complete spiritual ***changes*** in their lives!

<div align="center">†</div>

What is the ***main message*** that our Blessed Mother gives to her children through Joseph? As shared with me by Joseph's close prayer partners, Richard and Rocelia, on December 14, 1991, Our Lady told Joseph: ***"I Need Your Prayers More Desperately Than Ever Before."*** She asks us to pray more than ever: for peace in the world and in our families; for the release of souls in purgatory; and for her Son's priests, whom she loves so dearly (many of her messages are for priests). Our Lady asks us to repent and to convert daily, coming ever closer to Jesus, and drawing others to Him through evangelizing.

At the Cross in Hillside, we are reminded of the "weapons" Blessed Mother recommended to us at Fatima: The daily praying of the rosary, frequent Confession, and Mass and Communion on five con-

secutive first Saturdays of the month. In a way, the Cross at Hillside is a "child" of Medjugorje and Fatima.

<div align="center">†</div>

Receiving a full vision of Jesus and hearing His gentle voice is the ultimate gift. He gives His Mother for us to see and hear, and this is **wonderful**, too. The prayers she teaches us, the graces she gives us, the mercy and peace with which she asks her Son to shower us, and the photos of unusual phenomena—these are all smaller gifts.

I was completely unaware of the fact that I was part of God's long-range plan. He was preparing me in many ways to become His instrument. I was overwhelmed to be chosen as a **witness**, to the apparitions of Joseph of Hillside and Ivan of Medjugorje. I was also surprised by the unusual photos that I received on March 21, 1993: my **first** "gift" photo was of a Shekinah light, that came down on the right side of the Cross as my husband, Bob, was walking back to meet me; the **second** photo was of a Shekinah light, just after praying the Rosary, while Joseph was **receiving** a message from our Blessed Lady; the **third** photo was of a heavenly veil of light that flowed over Joseph as he gave the message from Our Lady to those present.

<div align="center">†</div>

During one pilgrimage to Hillside, while facing the Cross in quiet meditation, I spoke prayerfully from my heart to my Jesus: *"Jesus, will I go back through the light after my death?"*

284

1. *Shekinah light just after praying the Rosary, while Joseph was receiving a message.*

2. *Joseph is basked in a veil of light & Shekinah light came down on the right side of the Cross flowing over me as I knelt & took this photo.*

Deep inside I heard, *"Repent."* (I wrote this down in my daily journal, and identified the companion who was with me that day; my friend, Marie Pimm, who had also journeyed with me to Medjugorje.) The remainder of the day I kept thinking "Repent?" God wants me to repent even more than I had done before and after confession! After much discernment, I knew this to mean deeper sorrow! After these words from God, it is often my heart flows into sorrow for the sins of others as well. Swelling up and pleading to Jesus for His Mercy for others, and pleading for joy to be given to them through a new conversion.

◆ ◆ ◆

On this day, I photographed the Cross. When the film was developed, I counted the photos returned to me, noticing I was short one. I checked the negatives and found one that was dark. I felt a powerful closeness to the dark negative and decided to return it to be printed. I was amazed when I discovered that it

was another "phenomenon" photo! There are mercy lights pouring from the Cross, a brilliant "eternal light," and my tombstone on the left at the bottom corner! Amazing because there are no tombstones close to the current location of the Cross. The photos on the negative strip before and after are normal in color with people praying at the Cross.

<div align="center">†</div>

On this day, I recall I spent time **before the Cross soul searching and in prayerful meditation. Only** I remember being lifted in a joyous quietness.

<div align="center">♦ ♦ ♦</div>

Daily at the cross, a couple of men dedicate their souls to Our Lady. Joseph gives a general blessing to

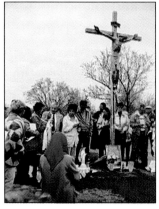

all on weekdays. One very holy woman was chosen by Our Lady to aid Joseph. I have also watched her spiritual growth through her calling.

On Sunday, he lovingly stays as pilgrims gather in lines for him to bless them individually, with his blessed olive oil all the

way from Medjugorje, mixed with Our Lady's tears, collected from her statue which sometimes weeps. At times, other priests come to pray and to lay hands upon those in spiritual and physical need of healing.

♦ ♦ ♦

Our Lady is calling all of her children. No one is considered more worthy than another. I have taken many protestants to the cross as well, and they have been greatly inspired.

†

We follow all pilgrimages to the Cross with attendance in Mass at a nearby church—Divine Providence, Our Lady of Lebanon, and others.

A few rules and requests are set up for the protection of the grounds and for the people. We ask all who are welcomed to come, to be respectful. Because exploitation (selling of articles) is not permitted near the cross. We ask all gatherings be outside the grounds, except for those who gather in assembly for prayer. Talking, is not permitted,*"This* 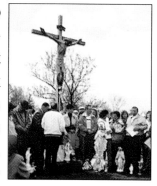 *is a holy place,"* Jesus says. Time spent before the cross is for soul searching and prayerful meditation only.

♦ ♦ ♦

Because I live in another state, some two hundred miles from Joseph, I can hardly consider myself as close as those in his personal prayer groups. Although I have had the privilege of joining in their prayer groups, occasionally, as his sister in Christ. However, Joseph is aware of the instruction given to me by Our Mother, especially those he has received to give to me. We share the blessings and the frustrations encountered when saying yes to Our Mother and Gentle Jesus. We are **not** saints, just servants, and we both ask for your prayers.

<div align="center">†</div>

On the first Saturday of each month, most follow Joseph to Mass, where at Our Lady of Sorrows Basilica, after Mass, Father Rookey lays his hands in healing upon the pilgrims who come. Many talk about healings they have experienced or witnessed. God shows his Mercy and heals many through this holy priest's gift.

<div align="center">♦ ♦ ♦</div>

By way of the Cross, I was **led** through Blessed Mary to Her Son, Gentle Risen Jesus, and to a deeper conversion to my Savior while in Medjugorje.

<div align="center">♦ ♦ ♦</div>

I am asked: "What do you think of this Joseph, Carol?" I know he is my brother in Christ. I know he is a chosen holy man whom God is using as His instrument to bring **again, His** Word to the people. I

288

have a great respect for this good, holy man who lives to obey God, and so unselfishly uses his retirement to serve all who are put in his path. Joseph and **I do not have a personal relationship** and know little of each other. **Joseph is called to his work and I am called to mine.**

In the heat of summer or in freezing winter, Joseph is devoutly at the Cross, awaiting Our Mother's visits. To be with Joseph on a pilgrimage to Medjugorje is a special gift. It allows for special privileges, for Joseph is well known there. There are those who believe in Joseph and those who don't. And that's okay! The truth will come in God's timing, I say. I'm at peace, for I have **witnessed** many times.

◆ ◆ ◆

During another pilgrimage on September 25, 1993, our Blessed Mother was so beautiful, dressed in all white, with no crown. Her *beautiful graceful face* looked down upon me and she said to me: *"You Are To Go Into The World And Bring Them To The Cross."* †

In Hillside on October 1, 1993, Joseph said with a great smile: "Carol, I am to tell you: *'You Will Travel Far. Do Not Be Frightened. [She] is with you. Spread the word of [her] Son. [She] is*

Joseph greets me with another message from Our Blessed Mother.

pleased with you.'"

<div align="center">†</div>

Joseph understands how overwhelming is the *desire* to obey our Blessed Mother. I am sure he will pray for our Holy Spirit to guide me in these writings so that through this book, more of God's Will is fulfilled.

<div align="center">♦♦♦♦</div>

Dear Brother in Christ, "Joseph, I go fourth to tell the truth. Should one ask me to do less than that which I am called to do? When I write it is evangelizing too. I leave your messages to the world for others to be hungry enough, and inspired by His Holy Spirit to hear."

<div align="center">♦♦♦</div>

If you are unable to visit the cross and wish for the messages Joseph has received for the world, please write:

At the Cross, Box 5224, Long Grove, IL 60047.

†

Heavenly Prince of all,
I thank You from my inner heart and soul.
You are my Savior for life eternal.
By our faith, by Your Word,
I know You are here with me.
When I am alone in silence,
I grow to know and feel Your Holy Presence,
For Your Light beams energy into me.
I pray, O Holy Spirit, that You will
pour graces upon me,
And mostly upon those
Who turn to me for help and ask for my prayers.
Pour out Your Mercy, God,
That I may be transformed
Into the person You meant for me to be.
May I be ever aware of Your Presence,
Your unmeasurable love for me.
Through Your Blood, wash me.
Through Your Mercy, separate me from sin.
Through Your precious Name, Jesus,
I pray, and know You hear.
Amen
(Little Olive Branch)

BY WAY OF THE CROSS, I was led through Blessed Mary to her Son, Gentle Risen Jesus, to a deeper conversion with my Savior.

Through Our Lady in Medjugorje

THIS NEXT CHAPTER IS a condensed logging (day by day.) Some events were so eventful that I have written them into total separate chapters that you will read further into this book after returning from Medjugorje.

Led to Medjugorje
Day by Day

H AVING ACCEPTED ALL CONFIRMATIONS that Our Blessed Mother was truly calling me to Medjugorje, I applied for my first passport. Bags were packed hurriedly in four hours. (Only after I had completed my assignment from an angel who visited me.) Did I have time to be concerned about what was ahead of me, and certainly did not take into consideration, that I was flying into a war zone. I was only feeling obedience to Our Lady calling.

◆◆◆

We gathered at Chicago O'Hare International Airport on March 28, 1993. I sat near visionary Joseph Reinholtz on the flight to Zurich, Switzerland, our first stop before flying on to Croatia.

†

En route, I showed Joseph, for the first time, the phenomena photos which God had given us, through our camera, at the cross. Next telling him of the angel's visit to me, and how I obeyed the angels assignment before leaving.

From Zurich, we were all anxious about what awaited us in the war zone of Croatia. Coming over the Adriatic Sea on March 29, we landed in Zagreb, Croatia, amidst tanks and soldiers. Smoke rose in the distance.

The view, as we flew over the Adriatic Sea and into Croatia, was geographically exciting. We landed at Zagreb airport, which was full of armed soldiers. Even going through to get our visas was a bit scary. None of us knew what to expect in this totally *irrational* war.

While in Zagreb, I had a chance to talk to a priest from Rome. I shared with him the visit of Our Lady at Hillside, Illinois, as well as telling him about the gift I received of the Holy Eucharist. Glancing, I saw the priest smile. Then, showing him phenomena photos, I told him about my witness of seeing Gentle Jesus and Blessed Mary at the Cross. His reply was, "This is great! This is really something!" I continued, *"One day, you will hear again of a visionary from Hillside, Illinois, outside Chicago. When you do, you will remember these gift photos from God and you will desire to hear the true words Our Lady is giving to priests through this man, Joseph Reinholtz. There he is. See how simple he is?"* I stated as I pointed over to Joseph. The priest feasted his eyes on Joseph standing near a post. (He was sizing

Joseph up.) I watched his eyes soften and he smiled softly at his new awareness. I, too, smiled, for I knew now this message would travel around Rome.

◆ ◆

Taking off from Zagreb was one welcomed event. Landing in Split, with its armed soldiers, you could feel great tension. Daydreaming, I thought: *"Why in the world was I convinced to come to a war zone? I would do this only for Blessed Mary. I will place my trust in her and in Divine Jesus. Why has she called me, through a dream, to meet visionary Joseph, and through him, to come here? This is almost insane. Or, is this a Divine plan?"*

◆ ◆

Our arrival into Split was not a joy. It was too frightening, with the presence of the military, and we were startled when guns were raised and we were all hustled away after we all heard a scream come from one of our women of the group. It turned out she was only excited to meet with an old friend from Medjugorje, from a prior visit. The military were serious and put fear in eleven of us. Being herded away quickly,

Upon our arrival in Split Croatia 3-28-93.

we settled into prayers together and asked everyone to control their enthusiasm.

The journey was long and the view would go from beautiful mountain peaks and valleys, to villages of shelled homes. The peasants, however, seemed unconcerned about our traveling through, and went about their hoeing in the garden or hanging out laundry on the clothesline. Men chatted at the edge of the road. Cars were half-way in ditches, burned and shelled. This gruesome scene is disturbing to us Americans, and we noticed children chasing each other in playful time as they ran up the steps of their shelled homes.

I was aware of snipers. We quietly held our prayers in as we went through the border. Then we would give relief and praise Our Lady for caring for us on our journey into Medjugorje.

At dusk, we arrived in Medjugorje village. The village was beautiful, serene, and quiet. Church bells from St. James' rang out several times a day. An entire village revolved around this holy Church. All business was devoted to religious items, suggesting that Our Lady of Medjugorje does appear here.

♦ ♦ ♦

The people of the village were happy people, always smiling and friendly. They are limited in sup-

plies, though they share so graciously. The children, like children everywhere, are happy when playing and chasing one another.

Croatian soldiers, as well as United Nations troops, filled the streets. Some

View of Medjugorje as we struggled up Mt. Podbrdo in Medjugorje.

refugees would speak and some would beg for help.

<div align="center">†</div>

The visionaries, ordinary citizens themselves, could be seen in church and driving through town. Almost anyone with a proper group guide could visit them. Some were even allowed to go into their homes. We were very privileged, because we were with visionary Joseph Reinholtz, who is a friend of Vicka Ivankovic, one of the Medjugorje visionaries.

We pilgrims were given a supper and some of us just returned to bed. We were exhausted and hungry upon our arrival.

<div align="center">†</div>

It was fifty degrees with no heat. This caused my legs to cramp and my spine to become very painful. I tried to keep warm with two pairs of socks, a flannel nightgown and my winter coat, a scarf on my head, two blankets, and still a bitter coldness would not allow me to sleep. I did not expect a suite, but I was surprised to be so inconvenienced and miserable.

♦ ♦ ♦

Day by Day

On Tuesday, March 30, 1993, in St. James' church, celebrated Mass was for us, in the quiet of this small chapel. Less than twenty pilgrims from the United States were in the group with Joseph Reinholtz, the visionary. He was at the left end of the altar. I was at the right end, close to the sacramentary (the book that contains the prayers of Mass.) Just before the consecration, Father made the Sign of the Cross asking blessing. *The Glow became brighter than ever and as wide as the altar itself, forming a pyramid of light.* As Father raised the Host and Chalice, I could see the brilliant Glow shine, spread wide, over Joseph's hands, folded at the altar, on the opposite side of the altar where I stood.

His Holy Spirit illuminating in light was almost to the level of my chest, and as I leaned against the altar, the light flowed over my hands. Again, tears of joy lightly streamed! Trickling tears of joy, for I could see our God was present! He was magnified in brilliance. No words could describe this *pyramid* of light. This light was softer than the light directly around the consecrated Host.

How beautiful it was to pray the rosary in a group, while wandering through the vineyard paths towards Vicka's home. As we prayed and sang, we were sisters and brothers in communion with Divine Jesus and Blessed Mary.

We could hear a rooster, then a cow and passed by sheep. We could hear peasants along the path, speaking Croatian. The birds were many in song. The air was fresh and cool. Dirt was freshly turned over for new seeding. Buds on trees and flowers were blooming. All seemed to be at peace within a village of godly people.

Then on occasion, reality hit—the sound of shelling in the distance. From the top of Mt. Krizevac, you could hear hand grenades exploding and see the smoke from the war in Mostar.

Below the mountain, about three miles out, I heard shelling and I saw the burst of flames as a bus was set on fire. The soldiers on guard checked it all out.

Why would Blessed Mary, our Mother, want me in this insane war? How could you not see the trauma around you? How could you walk away and not remember the faces of the refugees, and the sadness

299

in the faces of the mothers, whose sons were fighting somewhere?

We concluded this day with the rosary.

Those Who See Me

†

ON MARCH 31, 1993 the following words were revealed to us after the rosary by Joseph Reinholtz.

"Your presence is welcome here. Those who see me is God's gift to all of you. Have you converted this morning? If not, ask now."

Joseph continued, "(She) welcomes you in prayer. (She) is happy with us. (She) sends her love to all of you."

We just knew Blessed Mary was letting the others present know, that what I had told them about my seeing Our Lady was true. This message was a kindness of our Our Blessed Mother. Those of our group who were aware that I was witnessing Our Lady coming to Joseph were not surprised, and understood the affirmation of this message. I saw Blessed Mary often in Medjugorje, during the rosary group. During Joseph's apparition, she did not speak to me, but I could see her lips move as she spoke to Joseph, but I could not hear her.

♦♦

I remember one man named Guy, a prayer partner in prayer, who asked, "All right, 'fess up; is it you?"

Others near me were whispering, *"It's Carol."* Soon all knew. Some said that during apparitions my expression changed, and they called the coloring of my face *grace*. I was embarrassed others could see, as far as where I stood. From this day on, someone would always ask me, "Where was Our Lady standing? What was she wearing? What color was Blessed Mary's dress? Was she here the whole time?"

Then they would match my witness to Joseph's, who was across the room.

◆ ◆ ◆

When you are given the privilege to see Blessed Mary, you are drawn into her light, into her. Her love is her Son. She is so luminous, so beautiful. Her round eyes are pure blue, and her skin in nearly translucent. Her hair is very dark. When she is not wearing her veil beyond her head, such as her veil half-way back on her head, then the brilliant light that surrounds her leaves a cast of almost auburn touches to her dark hair on top. She wears various colors of clothing: white; white and blue; white edged with gold; gray; gold. She often wears a crown. It might be plain gold, or jeweled, or of different shapes. But sometimes brilliant stars, like diamonds, circle her head.

Her structure is frail. Her hands are graceful, with slender fingers and delicate knuckles. She is delicate and in perfect proportion. She wears no shoes, stand-

Led to Medjugorje

ing on a thick mist. Her beauty is beyond human description, for it comes from ***inner grace***.

Day by Day

The following morning was an especially good day for me. On this wonderful day of April 1, 1993, a prayer partner shared my experience of seeing again the Holy Sacramental Glow surrounding the Host and Chalice during Mass! Later we felt a sisterly bond as we climbed Mt. Podbrdo (Apparition Hill), while exchanging the miraculous experience.

<div align="center">†</div>

When we were more than halfway up Mt. Podbrdo, my prayer partner suddenly sat on a rock, while I continued up the mountain. (Later that day, she told me that she was sure she experienced a partial healing of her arthritic ankles.)

<div align="center">†</div>

As she stopped and sat for a rest, I forged and trotted up the rocks, often losing my balance.

Do Not Flinch For Our Angel Is Near

†

FARTHER UP APPARITION HILL, another pilgrim who traveled with us, met me as I struggled upward. She relieved me of some "luggage" I carried. She was unaware of my previous crippling and the difficulty in climbing this rocky hill.

†

As we searched for signs of a path through the rocky terrain, she asked, "You said before that you would tell me of your visit to Heaven. Will you tell me now?"

"Surely," I responded, *"let's sit on a rock while I tell you."*

We found large, "comfortable" rocks and I began the story of the event that happened to me in 1960, a story that I have told often.

†

As I began to speak, ***bees*** came at us...B U Z Z... Startled, she moved backwards. I knew instantly that something evil did not want me to share the truth of the great vision of Heaven. However, I remained on my rock and continued to tell of my death experience from double pneumonia.

304

<center>†</center>

Six bees landed on me. Four were on my hands and arms, one on my head, and one on the side of my face. I refused to flinch. I told her not to fear, even though the bees were like some horrible choir, buzzing their melody louder and faster as I spoke. When I stopped talking, they, too, became silent so that you could hear the breeze.

<center>†</center>

Once again, I began to tell of Heaven. The bees resumed their hideous serenade. When I raised my arm in emphasis, they clung to me. As the story came to an end, they chanted even louder, until my voice was raised to a yell. I finished the story. A moment of silence—and the bees flew away like sweet birds.

<center>♦♦</center>

I believe that my guardian angel, Bridget Bernadette, prevented these six bees from stinging me and causing me much pain. I know that I am under her constant vigilant protection:

> *For he orders his angels to protect you wherev-*
> *er you go. (Psalm 91: 11)*

<center>†</center>

She could not believe that I would just sit there with my Cross held high and talk above the bees.

<center>♦♦♦</center>

That evening before Mass, we were present in the

apparition loft of St. James' church. Our Blessed Mother came in an apparition before Ivan, one of the visionaries of Medjugorje. Her beauty left me humbled to kneel, and as I wept for all the people in war, for all the poverty; I wept for the sons in this war, for teens, for those who have left the Holy Sacrament, and I asked her to weep for my sons. Her holy presence was so warm and peaceful and fulfilling.

But I was sure she only showed herself to me quickly, that I was again to be a *witness*.

I was most delighted in her choosing me any time to see her.

As we departed from the loft, Ivan was upset and he stated that, Our Lady left us because she was annoyed by cameras, as people were more concerned about a photo (something for them), than the miracle of her presence in their hearts.

This was a hurtful lesson for those who were flashing cameras during the apparition.

<center>†</center>

Because I had pulled a ligament in the back of my knee on the mountain this day, it was difficult to climb the stairs to the loft and climb down.

Surely, the memory of this vision was worth any physical pain.

<center>♦ ♦ ♦</center>

Led to Medjugorje

It was April 2, 1993. We were seeing soldiers and refugees throughout the village, hearing shelling, and feeling the sadness of this war with the Serbians. We listened, too, to family fears and stories of death and separation from relatives–cruel, harsh lessons in compassion.

All this was nothing compared to what was to come later this same day.

♦ ♦

On my stroll to 9:00 a.m. Mass, I watched a beam of light streak from one side of the church to the other. I checked the windows, but none had a light that could account for the streak. During the consecration, I was again shown the usual vision of His Presence in light around the consecrated Host, and the flow of God's light that came up from out of the Chalice and flowed over! No words could describe seeing His Presence in Light or the enveloping of His Love for us.

♦ ♦

Two of us took the road as the others took the vineyard path in a rosary procession. Vicka was away. However, her mother, knowing Joseph, requested that he take everyone to visit this quaint private shrine in an upstairs bedroom. We were taken by the statue of

Vicka prays over Carol and Marie.

the Child Jesus on the bureau altar of Vicka's upper prayer room. Joseph would tell us of stories Vicka has shared with him.

♦ ♦ ♦

We left Vicka's house at about 11:00 a.m., and went up Apparition Hill, after stopping at a little gift shop below the hill.

†

People passed me by, and others stopped to chat during the climb.

He Drew Me In

†

MASS IS THE HIGHLIGHT of each morning in Medjugorje, followed by a planned trip up Mt. Podbrdo. On this April 3rd, I did not know why I felt so drawn to climb this day.

While sitting alone on a rock, I remained at the foot of the cross which overlooked the valley and vineyards and Mt. Krizevac nearby. Enjoying the splendor, the calm, the fragrance of the clean air, I was filled with tranquility and peace. I spent about an hour alone in prayer on Apparition Hill.

Then I heard Croatian voices as men, women, and children came up the hill, stopping at the cross. I began praying the rosary. Holding up my beads, motioning to one of the women to pray with me, she held up her rosary, and soon, all present joined in prayer, combining English and Croatian.

†

As we prayed, a brilliant light came forth from the cross. From inside this light came forth Divine Jesus, dressed in white, arms outstretched, head raised for

me to see. He drew me into His light, into His inner-most Super-Being, and I deeply loved Him. His light and mine were as one, as I basked in His holy Presence and love. In my sadness of His crucifixion, He made me feel better, when He showed Himself as the Risen Divine Jesus. He loves me this much, that He does not want my heart to hurt.

<div align="center">♦ ♦ ♦</div>

I knew He was pleased with the people, although He was imperceptible to them. I spoke out loudly: "Divine Jesus is with us," but no one understood my English. So I stayed, gazing at His glory! At times, the light was so dazzling, so illuminating, that I kept my eyes fixed on Divine Jesus. I would glance at the wooden cross and the sky, and then turn back to His Divine Presence before me. Each time, Jesus had remained for me to see and glorify! I was also test-ing. He gave me knowledge that this was only He!

<div align="center">†</div>

Just before Divine Jesus departed, the sky fell dark. A wind picked up and there was a quick shower.

Absorbed in His Divine Presence, I spoke to my Divine Jesus: *"I am one-hundred percent all Yours. I'm so deeply in love with You. You are my Salvation, my King, my Father. I adore*

Led to Medjugorje

You; take me with You. I hunger to be with You, always." I knelt in calmness, not feeling the rain or cold, until Divine Jesus left.

◆ ◆

Then the rain stopped. The sun shone again, while only the wooden cross remained. I had not noticed that the peasants had left with the rain.

◆ ◆ ◆

This was a most spiritual day with Gentle Jesus. I felt quiet for the remainder of the day. At 6:00 p.m. we all went to prayers and to Mass. Exhausted, I wanted to just curl up in my room and enjoy the presence of God in scripture.

◆ ◆

I was interrupted with the sound of distant shelling and at 11:00 p.m. and again at 12:00 p.m., I could hear more sniper shelling. However, I knew we were safe in Medjugorje.

◆ ◆ ◆

Day by Day

We climbed up Apparition Hill on this April 4, 1993. My leg was sore, so I used a

311

wooden stick as a staff. It helped me up part of the way, but I prayed to Jesus for help to come. I barely had made my request when three school boys came and helped me to the top, where we met many more children and a priest.

Marie Pimm in meditation.

After completing a rosary, Marie Pimm and I stayed for personal meditation until it began to sprinkle.

Returning down the rocks was like a slippery tub, and the wet clay was like a slippery bar of soap.

We strolled to St. James church. It was Palm Sunday.

♦ ♦ ♦

As I stood watching the procession with a peasant couple, an old peasant woman with clear eyes, handed me a portion of her olive branch to wave at the crowd. This generous gesture of hers moved me deeply. I kept the olive branch and brought it back home to Michigan with me. Later, you will read of the miraculous wonder of *my little olive branch.*

♦ ♦ ♦ ♦

Day by Day

On April 5, 1993, we had heat, lights and hot water! This was to be a nice day.

<center>✝</center>

After 10:00 a.m. Mass, we met at the home of Mirjana, one of the visionaries. She is so gracious and answered all our questions.

Joseph Reinholtz and Mirjana (one of the visionary's of Medjugorje) as she speaks in front of her home to us.

<center>✝</center>

Later, we visited a chapel in the village cemetery, where we joined a passion rosary.

<center>♦ ♦ ♦</center>

Sincere Passion

†

I FELT INTENSE PASSION while in Medjugorje.

On April 5, 1993, while our group was praying the first sorrowful mystery of the rosary, I empathized deeply with the grief of Blessed Mary. Then I received a vision of the scourging at the pillar. It was unlike anything I had ever imagined. The vision was so vivid, I felt close enough to touch. But then I was tugged or pushed backward.

I could see Divine Jesus tortured, sweaty, bloody. I saw Him beaten, whipped, spit upon, yelled at, stoned. I saw Him tied to a pole, wearing a crown of thorns so long that one pierced through His eyelid. I remember a bare hip–that leads me to believe that He may have been naked when tied to that pole. I watched each blow, and I ached as if a sword sliced through my own brain, and my own heart was pierced.

Looking back, I'm surprised that I did not suffer a heart attack and die on the spot, from the intense **heartbreak** of this passion.

Oh how Blessed Mary suffered as she watched her Child, and the pity she felt for those who hurt Him! At the cross, she called upon the Father and asked

314

Him to deliver Jesus. She knew full well that He was God's Son, so she raised her hands before the cross and said: *"Your will,"* letting go of Jesus.

<div align="center">†</div>

Forever will I remember that passion. My face and neck were soggy from the fountain of tears that flowed from me, while I was in this other state.

<div align="center">♦ ♦ ♦</div>

Later, we had a wonderful dinner of home cooked soup, home baked bread, chicken or beef, mashed potatoes, green leaf salad, fresh fruit, cake, wine and coffee. Our hosts shared all the supplies they received with the pilgrims.

<div align="center">♦ ♦ ♦</div>

In the evening, we were in church. Once again, Joseph arranged for us to go to the loft with Ivan Dragicevic for the apparition. This was a memorable experience.

Blessed Mary came! She was so beautiful. She was off to the right on a thick mist; she was full size, and the lower one-fourth of her figure was more silhouetted to my eyes. At one point, I lost sight of her. Then she allowed me to see her again!

Why is she letting me see her so often? Why am I being given this gift? What will Blessed Mary want of me?

<div align="center">♦ ♦</div>

Later in the day, a priest who spoke with me said, "You are probably being prepared." I laughed softly, for I have been hearing this sentence from other priests for years.

<center>†</center>

At prayer group time, I knew Blessed Mary would be coming to Joseph. On this evening, there was one priest, three nuns, and twenty-one prayer partners. After the apparition of Our Beautiful Mother, we were told, *"There is not much time left and soon she will not be coming. We must pray and fast for peace now."*

<center>♦ ♦ ♦ ♦</center>

I still have not read the messages of the other visionaries from Medjugorje, or any others. They say that there are more than six hundred visionaries around the world and that many are receiving similar messages. Also, the priest warned me that not all are true ones. I pray that our Father, the Pope, will be guided by Our Holy Spirit in the discernment of Our Lady's army of helpers.

<center>♦ ♦ ♦</center>

As my priest said, "Share with others your gift of the Eucharist." While sharing, one man from Australia, told me that he wanted to have a touching while in Medjugorje. I prayed very hard. Talking to Divine Jesus, I asked, "Please, Precious Jesus, I don't need all the gifts. Please share one with this hungry

man from Australia."

On the morning of April 6, 1993, he was with us in St. James Church. Before Mass began, I said to him, *"Do not look away when His Presence is raised by the priest. Keep looking at the Holy Host while saying over and over, 'My Lord, My God; My Lord, My God; My Lord, My God.' I ask You, Jesus, to give me this blessing from you."*

<div align="center">†</div>

I prayed for this man who had approached me, hungry for a touch from Jesus. I prayed for him to receive a spiritual healing.

<div align="center">♦♦</div>

During the Consecration at Mass, I was too much in awe of the brilliant glow I was being shown. I did not notice if the Australian was seeing the Presence of our God! I could not even think of looking away. But after Mass, he came up and hugged me, with tears pouring down his cheeks. His eyes were different, more pure, and he and I embraced in a communion of brotherhood and sisterhood in Christ, for he had received this same gift to see His Presence in light around the consecrated Host. God knew his need and gave him an extra touch. Although more blessings come to those who believe without seeing, Jesus understood.

After Mass, we strolled to the post office where I met a Croatian soldier, my cousin. Afterwards, we

went to the cafe and spent the time laughing.

◆ ◆ ◆

Later that mid-afternoon, I returned to church for 3:00 p.m. devotions, and visited for awhile in silence before returning to my room. Then, I was summoned to hurry to St. James Church to see a miraculous healing of Milenko, a soldier boy!

†

The church was filling up for 6:00 p.m. Mass and rosary.

†

Because it was a Tuesday, Joseph chose to not hold a prayer meeting. He continued in obedience to his Bishop, even while in Medjugorje.

◆ ◆ ◆

Day by Day

By April 7, 1993, I could not imagine what else might happen.

Jesus gave us such surprises in Medjugorje.

Each day seemed to give us a personal reward from Gentle Jesus and Sweet Mother Mary.

◆ ◆ ◆

At Mass, God revealed again, His Presence in

318

Light around the Holy Eucharist. It left me quiet and joyful.

◆ ◆ ◆

After Mass, we wandered near a cafe. I visited with my cousin, Kojel, a soldier. He said they must be on the front line by 6:00 a.m.

Then, I later walked over to a bench in the court-yard. About thirty soldiers found me, and asked me to pray over them.

†

About 4:00 p.m. more than 200 soldiers came. Most lining up for Confession.

†

I filmed the trucks and jeeps as they pulled away. My own relative left with them. I thought I may never see cousin Kojel's beautiful eyes again.

◆ ◆ ◆

Day by Day

There was a crispness in the air on April 9, 1993. As the sun came up, it peeked in and out around the clouds. We all gathered at St. James courtyard for a bus to take us to Listica, Croatia (a town about one hour from Medjugorje.)

319

This was a most rewarding morning to go before Father Jozo, a most holy Franciscan priest. (He is the priest who was the children's pastor when the visions first began at Medjugorje in 1981. He went to prison in defense of the children's' visions.)

†

Gathering in church, we attended Mass. During his sermon, he held his crucifix up and during moments, it would turn to total gold! (I and others saw his cross turn to a light gold.) One of the pilgrims of our group, Marie Pimm, took a photograph just as Father Jozo was calling down

Listica, Bosnia, Father Jozo is calling down Our Holy Spirit.

Our Holy Spirit. (A video at the time also shows Father and the people.) When Marie Pimm had her film developed, she was startled by the gift God gave her. The photograph showed the Holy Spirit filtered in misty light above the people!)

(All other photographs before and after were normal on the negative.)

†

The healing prayers by Father Jozo, and two other attending priests after the service, left hundreds

resting in His Holy Spirit on the floor of the church, including myself!

<center>†</center>

Although we could see smoke rising beyond the mountain, our ride back to Medjugorje was beautiful. We became one family in a rosary.

<center>†</center>

Returning to Medjugorje safely, we joined in Holy Mass at 3:00 p.m. back at St. James Church. Since it was Holy Thursday, the focus was on the Holy Eucharist.

<center>♦♦</center>

I spent the remainder of my day in my favorite place, the vineyards, until supper, and then shared with the others while waiting for prayer time with Joseph.

<center>♦♦♦</center>

Early on Good Friday, at 6:15 a.m. the walk from the house to Mt Krizevac was one and a half miles. The climb up the rocky mountain was excruciating. I intended to stay into the night and possibly overnight, once on top. This might not seem difficult to some, but for me, with my physical limitations, weak legs, severe leg cramps, a painful spine, a heart condition for which

I took nitroglycerin, I was setting out for an adventure much earlier than the others.

I searched for two sticks from the woodpile, listened to the roosters crowing, and filled my lungs with fresh air. I started down the muddy road with my duffel bag containing a statue of Mary, holy water, a blanket wrap, a "fanny pack" at my waist, my video camera, and the two sticks.

<div align="center">†</div>

When I reached the foot of Mt. Krizevac, I looked up, seeing grass, but not the rocky terrain ahead.

After the second station of the cross, I was already in so much pain that I could not sit on a rock or breathe in and out. (30° temperatures did not help.) I had no warm boots, only tennis shoes. I wore a sweater coat and no gloves.

By the third station of the cross, I did not know if I should continue up the mountain, but I wanted to offer the suffering for my brother, who also has multiple sclerosis, with faith in God's will that he might walk again. This gave me courage to go on. When my knees buckled, I sat on a nearby rock. Each station in prayer gave my soul and body rest.

<div align="center">♦ ♦ ♦ ♦</div>

He Sent Me Help

†

AT THE FOURTH STATION, I asked my guardian angel and Blessed Mary, my Mother, for someone to come by and help me. I went along a few more rocks. By now I was crawling over the rocks, dragging my legs so as not to put pressure on my legs or spine.

†

Gentle Jesus sent me help. Along came a Bulgarian refugee boy who had lived in Sarajevo. He fled from Sarajevo to Mostar, and then to Medjugorje. He told me that his parents in Sarajevo were dead, and his sister had been killed in Mostar. He sobbed as he spoke. Philip was a living angel for me. He took my duffel bag and video camera, which weighed about fifteen pounds, and he *guided* me up the remainder of the rocky mountain!

At the remaining stations, Philip would set down my duffel bag and camera and climb up to the "station rock" (a rock with a carved scene from the sorrowful crucifixion of Jesus, true *reminders* of what Jesus suffered for us).

323

Philip kissed each station, knelt on the rocks, and prayed with me a decade of the Rosary. We would sit with the sun coming up and warming us. I began to shed clothing, which meant more to carry. At one point I was crawling over some high rocks still slippery with dew, as Philip helped another woman's daughter who used two crutches. I grabbed a tree trunk to keep myself from falling, staying on this spot until some of the cramps in my legs departed and the pain in my left arm eased.

I reached the eighth station, and made a bed of the rocks and stones to rest while I waited for Philip, who was still behind with my belongings. I could hear the woman talking. Soon they caught up and then we all said a decade of the rosary. Philip went ahead to find the easiest pathway across the rocks. In all my years of being crippled, I have never tried such an insane venture. (I had stopped using my cane by October of 1992 and now I felt my heart was healthier.) I was sure I had the strength until I tried it.

†

By now, Philip was helping the other two women, while still carrying my fifteen pound pack.

I walked, climbed, and crawled my way to the tenth station.

Near the top, I spotted a *real* path, straighter and with fewer rocks. I could see the cross by now. I could hear groups below, chanting the Rosary and

singing. They were from Ireland. As I made my way to the top of the mountain, before the cross, each step upward for the next sixty feet was pure torture.

<div align="center">†</div>

At the cross, I walked to the side and saw two soldiers. I moved slowly to a tree, asking our Blessed Mother to protect me. I could see smoke from a distance. I felt uneasy.

Others came up, singing and puffing and searching for a spot to claim as their inch for the morning. I placed my statue into a tree trunk and making a grotto, set my sticks in a "V" form and placed my fold up stool inside the "V." I shared with Philip water, an apple, and some bread. I gave him two dollars in Croatian money for helping, and soon he went back down with another refugee. I remained to meditate and wait this Good Friday out.

Many came over and shared the grotto, kneeling and chanting their rosaries in all languages.

After two hours, I could hear much shelling and loud booms in the distance. We looked in the direction of Mostar and saw smoke. A chill—more than the cold on top of the mountain—overtook me. The thought of those who, right now, were being murdered and burned out of their homes, hurt me deeply. I prayed one peace rosary after another.

With the biting cold and the windy day, my chilled

body was wrenched in pain. The cold wind caused constant cramping in my legs and I shook beyond normal. At noon, crowds of people came to the cross at the top of Mt. Krizevac. I filmed much of the spiritual events of each group that came for prayer time and holy hour.

<p style="text-align:center">♦ ♦</p>

A great following came up with Father Pinto, (known as the "soul-reading priest") from New Mexico.

<p style="text-align:center">♦ ♦ ♦</p>

A Canadian man and his daughter were making a television documentary. They had been in many of the war-torn villages, experienced the bombings and interviewed many who came to the center of the war. They said that the United States and Canada, are not telling the total truth about the war.

<p style="text-align:center">†</p>

Later in the afternoon, only six persons remained when I heard mortaring to the southwest of the mountain. As I quickly trained my video camera down the mountain side, I saw a bus burst into flame. The soldiers hurriedly made their way down the mountain side. Soon word spread that a bus coming into Medjugorje had been shelled, and all the people burned. I zoomed my video lens to take in all I could, while praying for the souls of those below.

326

Within a half an hour, there were loud bangs and smoke coming from the direction of Mostar. I was to *know* and *feel* the war and the suffering. Refugees huddled under brush on top of the mountain, while a soldier stood guard.

†

Father Jozo, made his way up to talk with the soldiers. I asked for his blessing again. The presence of holiness radiates from him.

†

Thirty feet away, a peasant woman chanted and cried painfully. The cold wind whispered death. This was not at all what I had seen on television news before coming here. When I returned to the States, I was upset with the *distorted* details given by the newscasters.

†

Before pitch dark settled, I huddled behind the Cross, praying, trying to block the cold wind. I realized that I might not be able to climb down the mountain without falling. I had spent the day praying; now it was time to stop and listen. Inside myself, I heard, **"Use common sense and go down now."** After all, I had only hung up my canes one month before coming.

†

I gave up my hopes of staying the night on Mt. Krizevac and prepared for my trip down. I stumbled

twice on the rocks, fell once, picked up myself and my belongings, and up I struggled again.

<div align="center">†</div>

A drizzle began and soon the rocks were even more slippery. I asked Our Lady of Medjugorje to help me, send me a human angel to help me down. Just then an English couple came by. The wife took my heavy duffel bag. Her husband helped me. He talked of miracles in England and Ireland and of people and visionaries of whom I've never heard. I told him of Joseph of Hillside, Illinois.

Near the bottom of the mountain, we came across my companions going up the mountain. Our Lady was to appear to pilgrims, Vicka and Ivan at 11:00 p.m. on top of Mt. Krizevac. There very well could

be miracles, but I felt even more certain that down off the mountain was where Mary wanted me most.

Before apparition the Cross on Mt. Krizevac lit up & spun around. This was seen by thousands of people.

<div align="center">♦ ♦</div>

Later the cross atop Mt. Krizevac could be seen by all across the village, as it lit up and spun. Amazing? You bet! This solid concrete cross is ***impossible*** to move. It is stone grey in color, but that night it looked

328

brighter than a neon sign! I'll be glad to share photos of this miracle with anyone!

◆ ◆ ◆ ◆

Day by Day

On April 10, 1993, I was exhausted, having been up nearly all night with spasms created in my body from the intense climb and freezing cold. Though I was not about to miss Mass and the many wonders that could occur during another day in Medjugorje, I made my way to St. James Church.

We met the woman who translated the message Vicka and Ivan received from Our Lady the previous night. I followed the instructions given by Our Lady. Chosen by God to witness Ivan's apparition, I believed he had been given these instructions. I did not feel the church or any bishop had to give me permission to believe before I obeyed God's request. Even if a bishop was unable to believe the visitations, still, I would listen to a message through Ivan. If my own spiritual director would say, "Do not go here" or "Do not go there," I would obey. But no one can stop us from our free choice of thinking for ourselves, or believing or not believing a message. Discernment is a grace from God.

I spent most of the day praying over soldiers. In the last hour in the vineyards, I sat in prayer.

◆ ◆

In the evening, after witnessing once again the gift of seeing Our Lady speaking to Joseph during an apparition, I retired to bed.

◆ ◆ ◆

Day by Day

On Paschal morning, April 11, 1993, I was up with the chickens. It was cold, rainy, and dark. I carried my crucifix with me to Mass to have it blessed.

In compassion, I have often laid hands on the afflicted, feeling their pain. Jesus, hearing my cry, often showers them with His Mercy and Healing.

◆ ◆

This Paschal morning I was asked to pray over three people before Mass. One woman walked with either her crutches or canes, for six years after an auto accident. She handed her two canes to her sister, as God showed His Mercy to her in total healing that morning. Praise to Jesus, only!

✝

Laying my hands upon another person, I was feeling itchy. The heat in my hand became very hot against her hip, and she, too, walked after Jesus' healing care, and carried her cane away with her. Praise Jesus. I'm sure she will forever remember her healing in Medjugorje by Our Lady's intercession.

<div align="center">†</div>

The third person was a man, weeping. I placed my hands to his head, but my hands were *led* to his neck and center back. My hand was warmer, until it went up the back of his head. There the heat was so hot, that I felt it between his head and my face as I prayed and hurt for him. Moving my hands back to his forehead, I saw flashing lights and everything became white. Lifting his chin, I looked into his eyes. They had become soft and he even cracked a smile as joyous tears flowed. His face showed he was at peace. Jesus' Mercy flowed once again!

<div align="center">†</div>

Later, I was told by someone from his group, that he had a tumor and was in severe pain before coming to Medjugorje. He came, hoping for a cure. This man stated, "He has had no headache for two days now, and is anxious to get back and be retested to see if he is cured."

<div align="center">†</div>

While in a mission field for Jesus, we seldom get names, so often I do not receive the results of God's

331

timing in healing. Because I did not know him, I have no way of knowing the results. However, I have seen quick flashes of his peaceful face twice during my prayer time.

◆ ◆ ◆

Back at the host's home, at 12:40 p.m., we were served colored Easter eggs with lunch and a few candies. Our host tried to give us an American Easter.

†

At 3:00, we said the Divine Mercy prayers at St. James Church.

Then, we were told by a holy priest: ***"One* who is possessed is among you."** I was startled by this announcement. I glanced to see who among us had horns. Well, I saw none. So, I continued to feel uneasy and prayed to St. Michael for protection.

Later, I heard how one woman was singled out, prayed over, and asked to leave the town. Months later I heard a distorted rumor that fifty false visionaries had been sent away at Easter. I laughed at how it had gone from one to *fifty*. We who were there knew of only one asked to leave.

Nearly two weeks had passed since our arrival in Medjugorje. Only one week

As we strolled, I backed up to take a picture of Father Ken Roberts and visionary Joseph Reinholtz.

Led to Medjugorje

was left to enjoy tranquility in the vineyards; peace along the mountain paths; the love of the villagers; and the greatest sermons one could ever hear. (Including a wonderful homily given by Father Ken Roberts.)

♦ ♦ ♦

A special wedding took place at 4:30 p.m. Paschal Sunday, the wedding of Jakov Colo, one of the Medjugorje visionaries. Many relatives and friends from Italy, Yugoslavia, and America attended.

The town was full of Croatian soldiers, army trucks, and United Nations jeeps. There were American dignitaries sent by our president, as well as many pilgrim groups.

†

We strolled through the vineyards paths to Apparition Hill, followed by a prayerful stroll back to our rooms.

Medjugorje is a laid back and restful time zone.

*In Medjugorje, women labor
while tranquility of old ways &
new ways mix peacefully.*

333

Day by Day

On April 12, 1993, I was aided by a priest who asked, again, "Do you know why Our Blessed Mother wanted you here, Carol?"

I replied, "No, Father, I'm not totally sure, though I'm working out some questions I've had with God."

♦♦

This was a lonely day for me, for our spiritual director of the pilgrimage, and my new sister in Christ friend, Shirley, parted early for Split to go back to the United States.

✝

I roamed the courtyard in front of St. James church and then took my bench for two hours as soldiers came over to be prayed on.

✝

Now that the Easter was behind, the village was becoming much quieter. Pilgrims were leaving daily.

♦♦

One week in Medjugorje is perfect. Two weeks, without a feast day, is restful and a most spiritual time. Three weeks is too long for me. The feeling of never wanting to return was increasing.

At 1:30 a.m. in the morning and again at about 2:15 a.m., I was awakened by loud shelling and planes overhead. Looking out the window, I watched as traffic picked up during the middle of the night. Although you would expect fear to keep me awake, I trusted in Blessed Mother of Medjugorje's care and went back to sleep, safe in Our Mother's gentle love near me.

On Tuesday morning, April 13, 1993, I found myself determined to spend my day in surrender to Jesus and spend hours in the grape vineyards, reading scripture and meditating.

†

After 11 a.m. I made my way through the village, to the post office, and back to the St. James courtyard, to the bench I had been requested to sit on by a priest. I had not noticed soldiers about the village until the first three came up, saying, "Kogel cousin?" I responded yes. Language barriers prevented us from having a good conversation. They would kneel before me, or lift my hand and place it to their body. Through this gesture, I knew they were asking me to pray over them.

†

Soon, four more soldiers came, then a group, and

soon, many arrived. I watched as several did go over to the confessional where I had pointed for them to go after I prayed upon them. Watching as several military vehicles and trucks left Medjugorje in convoy, I sent prayers with them, that all my soldier boys would be safe.

◆ ◆

The remainder of this day, I visited the Blessed Sacrament and prayed before a shrine of Our Lady in the church before Divine Mercy devotions began at 3:00 p.m. each day.

◆ ◆

Being somewhat tired, I returned to my room to rest, only as I was about to enter into the doorway of the bathroom, I had a confrontation with a creature between the bed and the door. The ugly creature had returned and his gurgle was frightening. However, I was so angry that he could dare to visit me. I threw holy water at this creature. I called Our Holy Spirit upon me, saying, *"Begone with you, satan. Jesus, Jesus, Jesus!"*

When I opened my eyes again (due to a peace I was overflowing with), I saw Jesus' face before me in a vision. The creature was gone.

I read scripture until I fell asleep.

Peacefulness filled the room and flowed over me. I fell into a wonderful story in my bible and was fulfilled by His Word. My Holy Spirit lifted me in faith

and my whole being was at peace. I have never had, in my entire life, dealt with something so horrid. Pray for me that I never do again. I do know, however, that my Jesus will carry me through.

♦ ♦ ♦

Day by Day

After Mass on April 14, 1993, and receiving Our Savior Jesus in the Eucharist, I stayed for an hour to just quietly come in tune with Jesus for a new day.

Strolling to a telephone, I tried to call Bob back in the states; I missed him and the children very much.

♦ ♦

Going to my room after supper, I had a second bout with the creature. I became angry at the sight of this *thing*. I hurriedly picked up my Bible and began to read scripture. I flicked holy water about my room and holding my cross tightly to my heart, I focused only on *His Holy Word*.

I heard hissing and a gurgle. Refusing to give it any attention, I said, *"Begone with you, satan, in the Name of my Savior, Jesus, Jesus, Jesus, Jesus. I love Jesus, I trust in You,"* over and over, until the creature went into the bathroom and I never saw it again.

♦ ♦ ♦

I went down to the living room. One of my companions, Richard listened to the news, and was concerned about the trip back through Split. Snipers were as close as five miles from Medjugorje, scattered throughout the mountains and villages. We were feeling unsettled.

It was almost our prayer group time, and for visionary, Joseph Reinholtz', apparition time. Our Blessed Mary arrived! Because she **knew** that Richard and I had allowed fear to enter into our minds, Our Blessed Mother, in her motherly love, gave us peace. In part of her message to Joseph, she said, ***"Do Not Be Afraid. I Am With You."*** Richard and I were assured that the message was in answer to our fears about the news, although there may have been more than us who were becoming fearful of the war. Richard's wife, Rocelia held her faith that Our Blessed Mother would never let anything happen to us who obeyed her calling.

<div align="center">†</div>

Strolling back to church courtyard, I was with a fifteen year old refugee boy until late into the night. He had no coat, so I bargained with a taxi driver for his coat in the back window. We went over and ate at an outdoor cafe. He clung tightly to my purple sweater-coat. In church, he would stand so close, his arm touching mine. I was like an adopted mama for him. It was so painful to leave these refugee children

behind. Still later this night, I waited in line at the confessionals for three hours, just to be able to go before Father Pavich. This dear priest stayed on into the night until the very last soul had been heard and granted absolution.

Outside confessionals a peasant woman & Father Slavko visit.

<div align="center">†</div>

Our Church teaches that the Apostles passed on to their successors, the bishops, and the bishop's collaborators, the priests, the power to forgive sins that Jesus gave to them on the night of His Resurrection when He said, in John 21: 22-23:

> *"Receive the Holy Spirit. If you forgive anyone's sins, they are forgiven. If you refuse to forgive them, they are unforgiven." (John 21: 22-23)*

I began to feel a lot of inner peace. I began to reflect on the doors that I had closed and made peace with feelings of those who had been cruel to me in life. Forgiving them brought me even closer in love to Our Holy Trinity.

339

Day by Day

We wandered around after Mass on April 15, 1993, and finally I came upon a peasant who spoke of the history of Croatia and of the customs of today. This helped me to understand the reasoning of what seemed to be a senseless war. Americans would go to war for less than the reasons they were teaching me.

†

Today, I also spoke with two Muslim women, and later, a Muslim husband. Only one of the women knew broken English, but I was able to understand them. Their history differed from the Catholics, but most interesting was the teaching of their culture. They are modest and protective. Although they are not Christians, they do adore God, have respect for Mary and know of a Spirit. They showed me a book, the Koran, which I will read with an open mind at another time. I want to understand and respect all my brothers and sisters. One of the Muslim women let me hug her. I bought some crochet doilies from them and waved good-bye to their children.

†

After two hours, I returned to my room for prayer and later spent two more hours with a male Croatian as he explained his view of the war.

♦ ♦

340

We gathered for the rosary with Joseph at night, but tonight, I did not see Our Lady. Also, the message was only for Joseph.

Day by Day

Shopping after Mass on April 16, 1993, for the last little gifts for my grandchildren.

<div align="center">†</div>

How beautiful it was to pray the rosary in a group, while wandering through the vineyard paths towards Vicka's home. As we prayed and sang, we were sisters and brothers in communion with Divine Jesus and Blessed Mary.

We could hear a rooster, then a cow mooed, giving us the giggles. We could hear peasants along the path speaking Croatian. The birds were many in song. The air was fresh and cool. Dirt was freshly turned over for new seeding, and buds on trees and flowers were blooming for this Paschal season. All seemed to be at peace within a village of godly people.

<div align="center">♦ ♦</div>

Medjugorje has little to do with visionaries, although they are nice persons, and they are my sisters and brothers in Christ. They are *not* what drew me to Medjugorje. Our Lady called me in a vision within a dream. *God's lead*—these are the reasons I made this dangerous trip. And only a fool would say that there was no danger! I believe that we all were protected by Divine Jesus and Blessed Mother.

<div align="center">†</div>

Who needs visionaries? Only those who are lost souls. Who has to believe in them? No one. It's really okay not to believe, but if you are not yet perfect in God's eyes, *you could miss a needed message.* You see, it is not the messenger who is important. It is the message direct from heaven which we need to alert our souls.

<div align="center">†</div>

Tonight, I shivered and was up and down with leg spasms. At one point, I felt as though my blanket had been moved. I felt a soft pat and a warm breeze caress my cheek. I did not know who, in spirit, might be near me, but surely someone peaceful was giving me love. For some reason, I felt a closeness of Grandma Barbara.

Up at five a.m. on April 17th, hearing the chickens and its a great hour to wander in the cool morning air, reading all my daily prayers and getting my rosary in before Our Lady's shrine at St. James Church.

†

While sitting on the patio and visiting with Sandra, the wife of our guide, we then spent most of the afternoon in rest. We visited among the other pilgrims, exchanging events of the trip. Later, I began some packing. Then we all made sure we were at St. James Church at 3:00 p.m. for the Divine Mercy chaplet hour.

†

We heard on the streets how nuns and priests had been captured by the Muslims.

♦ ♦

After evening Mass and rosary, we returned to the house about eight p.m. for prayer led by Joseph. Our Lady came and tonight, others joined in prayer, and then hoped to receive Joseph's blessing.

†

We gathered to go to Benediction Vigil at the chapel. This is a most soul-lifting experience, with young and old singing and sharing in two hours of prayer.

343

Day by Day

Always Sunday is a lovely day, and today, April 18th, is no exception. Off to 10:00 a.m. Mass and an unforgettable chicken dinner by the host!

<center>†</center>

I could still hear mortar fire just miles away. I was not pleased that it seemed to come from the direction we would be taking back to Split.

<center>†</center>

The Paschal pilgrims have nearly all left, and the stillness of the village is awesome.

<center>†</center>

Walking in the evening air and watching the dancing stars, I was saddened to say good-bye to Medjugorje. I felt sorry for those Croatians who had waited three months for supplies only to receive three bags of sugar and one bottle of olive oil. They were saddened as they had expectations of more.

We stood by as Caritas trucks and military trucks moved in and out of Medjugorje.

Upon returning to our pilgrim home, there was no electricity, hot water or heat. My bedroom felt like an attic in winter back home in Michigan. Although it was fifty-two degrees before the rain began, it dropped to 30° by supper.

<center>†</center>

The war was as close as five miles away on one side of the village, and twelve miles away on the other. Still, we all felt safe in Our Lady's protective care within the boundaries of Medjugorje village on this day.

<div align="center">♦ ♦ ♦</div>

Day by Day

When we began our return trip home on April 19th, I tried to find encouragement in our Mother Mary's message. But now I also knew *why* I had been called to Medjugorje, understanding the knowledge I was to take back with me. At 1:30 a.m. we packed, and at 2:00 a.m., we boarded a bus and left for Split.

<div align="center">†</div>

We had a 50 minute wait in Split, before flying back across enemy territory to Zagreb, Croatia. I could see from the plane a fierce fire below, and knew the Serbs were not honoring a cease fire. We all felt fear of being shot down and prayed fervently for one another. (I began to feel safe once we were over Paris!) After a 60 minute layover in Zagreb, we flew on to Switzerland.

<div align="center">†</div>

345

Sitting in the airport terminals, waiting for sirens to signal missile or hand grenade attacks, was not being a scaredy cat, but was facing **reality**, knowing that only God's comforting Hand could guide us safely. Some of our group wandered off the airport grounds to look around and to shop. I felt that this was foolish and turned down their invitation to join them. But then I have heard that God protects the foolish, too.

The stern faces of customs officials were enough for me. My bags were sent three times through a security scan and the items tossed about. Whatever they thought they saw, must have been hidden well, especially all the gifts we had blessed.

Among the items, unknown to us at the time, was the wonder of my *miraculous little olive branch*, hidden in a sack that slipped through customs. Other items slipped through as well were the blessed oils, salt, a peace chaplet, along with my little soldier boy cross!

<div align="center">†</div>

Most of all, I would take back lessons and words from Our Lady.

<div align="center">†</div>

My calling from Our Lady to Medjugorje was now behind me. At least for now.

<div align="center">♦ ♦ ♦ ♦</div>

Conclusion of Day By Day

†

SUMMING UP OUR LADY'S call for me to come to Medjugorje, I noticed:

- A conversion of my soul which was deeper;
- A surrender of my will to Jesus' Divine Will was more trusting;
- A continuing of the blending of my natural will with His plan;
- Each hour I gave to Him was to increase His life in me.

♦ ♦

Blessed Mother assigned me the task to be one of the generals of her army. Divine Jesus gave me gifts necessary to share His Divine Mercy and peace.

♦ ♦

My flight home was a time of recollection, knowing "everything was understood." Gentle Jesus' compassion in me rose high. The love in me for all people of the world compelled me to lead others to prayer, confession and to bring all God's children to the Holy Eucharist.

♦ ♦ ♦

Jesus' compassion in me was now leading my heart

to spread the peace chaplet, as well as the Divine Mercy chaplet.

†

With God's peace, and a desire to spend much time helping others to make peace in their families and among their friends and co-workers, my days ahead would be filled with counseling.

†

Being in Our Lady's army, I knew the greatest weapon of war is the tool of the rosary. Prayer groups are essential to this battle.

♦ ♦

There is a need for the peace and unity of all, especially the unity of love and understanding between faiths. God did not divide His simple Church.

†

If I accomplish nothing more in life than to embrace all of God's faiths, all my brothers and sisters in the world, then so be it. God expects us to *hear, see and help* all who ask for help. Even if they do not ask, we must never pass them by without seeing, without reaching out.

†

Would I pass by a bird whose wing is barely fluttering? Then why would I pass by my brother or sister and not see they need T.L.C., too:

♦ ♦ ♦

With all the attention God is calling to Medjugorje with His Mother's visits, with His visits, with wonders in the sky and unexplainable phenomena, as well as the thousands of conversions in the confessionals–why do some still think that it is all a hoax? God permits thousands to see these miracles to strenghten convictions that He exists.

<p style="text-align:center;">†</p>

The greatest gift you will be given in Medjugorje is the joy when another receives.

<p style="text-align:center;">♦♦</p>

I am expecting my return home to be a great welcome from my holy and sweet husband. My children, I hope, will ask to hear! Many of my friends will await news of the messages.

I witnessed the apparitions for Ivan Dragicevic, and for Joseph Reinholtz, but I could not hear Our Lady speak to them. Therefore, I had few messages to take back from Medjugorje.

Nevertheless, my one message to all is:

"I can tell you this: the apparitions of Medjugorje, Croatia, and of Hillside, Illinois are true."

In this testimony, I rest my soul.

<p style="text-align:center;">♦♦♦</p>

The following chapters are unique stories of events I want to share with you. Each deserving of their own titles.

- *Gold & Its Significance*
- *Today's Angel*
- *Olive Branch*
- *Soldier Boys in Bosnia.*

Gold and Its Significance

M Y FIRST ENCOUNTER WITH gold my have been the thin gold band of my Mother's wedding ring.

The second was in 1948 when my eyes caught the brilliance of gold as the tabernacle doors opened and a illuminating light shown so brightly from the interior that the gold ciborium nearly disappeared from view. Then the doors closed again.

My third encounter with gold was in 1960, during my visit to Heaven. Gold edged a radiant woman's blue veil, while supernatural bodies were adorned in gold, and the man who spoke to me held a **gold staff** in his hand.

Most recently, in March 1993, **a fine layer of yellow gold** was found upon my inexpensive blue plastic St. Ann Novena chaplet beads. I took this as a sign that Our Blessed Lady was calling me to Medjugorje during Easter for a definite reason. In Medjugorje, all my rosaries turned gold, including some of those belonging to other people that I brought along for special blessing. Silver medals turned yellow gold, some completely, some partially,

as well as chains and the silver corpus of a crucifix which also turned yellow gold. And the miraculous wonder of Our Lady continues here at home; after only a few prayers, the links or the beads of my rosaries will turn gold. I give these rosaries to those who convert. I am convinced Our Lady is calling all who have gold to more and more prayer time.

A special golden moment in Medjugorje stands out in my memory. One afternoon, I laid hands on and prayed for a wounded soldier. Afterwards, deeply moved with compassion for all those involved in this terrible war in Bosnia, I stopped and purchased a silver and brown Peace Chaplet Rosary. I held my chaplet in my right fist; in my left was a crucifix given to me by "my" soldier boy. With tears streaming down my face, I pleaded intensely for conversion and an end to the war. Upon the second Our Father, the links of my chaplet rosary instantly turned gold before my eyes as others nearby watched. I knew then that I was being called by Blessed Mary to pray for more peace and to spread this message.

<div align="center">†</div>

The theme of gold is to be found even in photos. This miracle took place in a Chicago suburb while I was still en route from Bosnia to the United States. My precious husband, Bob, who was to meet our plane at Chicago O'Hare International Airport, stopped off at Hillside, Illinois at Queen of Heaven

Gold & Its Significance

Cemetery, the place of the cross where Divine Jesus and Blessed Mary have been sighted. St. Michael and the angels "visit" daily (except Tuesdays) with visionary Joseph Reinholtz. On this particular day, Joseph was with me on a plane, accompanied by fellow pilgrims. We were flying through a terrible storm.

Bob Ross, my spouse.

Bob was coming from Michigan and decided to make a detour at Hillside. He was alone for a while at the Cross. A few cars pulled up but the occupants preferred to pray their rosaries inside their vehicles, out of the storm. Bob, on the other hand, prayed at the Cross, sheltered by his umbrella. My usually level-headed husband was determined to perform this extra penance even though it was lightning at the time. He had nearly finished his rosary when a couple came up to him and the woman said, "Do you see Jesus bleeding?" Bob looked in amazement at the corpus of the Cross above him. He wanted to touch the blood but he is only 5′5″ and could only reach the feet of Our Savior. The woman, Connie continued, "This is meant for you; you were alone when Jesus started bleeding. This is a message to you." Whereupon Bob grabbed his camera and took a few shots in the downpour.

353

Before leaving he placed one rose at the foot of the corpus and touched the blood with another rose to give me.

†

Later, when Bob met us at O'Hare Airport, after handing me the rose, he was eager to tell us over and over in his excitement, what had happened.

†

Bob wondered if his pictures would turn out because of the dark day and the rain. I said, *"Honey,*

Bob Ross witnesses the corpus bleeding on the Cross at Hillside.

Jesus will give you only what He wants you to have." A few days later, we received the developed photos. Another miracle! The blood streaks showed up on the corpus, which had also photographed as if it were gold in color and not it's usual being-gray. The photo was of a gold corpus with a gold crown and a gold-tinged blood.

I was filled with joy for Bob. *"Oh, Bob, Jesus is calling you; He is telling you that He heard your rosary and that He is with you, too. The gold represents His Kingdom; it calls: 'Believe' and it welcomes you. Jesus wants you to believe in the mes-*

sages He and His Mother are giving Joseph at this Cross. This is your sign, Bob. Share this wonderful gift you have received."

Bob and I are on a spiritual journey, that was planned long ago by God.

<div align="center">†</div>

Though I am gifted with many heavenly gifts, Bob also is receiving his *full share of the gold.*

<div align="center">♦ ♦ ♦</div>

Returning to the Hillside Cross with pilgrims on a stormy day, Kathy Hale and her mother Bev, two from our group were chosen by Our Blessed Mother along with others. Our Blessed Mother asked a favor of them after the prayer meeting at the cross so we took a slow drive around the Holy grounds, as for some who see this cemetery have since decided to rest their one day. We were passing a shrine of Christ the King, though still drizzling and cloudy, Kathy (somewhat handicapped), leaped out of the van in hopes to take a photo of the majestic statue. Upon returning home and her photos developed, Kathy was disappointed that God had not given her a gift photo to with which she could minister with. Kathy shared the photos she took with others, when one friend, Marty Miller looked at her photos he said, "Kathy you have one here! I believe the statue is silver." Kathy upon hearing this, was sure God would not really choose to give her such

a gift. She was sure the gold statue in her photo was the actual color.

Marty stated to Kathy "Why don't you call Carol, she would know."

Jesus stated "This is Holy Ground." Kathy Hale of Michigan on pilgrimage to the Cross, was given a photo gift that she will know, HE, is here! On the grounds of Cemetery. My photo is the actual color silver. Kathy received Kingdom gold! Though the tower is red and white.

That evening I received a call, "Carol, this is Kathy, what color is Christ the King statue at Hillside?"

After a second of thought, I said, "Kathy, the statue is totally silver." I had to remove the phone from my ear as I heard Kathy's excitement.

Kathy returned with, "God chose me, he gave me a gold statue!"

Realizing this was another miraculous wonder, phenomenon photo. I stated to Kathy, *"You are given this gift that you will know that Jesus is there for I shall*

remind you of one of my messages received, when Jesus said,

> *'I have given you these photos to know that I am here.'*

Yes, Kathy, you may be called to evangelize. Not about your gift, but to evangelize the messages given by Jesus and Blessed Mary. Christ Our King is truly calling you to evangelize! You have a great purpose in this life for God and on that day you were chosen by Our Lady and by Christ the King."

<div align="center">†</div>

Some have captured Our Lady next to the cross, dressed all in gold.

Many who go to the cross have rosaries who's silver chains, change in color to gold!

<div align="center">†</div>

Why does Our Lady and Divine Jesus use gold? This gift given is only to give an AWAKENING and AWARENESS that something is really going on in Medjugorje, Bosnia and at Hillside, Illinois.

<div align="center">

</div>

Today's Angel

I prefer to keep all the angels' visits condensed to one chapter. I have placed them in chronological order...C.R.

The angels in heaven have bodies far different from ours, and the beauty and the glory of their bodies is different from the beauty and the glory of ours. (1 Corinthians 15: 40)

†

As a child, I remember a picture on my grandmother's wall, of two children on a bridge and an angel hovering over them. As a child, I memorized a prayer to my Guardian Angel. I learned from the stories my father told, as well as from sermons and the Bible, of angels coming to our Blessed Mother, Jesus, and St. Joseph, other saints, as well as the prophets and the chosen people.

†

I remember a near miss by an auto. The front wheel of my bike was struck, but a force stronger than the crash held me and my bike up. I especially remember, when crippled with polio as a teenager, losing

my balance as I struggled to drag my legs, with the aid of crutches, over icy sidewalks. As I lost my balance, it felt as if someone had caught me in mid-air, helping me to regain my footing. (A belief then the grip may have been my angel.)

<div align="center">†</div>

Then there was the "preparation" of the past two years—a voice calling out my name, **"CAROL"**

My husband, Bob, and I would search our home, but even though I answered that voice, calling, *"Who is it?* or, *"Where are you?"* no one came forth. We told our priest several times. He told us, "Just wait, you are being prepared."

<div align="center">♦ ♦ ♦</div>

Today's Angel

First Visit From An Angel

†

FOR TWO YEARS, in our house there had been a series of unexplainable phenomena. Then, early in the morning of March 26, 1993, I was suddenly awakened from a sound sleep before morning break; and literally lifted from our bed and stood on end. However, I was not frightened because I saw the form of a tall man, coming from inside a radiant light. He was pretty. Well, first of all, the angel I saw had a radiant light around the outside of his form. His eyes were so *pure* and his face, clear and pretty. His hair was blond and worn back, half over his ears. It was longer in back and curly. His robe was white, he was shoeless, and he stood on a silver-white mist off the floor. His tall wings were round at the top and in line with the top of his head. As for his familiar voice, it was strong, though gentle, and higher in pitch than the voice of Divine Jesus.

I knew no fear because I had been prepared for two years by hearing his voice when hearing my name called. As for being lifted up and blinded by the light, I felt little surprise, for so many signs have occurred throughout my life. I was at peace in the angel's

360

presence.

He had *pure* blue eyes and short light hair that fell half over his ears and longer in back. He was robed in white. A familiar voice said, *"CAROL, YOU ARE TO WRITE THE BISHOP OF CHICAGO A LETTER AND SEND THE PHOTOS WITH."*

In the hallway I was fumbling, still trying to focus, with the bright light in my eyes while the angel continued, *"ALL THE BISHOPS. YOU MUST WRITE SO THAT THE BISHOPS BELIEVE, BEFORE THE MEDJUGORJE CONFERENCE AT NOTRE DAME IN MAY."*

I went into my combined chapel and office and looked at the Sacred Heart picture above the altar. I blessed myself with holy water from a wall fountain, and in meditation, asked Divine Jesus: *"What do You want me to write?"*

<div align="center">†</div>

The angel, who had stayed beside me, answered, **"WRITE ABOUT JOSEPH."** He was tall and his puffy wings were at the top rounded and about the same height as his head, both touching a ceiling light and fan in the center of the room. The beautiful male angel stayed in the room and departed in the middle of the letter. I know this because the room became dark and I had to flick on the light above my typewriter. Up to this time, I made use of a brilliant light which surrounded the angel. Though until now I had

361

not realized I had not turned on lights from the bed-room or in the hallway or upon entering into my chapel.

<p style="text-align:center">♦ ♦ ♦</p>

On Friday, I spent the day in search of someone to retype the letter to the Archbishop of Chicago for me. At noon, frustrated not having found a typist, I sat in a parking lot and handed it all back to Jesus. *"I'm going onto my time with you Jesus, you arrange the day and the letter to be typed."*

As I normally do, I went to the stations of the cross at Our Lady of Grace Church. On my way out of church, I told Judy Fields about the visit from the angel and my instructions which I must obey. I asked her if she could type. Judy and her daughter worked steadily almost until our departure time to retype the letter and delivered it to our home as I completed my packing.

<p style="text-align:center">†</p>

I was consumed with the angel's assignment. I needed to find a bishop from another state. I did not know the name of any bishop in Chicago, Illinois, nor the names of any bishops anywhere except that of the bishop of our own Diocese of Grand Rapids, Michigan.

<p style="text-align:center">†</p>

With only forty eight hours to go until my flight to Medjugorje, Bosnia Herzegovina, how was I to find this unknown bishop, as instructed by the angel?

362

†

The next morning, after arriving in Hillside, Illinois, Marie Pimm, Bob and I and my cousin settled into a motel. We spent the first day trying to find an address to deliver the package to the Cardinal Archbishop of Chicago. The following morning, in desperation, I knew I would need to take this to Jesus for His lead. Marie Pimm wanted to go to Our Lady of Lebanon church. However, I felt drawn to go back to the church where I had first been led to in November 1992. The four of us agreed to go to Mass at Divine Providence Church, Westchester. Upon entering the church, we immediately found ourselves separated. Marie and my cousin went to the front and Bob and I took a pew in the back of church.

†

During Mass, I placed this task into the hands of Divine Jesus. I prayed that He would show me a path if He still wanted the letter and the photos to reach the archbishop.

†

After Mass, Marie and my cousin came towards the back of the church from the center aisle. Suddenly, Marie spotted a young man whom she had seen previously at the Cross at Our Lady Queen of Peace cemetery in Hillside.

Marie approached this man who God had left in our path. As he and Marie conversed, Bob and I hur-

363

riedly made our way to this one soul to whom I would quickly make a request. I asked him, *"Do you know the bishop of Chicago, and would you know anyone who knows of his address?"* He responded, "Which bishop?" I asked "Is there more than one?" This young man responded, "I may be seeing the bishop myself soon."

"Really? I said. Then he said, I must go now. I don't want to miss the rosary at the cross." Again, I asked him, *"Will you meet me after the rosary? I must talk with you."*

<center>†</center>

An hour later at the Cross in Hillside, we prayed the rosary with about two hundred people and the visionary Joseph Reinholtz. The man whom God had placed in our pathway from the church this morning made his way over to me through the crowd after the rosary. I whisked him over to a grassy area, telling him about the visit from the angel and the instructions, begging him to **become an ambassador for the angel** to help me in this emergency to get this package to the archbishop of Chicago.

He said, "I will if my prayer partner, after praying about it, says that it is okay."

I did not know this man before today, nor did I know his friends. Now near desperation as time was running out, I stopped cold and said, *"If he tells you not to deliver this package, he is a phony because*

I'M telling you, the angel was serious about the importance of this assignment."

<center>†</center>

I drew back a moment, calling down the Holy Spirit upon both of us. I felt calm and paused for a moment, I said, *"You were the only man left in the church, and I asked God during Mass to show me the path. I'm going to go with this path. I trust in God's lead."* I handed him this prayer-filled package for the archbishop.

The ambassador of the angel took the package.

Bob, Marie Pimm and others were with me during this last part of the assignment.

<center>†</center>

And at that, relieved after obeying and completing the angel's instructions, we pilgrims departed in peace for O'Hare airport to fly to Medjugorje, where I would await the angel's second visit.

<center>

</center>

<center>

</center>

Today's Angel

†

IN THE EARLY MORNING in Medjugorje, Bosnia on March 31, 1993, I awoke, surprised to have my room lit up so, at a time when we had no electricity or hot water. I heard a familiar voice say,

"THE WORDS ARE FULFILLED. PEACE."

I saw the angel before he departed. I knew that the message meant the package had been delivered, and I began to share the news of the angel's visit with others.

†

Later that week, I remembered while in Medjugorje, a priest once said to me, "Carol, do you not realize why God has sent an angel to ask you to do?"

"Not really, Father, I replied, *"I'm not sure. I'm just obeying."*

"Think, Carol. You were to tell what God wants them to know. Imagine, you were to reach the hierarchy of the Church, the decision makers," he said.

†

I received a confirmation when a letter from another helper of the angel out of Chicago awaited me when I returned from Bosnia Herzegovina. He

informed me that the package had reached the Cardinal Archbishop of Chicago and that I had directly received notice from a bishop that the Cardinal was pleased.

<div align="center">♦ ♦ ♦</div>

In May, I was requested to write another letter, updating my experiences from the time of the previous letter. Complying with the request, I included more gifted miraculous wonder in photos as well as documentation of conversions that have taken place *By Way of the Cross.*

<div align="center">†</div>

In June, 1993, in God's own timing, I received from nowhere the first list of bishops, archbishops, and cardinals across the United States along with postage for them to be sent out. Obedient to my instructions, I wrote the bishops about Joseph Reinholtz, the visionary of Hillside, Illinois who receives messages from Our Lady during prayer meetings in Our Lady Queen of Peace cemetery. By now I knew these visions were true and that I was called by God to witness many times. I also wrote the bishops about some of my husband Bob's encounters as well as mine. The next week, I was told there would be a bishop's conference and I continued to contact more bishops as I received their names and addresses. Trusting God to provide the names of those bishops when He selected to hear the

news, I patiently awaited His lead.

Some names were not on the first list. Surely this was because Divine Jesus knew those bishops that He was calling, and that some were not ready in God's eyes. Possibly, some may not yet be receptive, some may not be chosen for His plan of today. It would explain the selective list received.

♦ ♦ ♦

Today's Angel Returns
Third Visit of the Angel

<center>†</center>

IT WAS NEARLY THREE MONTHS (on June 23, 1993), after returning home. I was meditating quietly before my home altar. I often read scripture, along with prayers, for those in my petition basket and for the suffering souls in purgatory.

<center>†</center>

I was nearly ending my prayers of thanksgiving all His graces and mercy towards me and my children, when, to the right of the altar, came forth a bright light! As I looked at the top of the light, nearer the ceiling, I was shown the beautiful angel, who had come before me for the third time. He began to speak and **instruct** me.

His voice was soft, and he appeared inside a radiant light. He was within my reach, but I did not touch him.

In a gentle voice, although in a tone to which I felt obedient, he stated:

"USE THE WORDS, 'SACRAMENTAL EUCHARIST,' WHEN YOU SPEAK OF THE GLOW AROUND THE HOST."

I had never heard these words used together

before. When I took this message to my priest, he said, "The glow is the sacrament." Yes, Father, the glow is His presence! In receiving the Eucharist with glow, I receive a sacrament.

<div align="center">†</div>

After much discernment, I understood this to mean that the Glow and the Host are one in the Sacrament of the Eucharist.

<div align="center">

</div>

From this day on, I would always obediently use the phrase:

"Sacramental Eucharist"

<div align="center">♦ ♦ ♦ ♦</div>

Today's Angel

Today's Angel Behold
Fourth Visit of the Angel

†

ON JUNE 24, 1993, I heard the following voice say: *"REST. SAY YOUR PRAYERS."*

I answered, *"Dearest Jesus, it wasn't Your voice or Your Mother's that just spoke to me. Who is it?"*

And the voice said,

"DO YOU NOT RECOGNIZE ME?"

With embarrassment I smiled and said, *"Oh, hi!"* How could I not have known the familiar voice I had been hearing for two years now, God's angel.

♦ ♦ ♦

Later in October, 1993, I was led to West Virginia for various works for Our Lady. While there, I was to remember, through God's timing and through a prophesy told to me by a priest, that I had missed writing to one bishop of Our Lady's choice. This last bishop (lost to me), to receive my letter was: His Holiness, Pope John Paul II, *Bishop of Rome!*

†

Before returning for Michigan, we met a Lutheran gentleman at the Inn, with whom in sharing that we had much in common in our love for God. He owns a firm that designs computer software. Explaining to

371

him how I needed a graphic image that we could use as my signature stamp instead of my name as a signature. I also told him of how, in God's timing, I was to remember the Last Lost Bishop to whom I must write.

This new brother in Christ offered to design a computer graphic of the olive branch, the name by which Jesus referred to me. I wanted to use **this stamp signature in the letter I would send to the Pope**.

For me this was an affirmation. And gave me inner peace, in knowing of my continued obedience to the angel.

I would like to thank my new friend who made the computer graphic of the olive branch that I used for the letter to His Holiness, and for all my writings. In this book, in place of my signature, I use the olive branch.

What a wonderful God we have. Trust Him. Do His will and everything comes together.

◆ ◆ ◆

Upon returning home from West Virginia, I began to write the letter to the Pope as instructed by the angel.

After I prayed to Our Lady for a translator. Thanks to Our Lady, the letter to His Holiness (my last lost bishop) was now written in Polish as well as in English.

How was I going to get this letter to the Vatican? Presenting this issue to Gentle Jesus, I prayed:

372

"Jesus, lead me. Make a path for me, Jesus, if it is **still your wish that this package go to our Pope. Make the path, the way.** *I fear I shall not find the address to the Vatican. Even if I did, what building would my letter go to? Who would open it? I feel obedient to the angel's instructions and I want to be obedient to You. I want this task completed to YOUR WILL. You trusted little me to do it,* **Jesus, now I trust You to help me."**

Two days later I had nearly completed packaging my letter and photos with written testimonies of conversions to His Holiness, Pope John Paul II. Still not knowing how the package would travel, I went to bed, saying my familiar words to my Jesus: *"You will be up all night anyway, so You think about it, my Sweet Jesus."*

◆◆

The following day, I remembered the man I met in 1993 in the Divine Providence church in Illinois. I call him the ambassador to the angel. *"No,"* I thought, *"I'm only thinking of him because he was the man that Jesus left behind in the church, who became God's carrier to the first bishop."* Surely, he was not on his way to Rome too!

I continued to think about him throughout the day. About 8:00 p.m., I left a message on his answering machine: *"Please call me. Please, would you happen to know the address of the Vatican for me?*

About 9:00 p.m. he returned my call, "Carol, I can't believe this. *You'll* never believe this. For several days I have staying with me, a priest, who is a very good friend of the Pope."

I was stunned: *"What? Really? Amazing?"*

He continued, "I'm sure he has the Pope's address, or will obtain it for you."

†

At 11:00 p.m., he called back and said, "Father would like to speak to you."

"Sure, put him on," I said.

The priest asked what the letter was about. After explaining to him the instructions of the angel, the priest said, **"I will help you, and give it to my friend."**

After hanging up the phone, I hung my head and praised my Jesus! What was the chance in this world of asking for an address and receiving a **hand courier** to His Holiness! Only God could arrange such a well laid plan, A second ambassador for the angel.

†

On March 18, 1994, Our Lady's *courier priest* was to deliver the angels' instructions in a package letter and pictures to His Holiness, Pope John II at the Vatican in Italy.

†

Divine Jesus spoke to me on March 18, 1994. He said: *"MY PLAN IS SATISFIED."* A warm peace covered me, and I felt like a little child who had pleased her daddy. I continued to sit for hours in His Presence, in His Word through scripture reading psalms.

<div align="center">†</div>

On one visit with my priest for counseling, he stated, "Carol have you thought about the important assignment you were given through the angel? To reach the hierarchy of the church; the decision makers." I answered, *"Really Father? My job was important? I hope the bishop will listen, Father. All I know, is that whatever comes of this is not my doing. I only told the truth as the truth was laid before me, and it is up to Our Holy Spirit to feed the souls and minds of the bishop. I'm only a carrier for the angel who instructed me, we both work for God's plan."*

<div align="center">♦ ♦ ♦</div>

Praise to You only, my Jesus. You entrusted me with a task. Why me? I am lowly, but Gentle Jesus knew before I was born, that He would call on me in 1992 and use me as an instrument in His plan. I guess I need not understand–just be willing to say yes and obey.

I pray Jesus will remember me when I die, taking me up again to His Eternal Light, and raising me and the souls of all my children, up to His joy!

I'm often asked what it is like to see an angel, and what does one sound like.

Being before an angel is not so important. He is only a messenger. But *to be assigned to work for God is humbling*. I simply obeyed.

♦ ♦

In the past, I have asked Divine Jesus many times, that if there was something He wanted of me, to show me.

(In my next book you will discover the visiting angel's name.)

♦ ♦ ♦

My favorite daily prayer is:

ALL FOR THEE
Take my life and let it be
Consecrated, Lord, to Thee.
Take my hands, and let them move
At the impulse of Thy Love.
Take my feet, and let them be
Swift and beautiful for Thee.
Take my voice, and let it sing
Always, only for my King.
Take my lips, and let them be
Filled with messages from Thee.
Take my will and make it Thine;
It shall be no longer mine.
Take my heart, it is Thine own;
Let it be Thy royal throne.
Take myself, and I will be
Ever, only, all for Thee.
(Unknown Author)

My Little Olive Branch

B Y NOW WE WERE ready for Holy Week! Miracle? Prove it's a miracle!

<div align="center">†</div>

I know I was led to Medjugorje where many miraculous wonders take place. Sometimes you don't even realize one has occurred until God, in the design of His plan, reveals it to you.

April 4/93 Olive Branch from Medjugorje. Brought back in paper sack from Bosnia on April 19/93. After 7 months, I took photo to show Olive Branch still alive!

I would like now to recount the ongoing significance of the little olive branch that was given to me on April 4, 1993 by a peasant woman in Medjugorje. It was Palm Sunday in that war-torn country. The olive branches that are used traditionally in place of palm branches, were distributed for the procession at St. James Church. As I stood watching, an elderly Croatian woman with a weathered face and dressed in a long wool coat and black

lace veil, came up to me. Her pure eyes spoke with love. She shared her olive branch with me, breaking off a small twig with only a few leaves for herself. The larger piece of the olive branch, plump with blossoms and berries, she handed to me to wave during the procession. During the sharing of Mass and the waving of the branches, Blessed Mary came and we were all included in Her blessing.

◆ ◆ ◆

On April 19, 1993, I returned home to Michigan with my olive branch in a paper sack, crushed among clothes in a duffel bag. It was nearly seven weeks later that I took the branch from the bag. I placed it in an old picture frame on our home altar.

The following week, while we were praying the rosary in our chapel, my husband, Bob, stopped praying and said, **"That's not right. Those leaves should not be green and alive after two months. We'd better tell the priest."**

"Are you sure it's a miraculous sign? Let's wait six months," I replied.

After six months the leaves were *still* alive and Bob asked, "Are you calling Father?"

I said, *"Let's wait one year. I may lose my little miraculous sign."* I was afraid that if I told the Church, it might take my branch. Just in case, I took a photo to remember it. (Since then, I've given copies of the photo to whomever asks, as well as

leaves taken from the branch.)

<center>†</center>

During our weekly prayer meeting, a Croatian woman, who now lives in Michigan, looked at the photo. "That's not right," she said. **"I've never seen blossoms and berries on olive branches at the same time."**

<center>†</center>

Now I am certain that my alive olive branch from Medjugorje is a miracle! But why was I given this miracle? What does it mean? What is the message?

<center>†</center>

In October, 1993, my friend, Ginny, arranged for us to spend a week in Bel Air and Fallston, Maryland. I ministered daily to the sick, confused, and hurting. It was a week of great spiritual revival for all.

<center>†</center>

One day our hostess, Jean, requested that I visit her friend, Patricia, who was extremely ill. I told Jean, *"Let God lead us. If she is stronger in the morning, it will be my sign that God wants me to go."*

The following morning Jean called and was surprised to learn that Patricia *was* stronger.

We arrived at Patricia's home. Patricia made her way to the sofa where she and I talked for awhile. Then I prayed over her. During those prayers my hands became hot, and I had to back away from the

My Little Olive Branch

heat between us. As my hands moved to the top of her head, **I saw a vision of a white dove with a branch and a berry in its beak, and then, puffy clouds.**

After the prayers and once Patricia came out of her **peaceful** "rest in the Spirit," alert again, she touched my face with her hand and said, **"I see Jesus in you."**

I told her that I was sure Jesus lived in her as well.

<p align="center">†</p>

Then Patricia said, "Christ spoke to me."

I responded, *"Now! When?"*

Patricia stated, **"A few weeks ago."**

At that point, the other ladies who were standing close by told how, during a time of severe sickness, Patricia told many that Christ had given her a message (approximately September 28, 1993 and this was October 28, 1993).

<p align="center">†</p>

I asked Patricia: *"What did HE say?"*

She looked into my eyes and said, "Christ said to me: *'GO TELL ALL THE PEOPLE TO WATCH FOR THE OLIVE BRANCH.'"*

<p align="center">†</p>

I was stunned and I said, *"Oh, but I have an alive olive branch from Medjugorje!"* Is this some answer of affirmation?

I took the photo of my olive branch out from my purse and as Patricia looked at the photo and smiled, we were both in communion as sisters in Christ. We both felt such peace, realizing God was using both of us in His plan.

<center>†</center>

Patricia also asked, "Do you have a purple coat?"

"Yes," I replied. *"In the back seat of the car. Why?"*

Patricia responded, "After I saw Jesus, I was also shown a women with a purple coat, but I didn't see her face."

I answered, *"I was wearing the purple coat when I received my olive branch."*

<center>†</center>

I hung my head and called Our Holy Spirit upon us, then exulted Him, for giving me this affirmation of this miraculous wonder, my little olive branch.

<center>♦ ♦</center>

That evening we shared with the people in St. Mark Church this connection to the olive branch from Medjugorje.

By the end of the week, God's plan, including a direct message, was definitely in motion.

My Little Olive Branch

She Needed Healing

†

AFTER MASS AT THE Church of St. Mark on Saturday morning, we headed west towards Michigan, except for a slight detour. Ginny drove us to Emmitsburg, Maryland, to visit the shrines of St. Elizabeth Ann Seton and Grotto of Lourdes. While at the Basilica of St. Elizabeth Ann Seton, an elderly nun looked into my eyes and said, "You're with God. Will you pray over me?"

I responded, *"And Jesus is in you,"* and knowing that my mission field is where ever God leads, I began to pray. Feeling the heat from my hand, Sister began to direct my hand to her hips, stomach, leg, elbow, chest, and finally, her left ear, where she held her hand tightly over mine. As tears fell from Sister's clear blue eyes, her face glowed with **peace**, a miracle by internal faith which make a change. It was then that I smelled the fragrance of flowers, the familiar fragrance that signals Our Lady's presence and Her approval.

♦ ♦ ♦

He Gives Me a Name

✝

We continued on in the rain, fog, and chill, to the mountain shrine of the Grotto of Lourdes. We knelt in the tiny stone chapel where the Holy Eucharist rests in the tabernacle, at one in His loving Presence. A few more steps up the mountain and we were at the grotto where water is collected from a spring that many believe to be miraculous, healing.

This replica of the Lourdes Grotto is wonderful and so peaceful. Autumn leaves had fallen, covering the earth in a blanket of crimson and gold, brown and green. I looked at the brown leaves and thought of the olive leaves from Medjugorje that would not die.

Back in the parking lot, I spied the top of a building built on the side of the hill. Ginny showed little interest until I suggested, *"Ginny, it might be a gift shop."* Ginny, upon hearing those magic words "gift shop," followed me to the building which we discovered to be a chapel!

♦ ♦ ♦

As we approached the glass doors, I said, *"A GLOW! Ginny, the Glow!"*

Ginny answered, "Shhh."

Benediction was being celebrated. Surrounding the

Monstrance, I could see the illuminating Sacramental Glow. Inside we quietly took seats and joined in the singing and meditation. Soon, behind the altar and to the side of the monstrance, came Gentle Jesus. His robe was white and His face peaceful, with pure blue eyes. As He looked at me, He spoke, *"O MY LITTLE OLIVE BRANCH, GO FORTH. GIVE PEACE, PEACE, PEACE."*

I was lost in *time, peace, and joyfulness, in the Presence of Divine Jesus.*

After Divine Jesus departed, I looked at Ginny and nodded with a smile. But Ginny, tears flowing freely, had already sensed that I had experienced something very special. After Benediction and during a healing service, we both "rested in the Spirit."

◆ ◆ ◆

Two hours later we pulled into a motel in a tiny town near the Maryland/Pennsylvania border. The following morning, after Mass, I decided to share my gifts with the very holy priest. (After all, our parish priest has told me to tell those priests who will listen of my gift of seeing a Sacramental Glow around the Host.)

I told Father about the beautiful Sacramental Glow that I saw when he raised the Host and the Chalice. Father seemed to take this well. I told him of the other miracle gifts and visions. He accepted these as well. Finally, I told him of the miracle *olive branch* and the message I was told in Maryland. That's when

Father broke in and said, **"Before you go home, you must go to Maria's Garden. You'll know why you are there."**

We looked at one another, realizing that once again we were being *led* by God's plan. I said, *"Really, Ginny?"*

♦ ♦ ♦

We drove eight miles into West Virginia to a bed and breakfast inn! We ordered breakfast and asked to speak to the owner, called "Maria" by some. She joined us at our table, but before we could begin, Ginny blurted out, "Let's cut to the chase. Do you have an olive tree?"

Startled, the woman replied, "No." Then she told us that some coming to the inn, considered to be a contact point for those whom the Blessed Mother wishes to bring together.

†

Then she asked, "What is your story? Who led you here?"

I said, "A priest gave us your name."

I told her our story, and when I spoke of the **miraculous olive branch**, the owner said, "Wait, I may have your connection." She left the table to make a phone call and returned a few minutes later saying, "He will be here in an hour."

†

We spent the time resting and trying to understand

where Blessed Mary and Divine Jesus were leading us this time.

◆◆◆

In one hour, we met our "connection," but still we wondered what this had to do with the olive branch. Our "connection" was a priest who told us, "You are the two holy women I've waited for." Looking at me, he added, "I have waited one year for you. You have come to pray over me." I agreed to do so, as it appeared we were truly led to this place by God. (Though it would be several hours later because Divine Jesus had other plans for us.)

†

In the meantime, Ginny suggested that I tell the priest about Gentle Jesus' apparition to me at the Lourdes Shrine. However, I felt strongly that I was to say **nothing** to him of Jesus' message at that time.

†

Later, while en route to Mass, Father touched my arm and said, "I believe *you* are from the olive branch." Ginny excited in the back seat again said, "Carol tell Father." So I told Father of the vision and message from Jesus. He grinned, as though he knew something we didn't.

†

Father also shared that he too is a visionary, for four years. (All he told me, I choose to keep silent.)

†

After Mass, Father led us to share with the faithful. He asked I pray with the people for healings. As he said, "Our Lady told me she would send you." Then Father stopped a mother and asked for her child. She said her child was home.

Father asked, "How far?"

And she replied, "Around the block."

We followed the mother for some twenty miles to their home. All of us knelt with Father and prayed. While Ginny, Our Lady's companion for me, knelt at the foot of the child's bed, each tear became a prayer. I prayed over an eleven year old boy who has been in a coma for six years after drowning in an irrigation ditch. As I prayed, his head lifted up high from the pillow and I looked into his eyes!

<div align="center">†</div>

Finally, at the end of the evening, I prayed over the priest. I am searching to see if there is a connection to my alive olive branch. Gentle Jesus told me that I am the "Little Olive Branch" meant to bring peace to others.

<div align="center">†</div>

What Ginny and I *are* certain of is that my mission field is where ever Divine Jesus and Blessed Mary lead me. This connects with the olive branch because God uses me as His instrument, to bring peace of mind, soul and body. Surely, the gift of my faith is this miracle.

<center>†</center>

I await God's lead for my work in life. On November 1, 1993, Ginny and I were en route back to Michigan, from a spirit-filled trip to Maryland. I've learned that wherever my mission field is, Divine Jesus, Blessed Mary, and my Holy Spirit are ever so close by.

<center>♦ ♦ ♦</center>

Along highway I-96, between Lansing and Grand Rapids, Michigan, Ginny and I were praying the fourth decade of our third rosary for the day (in accordance with our Blessed Mother's request). I noticed directly ahead, a bright star. By the time we were into the fifth decade, we could see a funnel of brilliant light from as high as one could see. At the bottom of the funnel of light was our Blessed Mother! Her short veil and dress, outlined in an illuminating shimmer of silver and white, were blowing in the wind! She stood on a small cloud, facing the star!

<center>†</center>

I pulled off onto the shoulder of the highway. We craned our necks (Ginny could see her, too) as we watched our Mother Mary move to the left, floating away from the star. When she stopped, I'm not sure, for I was lost in time and awe, in joy and peace.

Blessed Mary Mother of America then spoke to me: ***"Your Fruits Are Bearing. Your Sacrifices Were Many. You Are My Daughter. I Am Your Mother."***

When I finally turned and spoke to Ginny, I could see her tears of joy and a kind of blush on her face. She was full of grace. She reached for paper on which to write the message given to me.

We sat quietly for some minutes, as Blessed Mary Mother of America remained, hovering in the sky. I would look back every so often. She was still there. I realized she was watching over us, as a mother would watch over her children on the street. We felt so comforted. As I drove away, I looked to the left, out of the driver's window. Like a small child, I said to Her, *"Bye. Good-bye,"* feeling as though I was a little girl again. I waved with the fingers of my left hand. I was humbled, feeling like a child protected by her mother.

◆ ◆ ◆

Miraculous Sign

Another Affirmation

†

AFTER RETURNING TO MICHIGAN, my friend, Nancy, called. She reminded me of two leaves from the olive branch that I had given away in April, 1993. She said, "Guess what? I was looking, after eight months, at the leaf you gave Marty, her husband. "We keep it in a plastic bag and it is still green and slippery." Then Nancy said, "This is great, but I wonder what it means. And RoseMarie has one, too!" (RoseMarie is her best friend.) Now it is their turn to wait for an answer to how Blessed Mary plans to use them towards peace.

†

All who have received a leaf from the original branch must remember that the branch was blessed by our Mother of Medjugorje in her presence in Medjugorje. I believe that all who have a leaf are called to help work for peace in a special way.

†

I believe the olive branch has even more meaning. I have seen that those who receive a leaf from my little olive twig seem to be called into the Spirit. I hear of new revivals in faith. Many, like me, are being

391

called to spread peace. Even those who receive a photo of the gift of my alive olive branch are connected now to spreading conversion and peace.

<div align="center">†</div>

I have given hundreds of photos of the olive branch to Catholics, Protestants, and atheists. Some receive two, so that they may give one to someone with whom they have not yet made peace. I encourage all to make peace *immediately* with family, friends, co-workers, and neighbors. Place this photo on your wall to remind you always to be of a *peaceful* nature.

<div align="center">♦ ♦ ♦ ♦</div>

†

WHEN A MIRACLE IS YOURS
I rejoice; I'm at the beginning;
I am in Peace.
I have reached deep inside,
And given all I am and all I can to others.
My ache of love is beyond my old thoughts
And practices of thinking only of myself.
You, Jesus, You are first.
You are my Driver, my Molder, my Worth.
O great Spirit of Life,
Enter into me, wash me;
Stand me strong against evil.
Let Your mighty fire leave a burning desire in me.
Put a plan into my mind that I may do only Your
Will.
Lord, I am thirsty, so thirsty.
Give to me the Spring of the Water of Life.
Let me eat the Fruit from the Tree of Life.
You are my bright Morning Star, my A through Z.
My miracle is faith in knowing and loving only You,
Gentle Jesus.
Amen
(Little Olive Branch)

God's Soldier Boys in Bosnia

GREETINGS FROM BOSNIA HERZEGOVINA: a world of deep faith, dedicated children of Blessed Mary, obedient Christians, and Muslims. *Faith is worth dying for.*

On March 29, 1993, we arrived on Croatian soil. It was devastating to view the mortared buildings of a once beautiful city. As we stopped at the border between Croatia and Bosnia Herzegovina, I felt a fear inside, that I have never had to deal with before in my life. Yet, even with the smoke, artillery pounding in the distance, and NATO planes flying over, I felt a sense of peace. I felt our Blessed Mother's mantle of protection.

Croatians are willing to die for their freedom. These people have risen above oppression and economic hardships. They survive with friendship, a sense of humor, smiles. You hear their laughter, and you witness their devotion to God. You watch as they really care about their neighbors, and share the last of what they have with one another.

I offered six carrots to a Christian peasant woman. She gave two carrots to a neighbor to the west of her and two carrots to her neighbor across the road,

keeping only two for her own family. I asked a Croatian woman to purchase several items in a small local store. She reached for *one* box. I said, *"More? Buy more,"* and I attempted to hand her more boxes. But she waved her hands and shook her head. She nodded her head, smiled, and thanked me for the *one* purchase. Outside the store, I saw her open the box and pour half the contents into a bag for another peasant. They hugged and moved away. This is real charity.

<div align="center">†</div>

In a chapel in Medjugorje *united* in a faith filled prayer meeting, it felt like back home where it is safe and common place to *unite* in prayer meetings even of different faiths. The U.S. is a wonderful and free country in which we live. Unfortunately, Croatians are fighting Serbians to keep the same freedoms we take for granted.

<div align="center">†</div>

This holocaust is made up of Croatians, Muslims, and Serbian Orthodox Christians, communists, and atheists. They are old Yugoslavia. When the time of free elections came, the Serbians, who have the third largest military in Europe, elected to claim the choice land, even if it meant murdering the people who lived there. First they removed all possibility of employment by destroying factories and public buildings. They wiped out medical facilities. The people were devastated. Livestock was slaughtered,

395

entire towns burned, and priests and nuns murdered.

The United Nations placed an embargo on the Serbians. However, instead of stopping the war, it resulted in a holocaust. The armed Serbians over-powered the Croatians.

The Croatians of Bosnia Herzegovina formed their army without the technology of modern artillery. They are soldiers without uniforms; four or more share one rifle. They stand in need of rifles, bullet-proof vests, helmets, and modern tanks, if they are to defend their homes and their families.

The Croatian soldier serves ten days each month in return for a pack of cigarettes. He has become a liv-ing symbol of his people's love for God and Mary, family and country, *freedom.* Even the husbands of the Croatian visionaries of Medjugorje are soldiers of war.

<div align="center">†</div>

I met Muslims who entered Croatian (Catholic) towns to flee from the Serbian Orthodox. I spoke with one family through an interpreter. They helped me to understand the hatred that exists. Communism, the Muslims said, kept them in oppression and they did not want to live with Catholic Christians, for they did not want the Christians to ethnically influence their children. They explained it like this: consider that you live in a small, rural, Christian village and fifty satanic families move into your town. The

396

God's Soldier Boys in Bosnia

Christian families meet and decide to take up arms, moving the fifty satanic families out of the town, so that they would not have to live or work with persons of a different belief.

<div align="center">†</div>

When interviewed, a Christian family said that they are fighting for the freedom to come out of oppression. They were determined to stop giving 80% of their wages to the government. They wanted freedom of faith and improved schooling for their children. They did not want their children influenced by Muslims, who do not believe that Jesus Christ is Son of God. In addition, Muslims are raping Christian women, ages seven through eighty four. As for the Serbian communists, the Catholic Christians fear them. Many women are raped by the Serbian communist soldiers, as well, and their children are murdered. They are disgusted by their greed. They do not want to live or work with those who make the government their god and take power by means of warfare.

<div align="center">†</div>

It was clear that these groups did not intend to live together in *peace*, even though many Catholic Christians and Muslims are forced to at the present time. This reminds me of the floods in the United States, which forced those who hate one another to come together in peace for a time, to help each other.

When I think of the Croatians, I think of the American Indians, and how they were massacred for their land. They were forced into oppression and their people killed to near extinction. History repeats itself from century to century because of greed and power. It is clear that the Croatians believe that the United States *could* stop the aggression in a few days if it was the leader it claimed to be.

<div align="center">†</div>

Croatian refugees—women, children, families—continue to make their way into Medjugorje, having fled from burning homes, leaving behind massacred towns. One refugee woman told me how her husband was shot and her two children set afire in front of her as she was raped by two Serbian soldiers. A three year old had two eyes cut out. He wandered to farmers who took him to the sisters.

I was told boldly how Iraq, Iran, and other mideastern countries are uniting and sending help for the Mujahedin fighters (Muslims) who believe it is their sacred duty to kill Catholic Christians. During my stay in Bosnia, word quickly spread one day that a priest and some missionary nuns had been kidnapped by Muslims. It was the United Nations that bargained for them, and obtained their release, alive. They were fortunate; most are not even bargained for.

<div align="center">†</div>

Although these Catholic refugees lost all they had,

God's Soldier Boys in Bosnia

including families, they did not seem hateful. Instead they knelt daily and praised God for their safety thus far. They were friendly and generous with their mere belongings. These are average, devout people, who love their children and respect their parents and the elderly.

<div align="center">†</div>

While I was there, the war pushed all the way to the Adriatic Sea. I saw United Nations soldiers doing little, for they were not even armed.

<div align="center">†</div>

At one point two hundred Croatian soldiers were in Medjugorje. Many stood in long lines at the confessionals located outside St. James Church. At Mass the soldiers flowed out onto the church steps. It was quite a scene—one which gave hope to the people. I was sure Our Lady and Gentle Jesus were wrapping their veil of love around them. When a man called out, whispers spread, and the soldiers left swiftly. I picked up my video camera and taped the caravan of trucks rolling out, as the sound of Christian songs from St. James rang in the air.

<div align="center">†</div>

I am not into the politics of this nation. Divine Jesus and Blessed Mary brought me to Bosnia so that I might know *all* these people and their sufferings. Blessed Mother assigned me the task of bringing peace prayer groups together. Divine Jesus gave me

399

the gifts necessary to share His Divine Mercy.

Remembering on our second day in Medjugorje, how our group spiritual advisor asked, "Carol, do you know why Mary wants you here?"

I responded, *"No, Father, not yet."*

A few days later he commented, "You must see by now why you're here."

Again I replied, *"No, Father."*

I came home knowing my calling to Medjugorje: miracles of healing and the conversion to love Divine Jesus, even more than when I arrived. My compassion deepened and I knew that I must return home with this same love for everyone in need and lead others in peace prayers.

†

On March 31, 1993, in Medjugorje, our group gathered for daily rosary and to be with visionary Joseph Reinholtz during his apparitions. On this day when Blessed Mary came, she allowed me once again to *see* her. I had shared the experience of this gift with others in the past. But on this particular day, the message given to those present by Blessed Mary through Joseph was: ***"Your Presence Is Welcome Here. THOSE WHO SEE ME Is God's Gift To All Of You. Have You Converted This Morning? IF NOT, ASK NOW."*** Joseph continued, ***"[She] welcomes you in prayer. [She] is happy with us. [She]***

sends [her] love to all of you."

I knew that this message was directed about me. I thanked Blessed Mary for letting others know that ***"THOSE"***, meant others in the group could see, too.

<center>†</center>

It was April 2, 1993 and we were seeing soldiers and refugees throughout the village, hearing shelling, and feeling the sadness of this war with the Serbians. We listened, too, to family fears and stories of death and separation from relatives—cruel, harsh lessons in compassion. Yet, all this was nothing compared to what was to come later this same day.

<center>†</center>

Coming down from Apparition Hill, I was waiting for a taxi when a young soldier and a woman came over to me. The soldier, Milenko, whose hand was wrapped in a cloth, spoke to me. First, he reached into his pocket and handed me a crucifix. (I call it my "soldier boy cross.") Then his companion unwrapped his hand, which had been wounded in a shelling attack, exposing torn flesh and fingers separated from the palm. Milenko asked me: **"American woman? Please. Pray over my hand and pray for my mother and sister in Mostar."**

Even though his was a gross injury, and it appeared to me that an amputation would be the only recourse, he turned to me and asked me to pray. Seeing his

<div align="right">401</div>

wound, I was filled with a deep compassion and pain for the soldiers, the mothers, the country as a whole. I ached inside until I felt the pain pass through my heart to my back, and I wept for him. I felt helpless. All I could do was place the crucifix on his wounded hand and weep while pleading for Jesus' mercy.

After such a devastating and emotionally draining experience, I became aware of a growing compassion for all God's Croatian children. I stepped into a local shop and introduced myself to my first silver and brown Peace Chaplet rosary.

At 6:00 p.m. I was in the front pew of St. James, along with the rest of the villagers, praying the Peace rosary. When my fingers caressed the second Our Father, I saw the chain of my rosary turn gold before my eyes. With Milenko's crucifix in my left hand and my peace rosary entwined in the fingers of my right hand, I wept through the remainder of the rosary.

Four days later, Father sent two women to bring me to St. James Church. There was my soldier boy, Milenko. *"Oh! Milenko! Milenko, you're alive!"* They unwrapped his hand—***his MIRACLE!*** Without stitching, his fingers were attached to his hand, and healing! Praise God for His Mercy and His Love.

<div align="center">†</div>

When the hugging and the happy tears subsided, Father Paul took me into the church, outside the sacristy door. He washed my fingers in a dish and

God's Soldier Boys in Bosnia

prayed, making crosses on my hands with oil. Then he told me to go forth as Christ's extension and continue.

<p style="text-align:center">†</p>

April 6th marked another miracle! We visited the post office in Medjugorje. I noticed three Croatian soldiers. I'm a friendly person by nature and I was acquiring a deep feeling for these young men, so I spoke to them asking, *"Speak English?"*

God's soldier boys of Bosnia talk with me.

One answered, "English? Some." I asked his name and he replied, "Kogel B."

Surprised, I exclaimed, *"B? I'm a B!"* (For security reasons, I'm withholding the actual name.)

We exchanged family ties and found that, indeed, we were related. When Kogel and his companions told us that they were going back into combat early the next morning, I felt as if I was saying goodbye to my own son. For what were the chances of meeting a relative here—both of us from other countries and in Medjugorje for the first time? There is no doubt that Divine Jesus and Blessed Mary prepared this meeting, so that I would have more compassion.

<p style="text-align:center">†</p>

I climbed Apparition Hill three times and Mt.

<p style="text-align:right">403</p>

Krizevac once, in three weeks. Most of my time was spent in prayer, going to services, being with the soldiers, villagers, and refugees.

I was swept away with love; especially, for the refugee children. I learned about their cultures and their feelings, fears, and dreams.

It was as though the eyes of the soldiers were drawn to me. Day after day I would meet more and more of them. Those who spoke some English would call me "American Woman With The Long Braid," or, "Kogel's Cousin." I laid on hands and prayed. Then I requested them to go to Jesus' Mother for another blessing and, if possible, to contact their own earthly mothers. Oh how I ached for the families of these boys.

Green and brown berets were worn by Croatian soldiers; blue berets, by United Nations troops. I never saw a soldier with a helmet. Most local soldiers wore their everyday clothes. Most of them went to Mass and to Confession while in town.

As I watched caravans move out, my heart burned. When I left Medjugorje, I felt as though I was abandoning my children. Each soldier was as meaningful to me as my cousin, Kogel, to whom I also waved goodbye.

<center>†</center>

This trip has totally changed my life. The next chapter in my life is to bring the *truth* back to the

404

United States, and to beg prayer groups and individuals to make the Peace Rosary a daily hunger.

I recently was told by a local college student: "The people were better off before the war, under communism."

"Who is your instructor, I asked? *"To visit this country is to know the **truth**. To **talk** with the citizens is to know the **truth**. The propaganda you are hearing appalls me. I even wince when I listen to CNN and the politics of their newscast.*

*"Let me explain to you, young man, that these people were **not** better off under communism. Three years ago they lived in oppression. They gave 80% of their wages and crops to the government. They are fighting to create a government, to which they will give only 40% to 50%. Sure, they had factories and jobs. They **still** would, if **every** factory, hospital, and business had not been blown away. Left alone in their elected freedom, they would be **prospering** and free. They would be working their ethnic problems out alone.*

*"Roman Catholics, Serbian Orthodox, and Muslims all want peace. They **are** willing to get along rather than be under communist dictatorship and oppression.*

*"Some speak of Serbians, and that they want communism back. Many Serbians do want communism back. But remember, to these Serbian communists, their government **is their god**. To them, human life*

lasts only until death.

"Many Serbians have intermarried with Catholic Croatians. Some Croatians now are turning on and killing their own families because of their new beliefs in government over God. Communist **fear** kept them working together, yes. But I spoke to both Muslims and Catholic Croatians. These people of different cultures are **willing** to work together. But there are **no** jobs.

"The Serbian communists did **not** give the people a **chance** to prosper under peaceful conditions. They were not allowed to set up their own government without interference. They had to concern themselves immediately with a war. If the war is halted and nations bring in aid, I believe that peace will reign. Who has a right to exterminate those who have different beliefs?"

<p style="text-align:center">†</p>

Please! Please! Divine Jesus and Blessed Mary showed me this suffering. Please. Pray! Pray! Pray! For conversion and peace. *Cry* for the *soldiers*. *Ache* for the *refugees*. Love everyone around you. Today! Forgive, repent, convert—to be like Gentle Jesus.

Praise Jesus!

†

Jesus, listen,
As I bend Your ear.
My heart is beating;
I am crying tears.
So many miles from me,
Another country awaits my plea.

Soldiers with courage, risking their lives.
People gather in hiding, to pray by night.
Hunger, torture, exhaustion,
In the fields and mountains.
These soldiers and Christians,
Awaiting peace.

Dearest Jesus, sweep special graces
Over these troubled souls.
Bring other nations
To their brothers in the cold.
Save my tears, each one a prayer.
Keep my soldiers in Your loving care.
Amen
(Little Olive Branch)

His Dazzling Presence

O N APRIL 19, 1993, WE returned to the United States. I wondered if all visions would stop now that I had obeyed our Mother Mary and was back at home.

<center>†</center>

During Mass at St. Michael's in Muskegon, Father raised the Host and a Glow of about six inches illuminated the Host, first, and then the Chalice. A four inch Glow flowed over Father's hands. When raised together, the light was dazzling!

My gift continues during most Masses, no matter what city I'm in. I know now that my priest was right when he stated, "This is your gift. You are given this gift in your own church or across the world, for our God is everywhere!"

<center>♦ ♦ ♦</center>

My husband Bob and I attended the May 1993 Medjugorje Conference, held at the University of Notre Dame, as guests of friends. (I first heard about this conference in the instructions from an angel.) Many miraculous signs took place at this conference.

One was a visit from our Blessed Mother, looking

over her children. She stood to the left of the stage.

♦♦

Another was a Eucharistic wonder during the con-
secration of the Mass. The altar dazzled in the illu-
minating Glow. There were many Chalices and
Patens filled with the consecrated Wine and Hosts. I
tell you, I saw the most beautiful Sacramental Glow!
What a spectacular sight! What a ray of continuous
illuminating light for me to see His Presence! My
eyes were set, seeing His Presence in a Sacramental
Glow flowing from one end of the altar to the other!
More brilliant than a lawn of diamonds!

I was frozen, watching the brilliance as the priests
carried away the Chalices and Patens. It was as if
they each carried a candle, with a silver-white flame.
I watched the light go up stairs and down aisles.
Everywhere there was a brilliant light, there was a
priest. Such awesome splendor! His Presence in the
Eucharist, all over the auditorium! Surely, His
Presence was in this place!

♦♦

And then Benediction! This was beautiful! A light
was centered on the monstrance, I began to cry. What
I was gifted to see was brighter than anything they
were using. Perhaps those who remember the
mechanical light, can imagine in their minds what I
view with my eyes, only much more brilliant! For
the Presence of God is illuminating!

I usually see this Glow at daily or Sunday Mass. However, one time I did not see it, I kept looking and saying, *"God, where are You?"* And as the Eucharistic ministers received Communion, I realized that I would not see this wonderful vision that day. I asked, *"Jesus, am I not cleansed enough?"*

Deep inside my heart I heard, ***"I AM HERE."***

◆ ◆ ◆

St. Lazares

A FTER MY RETURN HOME from Bosnia
Herzegovina on April 19, 1993, I was sure
my visions must be behind me. Until May
10, 1993, when three of us were in a prayer group in
the chapel of St. Lazare Retreat House. While in
deep meditation, a familiar feeling of warmth and
peace overcame me. I looked up during the Lord's
Prayer, glancing at the crucifix beyond the altar. I
was about to bow my head and meditate back into
the passion of Christ, when my eyes picked up light
to the left of me. I saw the full vision of our Blessed
Mother's face. I was stunned, but when I looked
away to the altar and back again, Her beautiful face
was gone.

I bowed my head and lifting my face, opened my
eyes to see the gentle, beautiful face of Blessed Mary
once more. Again I shook my head and looked to the
altar as if I could not believe what I was seeing. I
prayed, *"Please, Jesus, guide me. Is this really Your
Mother?"*

We entered into more prayers, and I thought,
"Wow! Why is this happening?" For the third time

she came forth and this time she stayed, looking so gently at me. I asked, *"Is it really you, Blessed Mother? What do you want of me?"*

She departed, but near the end of our prayers, Blessed Mary came forth one last time. Her face was the same face I had seen many times in Medjugorje. I was not sure, but Her dark hair seemed to be more noticeable than before. I was in an awesome peace. I then said to my Mother Mary: *"We are your daughters. We give ourselves 100% to you. Do you want us to come again. Are you calling us to something? Is your visit for all of us or for me? We love you so much. I will do anything for you, my Mother."*

She did not speak to me on this day. I told the women with me. One asked the priest if we could return, just in case our Blessed Mother was going to call us back. One of these women has become devoted to God's Will. I have shared so much with her.

In A Heart Beat

S UMMER IS RACING ON, our spiritual journey rolls
forward as well.

†

We enjoyed spirit filled assemblies and when our
friend Marty called and invited us, we said yes. After
all, spending time with Marty and Nancy is spiritual
growth in love and sharing.

♦ ♦ ♦

When you've raised your family and you decide to
go on a spiritual vigil, you expect a quiet retreat of
meditation and reading. You certainly do not expect
an all night family revival.

♦ ♦ ♦

A lovely winding drive bordered by thickets of
trees leads to scattered cabins and community build-
ings. From there, several paths lead to a magnificent
view of Lake Michigan, its beige sandy beach dotted
with driftwood and small drifting dunes, rolling to
some steps.

I expected the noise of energetic, squealing chil-
dren as they ran up the paths and barged in and out
of the restrooms. How could this excited crowd

become a reverent prayer group within a few hours?

<div align="center">†</div>

Evening crept in through the chapel window as the sun rested on the lake. A sailboat floated by. There were hours of song, and then finally came the familiar sound of a procession, making its way under a midnight sky along paths lit occasionally by candles. Each person was given a candle as they joined in the prayers.

The evening turned cold; the air chilled with damp lake breezes, whistling over the banks, adding the smell of water and fish to the air. Midway into the procession, this fragrance was overcome with a new scent that floated in and out of the chain of prayerful people—the unmistakable fragrance of roses. Some people stopped to look around at what had changed the air, while those behind bumped into them. Some stepped out of the procession, searching for the source of the strong fragrance. Surely we must have passed an area of flowers along the path. Only those in deep prayerful harmony with the rosary knew that a search for flowers was not necessary. Many felt a heavenly presence.

As the priests led the prayers, some women held candles or flashlights at risky turns, though I hardly think anyone felt less than fully protected by Our Lady herself that night.

A service was held in honor of Divine Jesus. Six

414

priests heard confessions, while the choir led us in singing praise. Mass was at 11:00 p.m. The Sacramental Glow shined around the Eucharist, Chalices, and Paten once again. After Mass a vigil watch in front of the Blessed Sacrament was led by the most spiritual priests.

<center>†</center>

Some dozed briefly in their cars while others went to cottages for short naps. My husband, Bob, chatted for hours near the coffee and tea in the community house. With friends, Marty and I remained in vigil, hoping not to miss a thing. During the hour of adoration the priest called upon the Holy Spirit to envelope each of us in His Holy Presence. As we chanted, "Come Holy Spirit." we could sense a certain serenity. Lost in deep prayer and enjoying the Divine Presence, many raised their arms with hands open.

<center>†</center>

I felt a current of air "circulate" into my palms. Next I felt as if my hands were holding a substance weighing about four pounds. I was unable to bring down my hands for fear of dropping whatever I was holding. Then the substance took on a pulsation, as if a heart was beating. Tears flowed as I continued to praise the Sacred Heart of Jesus. I felt stronger and stronger, as if I were in "completeness" with the Father, Divine Jesus, and the Holy Spirit. I felt

as if I was one with the Holy Trinity. My whole being was on fire, in love with God. As people reached to take hands, my hand was taken from the weight. I felt the weight rise from my hand as another touched me. Uncontrollable tears of joy streamed down my face as I knew I was as close to His Holy Presence as I could be for now!

This was the same overflowing love that I feel whenever Divine Jesus appears before me, beginning with His apparition to me on February 25, 1993. No words can ever describe the ultimate blanket of love and peace flowing inward and outward, such tranquility and joy!

<div align="center">†</div>

Morning light approached and another Mass at 6:00 a.m. Again I experienced the familiar awareness of His Holy Spirit and the full Glow of radiant light around the Sacramental Eucharist. The wide bright Glow flowed over the hands and wrists of the Eucharistic ministers. Oh, if only everyone could be gifted to see this splendor!

<div align="center">†</div>

In the cafeteria, everyone was ready for breakfast. A priest spoke to me saying, "You have miracles."

"Yes, Father," I responded.

He continued, "And your rosaries turn gold?"

"Yes, Father, twelve so far."

416

He asked, "Would you like to tell me one thing?"

I quickly said, *"Yes, Father. My priest says it would be nice if I shared this with all priests. During the Consecration I am gifted to see a brilliant Glow around the host and the chalice."* He quickly responded, **"I do, too."**

"Wonderful, Father," I said.

Then he asked, "How wide is the Glow?"

I replied, *"Sometimes maybe six inches; sometimes maybe two inches."*

Father then showed me with his fingers that the glow he sees is about half an inch.

I stated, *"That's okay, Father, it will grow wider as you grow in Spirit."*

We laughed.

<div align="center">†</div>

Recently, I tried to meet with this priest before he left once again for Medjugorje, Bosnia Herzegovina. I'm sure his return to Medjugorje will be filled with a deeper growth in Spirit. Even when you think you could not love Divine Jesus more, our Mother helps you to fall deeper in love with Him. Nearly everyone who has been to Medjugorje or Hillside return never the same.

<div align="center">♦ ♦ ♦ ♦</div>

417

CHAPTER 32

Sacramental Eucharist Visions

In February, 1990, while in Arizona is when I first saw a rose-colored Glow above the Chalice and Paten at Mass. I blinked my eyes, looked away, looked back, looked at the choir, and looked back again. The rose Glow was still there, as if a light under the altar was shining upward. I knew this was something special, for when I looked, I felt wrapped in peace. This now was my lifes second miraculous wonder of the Holy Eucharist.

†

During the next Mass at St. Elizabeth Church in Sun City, Arizona, I saw a white, nearly silver, shimmer of light around the edge of the Host when it was raised. It was about half an inch wide, shining outward from the Host.

†

Some time passed, and in June at Mass in Our Lady of Grace Church in Muskegon, Michigan. I again saw the white light. It remained even when I looked away and back again. It was as bright as a flame with the yellow gone. This time it was about an inch wide, outward from the Host!

<p style="text-align: center;">†</p>

In Grand Rapids, Michigan, **a priest made the Sign of the Cross above the chalice**. Then again I saw a sudden illuminating Glow flowing over the Paten, and overflowing the Chalice. I was sure these were very holy priests, and I believed that this miracle belonged to them.

<p style="text-align: center;">†</p>

In June 1992, I saw the Glow was still coming at many Masses. I realized that possibly I was seeing a miraculous wonder, but I told no one except my husband. Then November 1992, I was called by our Blessed Mother to make a trip to Medjugorje in the spring of 1993. Many things were happening during the years 1990 through 1993.

<p style="text-align: center;">†</p>

Another sign of this time was a voice calling out my name in our home. My husband and I would go from room to room, checking to see if someone had come in. No one else was in the house. ***Oh yes, I felt that I was being prepared.***

<p style="text-align: center;">†</p>

In February of 1993, I went to my priest after Mass who was my spiritual director, *"Father, I want to tell you something you may not know. I SEE AN ILLUMINATING LIGHT around the Host and the Chalice during Consecration. Something very spiritual and*

*wonderful is happening with **you**! I do not see in all churches and not with all priests, but YOU are one it happens with most."*

"Wonderful," he stated, *"**this is your gift, not mine**. **You see the Glow, so it is your gift!"***

"My gift? Really?" I said, *"This has been happening on and off since 1990."*

"That's good," Father responded.

"Father, I always knew the Presence of my God was in the Eucharist and now I can see His Glory! Thank you, Father!"

<div align="center">†</div>

Father instructed me, "Go tell, especially priests and others if they will listen." And so I did. First I would tell the priests in the churches where I could see the Glow. Later, I began to tell a few friends within our church and family. I would share by telling all who wished to listen. Many priests do not believe and many Catholics today do not believe in the priests power of consecration. And so it began. This maybe only the beginning.

Seeing the Glow and knowing it is (a gift) was affirmation God is surely close in my life.

<div align="center">†</div>

On April 19, 1993 after we returned to the United States. I wondered if all visions would stop now that I had obeyed our Mother Mary's instructions and

Sacramental Eucharist Visions

was back at home in Michigan.

<p style="text-align:center">✝</p>

During Mass at St. Michael's in Muskegon, Father Fred, who often said mass weekly in this church too, raised the Host and a Glow of about six inches illuminated the Host, first, and then the Chalice. A four inch Glow flowed over Father's hands. When raised together, the light was dazzling! I was filled with such joy in seeing God's Presence in Light!

<p style="text-align:center">✝</p>

Seldom do I *not* see this Glow at daily or Sunday Mass. The *first* time I did not see it, I kept looking and saying, *"God, where are You?"* And as the Eucharistic ministers received Communion, I realized that I would not see this wonderful vision that day. I asked, *"Jesus, am I not cleansed enough?"*

Deep inside my heart I heard, ***"I AM HERE."***

<p style="text-align:center">✝</p>

My life continues to be busy with speaking engagements in churches and pilgrim trips to Hillside, Illinois, where I take caravans of cars to the Cross. After praying the rosary at the Cross, we go to a local church for Confessions and Mass.

<p style="text-align:center">✝</p>

Benediction is a time of visions as well. The Sacramental Glow is so brilliant that it flows out to the peaks of the monstrance. I do not have enough

time to tell you every vision. I am highlighting these events that you may know they continue. I tell you, **His Presence *is* with you!** Be joyful! Rush! Run! Open your hearts and feast on receiving your God!

<div align="center">†</div>

I am amazed at the people who have contacted me and told me what my sharing of these Sacramental Eucharistic vision has done for them. I especially was pleased when an Eucharistic minister told me: "I am so happy. I will never be the same, after reading of your visions of the Sacramental Glow around the Host, and how you see the Presence of God flow over the hands of priests and Eucharistic ministers. I was shocked and choked up. I never ***REALLY REALIZED*** God is present in the Host and present in the Chalice. I was only doing a ritual, with no more meaning than lighting a candle. I was told long ago that it is God. But it never sunk in. Now I try to see from your words of the Glow. Now when I go to move the Chalice, I am more reverent. I move slower. I am growing spiritually, growing to love ***HIS PRESENCE***, as you do. Sometimes I look at my hands holding the Chalice and wonder if ***HIS PRESENCE*** is flowing over my hands. Communion has taken on a whole new meaning for me. *I believe you have this gift of visions for people like me*. Thank you for sharing. Thank you for showing me Jesus."

<div align="center">♦ ♦</div>

Just when I thought it was my private gift, God gives my gift, ***through sharing***, to everyone! Isn't this wonderful?

<div align="center">♦ ♦</div>

To date, I still am blessed with these precious gifts. Come join me in sharing the celebration of the Mass! Come share His Presence with me!

Jesus, my Friend, my Brother,
I pray You will touch my life.
Forgive my weakness.
I confess with my inner heart and lips,
That You, alone, are my Savior.
Take away my burdened heart.
Lift me up in joy.
Cleanse me, mold me to Your Gentleness.
I receive You, right now;
I feel Your warm Light.
Mend my soul, my mind, my body.
You know my needs; meet and heal me
By Your Mercy.
Fill me with Your Presence.
Give me a nature benefitting of Heaven.
I believe in miracles of Your Power.
I expect my healing in Your Name.
*Jesus, **I adore you**.*
Amen
(Little Olive Branch)

†

My most fervent Quest of my soul,
I pray that You will impress upon my heart,
Works of spiritual and corporal love for others.
I ponder within myself,
And contemplate Your living sacrifice.
Come Holy Spirit.
Make me grow deeper in love with Your Glory.
My Lord, You are manifest in my Food of
Holiness.
Our Great Sacrament Revere.
Bring me into Your Light.
Come Holy Spirit.
Let me give You thanks.
Amen
(Little Olive Branch)
†

"My Eyes Are Set Upon the PRESENCE
Of My GOD!"

(My prayer as the Sacramental Eucharist is raised
during the Consecration of all Masses and
Benedictions.)

♦ ♦ ♦

(You will notice ahead that I choose to separate the Eucharistic wonders from the visitation wonders! In both chapters you read of wonders not registered in other areas of this book, however, they are from my personal journal and as a major part of my autobiography. Those who have already been told say, I must share with the world that you must all enjoy in God's Wonders!)

Visitation and His Word

ONTHS RACE ON, God's plan for my life and time continues.

†

While reminiscing, I shall remind you of my first vision of Sacramental light was in the fall of 1948 at age ten. The second miraculous wonder of light was in 1960, when I was sent on a supernatural journey and a visit to one of God's heavenly abodes. The third vision or wonder was four exact dreams during the 1970's, whereby I am to find a certain mountain. A special encounter will take place there. I have searched and in God's timing I will be led to this mountain.

◆ ◆ ◆

MY FIRST FULL CORPOREAL VISION OF JESUS

On February 25, 1993, we were at Thursday evening Mass in Our Lady of Grace Church. During this time I glanced at the tabernacle in front of our pew on the left side of the church! I was speaking to God within the tabernacle. I saw a dim light that became brighter, until it was illuminating in a bril-

liant glow. Inside the light was a form, then the total **Heavenly Being of Gentle Jesus.** I was drawn into the light within Divine Jesus. His light was one with my light. I felt one with Him.

His pure, blue eyes had a clearness that was gentle and drew me into Him even more. A joy deeply filled me. His gentle face was almost translucent and of olive tone, though so fair. His nose was slender and perfectly in proportion to the frailty of His structure. His hair was medium brown. It seemed sandy at the top, perhaps because of the glow of light surrounding Him, giving a cast to the top of His hair. It was wavy, curling at the bottom and resting on His shoulders.

He was of average height, though I did not think to judge His size for He was standing upon a thick mist. His fingers were perfect and long, like His Mother's. He wore a simple white robe and His feet were uncovered.

His voice was gentle but fatherly, masculine but not frightening. He was adorned in this illuminating light, and I basked in His love. When He gave instructions, His words were slow and direct. I hung my head in humility. My tears began to flow. I covered the top of my head with both hands for a moment. He spoke to me and said: *"I AM HERE WITH YOU."*

As I returned my eyes upward to Him, I was *alive* with *joy!* Tearfully, I watched as He floated to the

right side of the center altar. At this same time, our holy priest was about to raise the Host and Chalice. A four inch Glow adorned the Host and Chalice! More brilliant than other times when I had seen this Glow! Divine Jesus departed just as our holy priest was raising the Eucharist.

<center>†</center>

In the sanctuary, I shared with Father the visit of Jesus and His speaking to me. Father stated, "This is your gift."

I'm not sure the apparition really sank into his mind on that day.

Later I reminded Father again of the event, and of the Glow I continue to see, and he said once more: "This is your gift."

<center>†</center>

One day a friend said to me: "I believe but others are questioning how can you see Jesus."

I said to Nancy: *"I know you are referring to the Bible, and one does wonder, including me. I only know my vision is true. I'll take this to my Jesus."*

I spent many hours in meditation and then went back to God's Word in my Bible. My Bible fumbled and as I caught the Holy Word in mid air, the page opened to the book of Matthew. I began to read Scripture and quickly I came across Matthew 23: 39:

For I tell you this, you will never see me again

until *you are ready to* **welcome** *the one sent to you from God.*

I smiled and said, *"Thank you, my Jesus."*

♦ ♦ ♦

Time passed and on March 21, 1993, my Divine Jesus used me once again. This time as a ***witness*** in Hillside, Illinois where Divine Jesus "flowed" over the corpus upon the Cross, and then moved to the left of the Cross. He was all in white, looking the same as in February, inside of a brilliant light.

The following day, March 22, 1993, I was called by God to be a ***witness*** to our Blessed Mother's visitation to Joseph Reinholtz. Little did I know that for the next few weeks, I would remain a witness to Our Lady, during Her apparitions to Joseph and to Ivan Dragicevic of Medjugorje, Bosnia Herzegovina.

♦ ♦ ♦

After my return home from Bosnia Herzegovina on April 19, 1993, I was sure my visions must be behind me. On May 10, 1993, I received a call, "We would like to invite you to a prayer meeting with us, could you come?" Upon saying yes, **I was unaware** of a reason for the invite. One of the women had a dream where Our Lady came at St. Lazares. She kept going weekly for a very long time but Our Lady did not come to her then she decided she was to bring someone else Our Lady may appear to. After hearing I

Visitation & His Word

was a visionary, she wondered if it was me she should ask!

One morning when three of us were in a prayer group in the chapel of St. Lazare Retreat House in Spring Lake, Michigan. While in deep meditation, a familiar feeling of warmth and peace overcame me. I looked up during the Lord's Prayer, glancing at the crucifix beyond the altar. I was about to bow my head and meditate back into the passion of Christ, when my eyes picked up light to the left of me. I saw the full vision of our Blessed Mother's face but this time is was more vivid. I was stunned, but when I looked away to the altar and back again, this beautiful face was gone.

I bowed my head and lifting my face, opened my eyes to see the gentle, beautiful face of Blessed Mary once more. Again I shook my head and looked to the altar as if I could not believe what I was seeing. I prayed, *"Please, Jesus, guide me. Is this really Your Mother?"*

We entered into more prayers, and I thought, *"Wow! Why is this happening?"* For the third time she came forth and this time she stayed, looking so gently at me. I asked, *"Is it really you, Blessed Mother? What do you want of me?"*

She departed, but near the end of our prayers, Blessed Mary came forth one last time. Her face was the same face I had seen many times in Medjugorje.

431

I was not sure, but Her dark hair seemed to be more noticeable than before. I was in an awesome peace. I then said to my Mother Mary: *"We are your daughters. We give ourselves 100% to you. Do you want us to come again. Are you calling us to something? Is your visit for all of us or for me? We love you so much. I will do anything for you, my Mother."*

She did not speak to me on this day. One asked the priest if we could return, just in case our Blessed Mother was going to call us back. JoAnn is devoted to Our Lady and God's Will.

◆ ◆ ◆

On June 29, 1993, we visited the Divine Providence Church in Westchester. After Mass we gathered in the prayer room. Near the end of meditation, I felt a tap on my left shoulder. I was overcome by light and the total form of Gentle Jesus, standing before me. I was lost in time. He spoke to me, saying, *"I AM COMING SOON."* His beauty filled me with joy, and I was in peace!

After prayer, I felt a hand on my right shoulder. This time it was Joseph Reinholtz, smiling. Often I find that the message is part of another message to come. In this case my spiritual director reminded me that we knew it from Scripture all our lives. I realize from other messages I've received, however, that something more is coming very soon.

On that day, God's Presence was felt strongly

among others. My friend, Rocelia, said, "You had a vision, didn't you? I know because I've seen you before during apparitions. I could feel God present." Still in a quiet state, I nodded yes to Rocelia.

In this room, on this day, were three locutionists, two visionaries, and many spiritual prayer partners. Each person there was so in love with Sweet Jesus and had a deep trust in His Mother.

<div align="center">†</div>

August 2, 1993 was a wonderful day at the Cross in Hillside. Blessed Mary allowed me to see her twice during the apparition to Joseph. Once again I was a witness. She overwhelmed me when she spoke to me and said, *"I Am Pleased, My Daughter."* I lowered my head, feeling so shy, not at all worthy of her notice of me.

<div align="center">†</div>

My friend, Ginny, was also permitted to see the silhouette of Blessed Mary on this day! Her joy in this gift was reflected in the awesome expression upon her face. I was so happy that she was chosen also to be a witness at Hillside, Illinois.

<div align="center">♦ ♦ ♦</div>

Divine Jesus' voice came to me on September 22, 1993. *"BE PREPARED,"* He said. This was a very deeply moving moment. The following day, He spoke to me once more: *"REMEMBER MY RAINBOW."* Did this refer to God's promise after the

433

flood, in Genesis 9: 11-13:

" . . . I will never again send another flood to destroy the earth. And I seal this promise with this sign: I have placed my rainbow in the clouds as a sign of my promise until the end of time, to you and to all the earth."

Or, did it refer to the rainbow that appeared in the skies over Denver when Pope John Paul II spoke there in August, 1993?

◆ ◆ ◆

On September 24, 1993, Divine Gentle Jesus appeared to the left of the cross in Hillside, Illinois. Gentle Jesus' face with clear eyes and in a radiant light, dressed all in white with His hands outward said to me: ***"BRIDGE ILLINOIS TO MICHIGAN."*** I still did not understand until my priest helped me to discern that I was to bring pilgrimages of souls to Illinois and to one prayer group.

†

On September 25, 1993, in Hillside, Illinois in an apparition, Our Lady so beautiful in light before a tree to the right of the cross spoke to me: ***"You Are To Go Into The World And Bring Them To My Son."***

†

I was in St. Mary's Church in Muskegan, Michigan on September 27, 1993, when Jesus came as a silhouette near the side organ. He told me: ***"THE***

PHOTOS ARE YOUR GIFT TO TELL YOU I AM HERE." This was startling to me because only God could have known that I was troubled about the many "phenomena" photos we were receiving in Hillside, Medjugorje, and in our own home.

<p style="text-align:center">†</p>

It was 10:05 a.m. on September 28, 1993. I had spent much time in meditation and prayer that morning, for I needed my Holy Spirit to guide me this day. In a few hours I was to speak before a group of women in a local church. I was feeling peaceful and full of His Holy Spirit when a brilliant light, a shimmering Glow of silver and white, appeared, and Divine Jesus came forth. I was lost in the warmth, the peace, the joy. I looked up and asked Jesus, *"Am I your handmaiden?"*

He replied in His gentle, yet masculine, voice: *"YOU ARE MY WARRIOR. GO THROUGH THE WORLD. KNOCK ON THE SOULS OF MAN."*

"Thank You, Jesus," I responded.

Risen Jesus was so beautiful! He was, as I always see Him: in His thirties; His gentle face with purest soft blue eyes looking upon me; wavy brown hair to His shoulders; He wears a white gown!

<p style="text-align:center">†</p>

On October 1, 1993, at 12:50 p.m. at Visitation Church in Elmhurst, Illinois, during Benediction, Our Lord gave His tabernacle an illuminating Glow

as the door opened. The tabernacle is to the right, facing the altar. When Father lifted the Host in his hand, it was so aglow that Father's hand was covered by the illuminating silver-white light. The monstrance was aglow and I lost time, for I was overcome with joy as Gentle Jesus came forth from the right side, facing the altar and people.

His face and arms were vivid. His lower body was more of a silhouette. Gentle Divine Jesus spoke to me: *"COME, FOLLOW ME; I WILL CARRY YOU. BRING MY CHILDREN."* **(silence, and then)** *"DO MY WILL. I AM WITH YOU."* Once again my priest helped me to understand the meaning of this vision.

It was after this vision, that I leaped from my image of myself as a "purple sheep," to that of a "white lamb" in Jesus' care.

<div align="center">†</div>

I was led to Maryland to speak. Many signs took place, including healings, conversions of soul, and a powerful movement of our Holy Spirit. Though this was to be a week of spirituality for others, I, too, received my share. My companion, Ginny, and I were returning home to Michigan on October 30, 1993. We stopped to visit the Grotto Shrine of Lourdes in Emmitsburg, Maryland.

After a visit to the chapel, where His Holy Presence is reserved in the tabernacle for all to visit, we wandered into another chapel where Benediction

Visitation & His Word

was being held. Once again, the Sacramental Eucharist was before us in the monstrance.

<center>†</center>

Then Gentle Risen Jesus came behind the left side of the altar and He spoke to me. ***Divine Jesus comes during the Eucharist and Benediction time.***

<center>†</center>

I await God's lead for my work in life. On November 1, 1993, Ginny and I were en route back to Michigan, from a spirit-filled trip to Maryland. I've learned that wherever my mission field is, Divine Jesus, Blessed Mary, and my Holy Spirit are close by. Along highway I-96, between Lansing and Grand Rapids, Michigan, Ginny and I were praying the fourth decade of our third rosary for the day (in accordance with our Blessed Mother's request). I noticed directly ahead, a bright star. By the time we were into the fifth decade, we could see a funnel of brilliant light from as high as one could see. At the bottom of the funnel of light was our Blessed Mother. Her short veil and dress, outlined in an illuminating shimmer of silver and white, were blowing in the wind. She stood on a small cloud, facing the star.

I pulled off onto the shoulder of the highway. We cranked our necks (Ginny could see her, too) as we watched our Mother Mary move to the left, floating away from the star. When she stopped, I'm not sure,

for I was lost in time and awe, in joy and peace.

Our Lady of Americas, then spoke to me: *"Your Fruits Are Bearing. Your Sacrifices Were Many. You Are My Daughter. I Am Your Mother."*

When I finally turned and spoke to Ginny, I could see her tears of joy and a kind of blush on her face. She was full of grace. She reached for paper on which to write the message given to me.

We sat quietly for some minutes, as Our Lady of Americas remained, hovering in the sky. I realized Our Blessed Mother was still there. I realized She was watching over us, as a mother would watch over her children on the street. We felt so comforted. As I drove away, I looked to the left, out of the driver's window. Like a small child, I said to Her, *"Bye. Goodbye,"* and waved with the fingers of my left hand. I was humbled, feeling like a child protected.

♦ ♦ ♦

As I have stated before, God has blessed me with my husband, Bob, who accompanies me in this journey of deep faith. Bob has had his share of miracle happenings as well. The vision of Gentle Jesus December 7, 1993 belongs to him told by my husband to the world.

†

It was about one o'clock in the morning, when Bob awoke and sat up. He described to me what he had seen. He said, "Across the bed, standing beside you,

was a man in a white, long-sleeved robe. His hands extended outward. My eyes moved up the arms of the man. His face was not totally clear, but the wavy hair reached to the shoulders. An unusual peace flowed over me."

Bob's face is filled with grace, and he glows as he tells his story: *"I knew who He was. I had an inner knowledge He was JESUS.* I was peaceful, and kind of smiled. I looked at Carol. She was sleeping. I looked back beside her and Jesus was still there. Bob ends with, "I just felt like it was natural. Jesus was beside us. So I rolled over and peacefully went back to sleep."

♦♦♦

Often people ask, "How do you expect people to believe in visions?

I suggest that they open their Bibles and turn to Acts 2: 16-18:

> . . . *What you see this morning was predicted centuries ago by the prophet Joel—"In the last days, God said, 'I will pour out my Holy Spirit upon all mankind, and your sons and daughters shall prophesy, and your young men shall see visions, and your old men dream dreams. Yes, the Holy Spirit shall come upon all my servants, men and women alike, and they shall prophesy.'"*

♦♦♦

I believe I am a *witness*, telling others of Divine

439

Jesus' return, to quickly repent and prepare. For this reason, I have told my spiritual director that I will continue to share the gift of my visions and messages, with others. I believe that I was gifted to view one abode of Heaven, and that I may impart to others this wisdom and understanding, and offer them encouragement. Do not fear the bridge we cross to enter life everlasting.

†

WHEN A MIRACLE IS YOURS
I rejoice; I'm at the beginning;
I am in Peace.
I have reached deep inside,
And given all I am and all I can to others.
My ache of love is beyond my old thoughts
And practices of thinking only of myself.
You, Jesus, You are first.
You are my Driver, my Molder, my Worth.
O great Spirit of Life,
Enter into me, wash me;
Stand me strong against evil.
Let Your mighty fire leave a burning desire in me.
Put a plan into my mind that I may do only Your
Will.
Lord, I am thirsty, so thirsty.
Give to me the Spring of the Water of Life.
Let me eat the Fruit from the Tree of Life.
You are my bright Morning Star, my A through Z.
*My miracle is **faith** in knowing and loving only You,*
Gentle Jesus.
Amen
(Little Olive Branch)

Our Lady Loves Lebanon

and St. Sharbel

O N DECEMBER 8, 1993 THE feast of the Immaculate Conception, we were on pilgrimage to Hillside, Illinois, to join in prayer with others. We then attended an eleven a.m. Mass at Our Lady of Lebanon Church in Hillside, followed by benediction and a full day of Masses, the rosary, and other Marian devotions. This is a great church to be in on a feast day of Our Lady!

†

During Mass, as the priest, leaned deeply over the chalice, he made the blessing of his hand over the paten and chalice, a Glow came forth. His face was reflecting the glow from the illumination over the paten and chalice. As Father raised the Host and chalice, the brilliant Sacramental Glow caused me to cry joyful tears. Each Host from the paten was aglow as the priest placed His presence on tongues.

♦ ♦ ♦

During Benediction following Mass, the Sacramental Glow was beyond the points of the monstrance. While the priest set the monstrance above the back altar, the people sang in Latin. During

the chanting, I was given a vision in sequence. *From the center of the monstrance came forth a Host, whiter than white, about four times larger than the circumference of the actual consecrated Host in the monstrance. There was the Gentle, Beautiful, Face of Jesus. I do not recall the time or what may have been going on around me. I remember that His Presence was still there, (even when His Gentle Face left me in a wonderful **first vision**.)*

<div align="center">†</div>

A rosary began and the Ave Maria's were still being sung by the people, when above the glowing monstrance *came forth Our Blessed Mother in a first corporeal vision. She was in a shimmering white dress with gold at the neckline and gold edging. She wore a golden crown as she looked downward over the monstrance. Her arms came inward as her graceful, slender hands cradled her Son in the monstrance. This **second vision** was so beautiful!* (Then Mother Mary departed.)

<div align="center">†</div>

Soon there came forth in this sequenced vision from the center of the monstrance, *another Host pulsating. Coming forth from the Host was the vision of little Baby Jesus! His chubby baby body had no clothes. His little feet moved and His left arm moved upward. He was alive in movement! His head had soft, wavy, curly hair. (He then departed from this*

443

third vision.)

<div align="center">†</div>

Ave Maria was being sung as I was in stillness in time during this apparition. A drift of roses gently passed by our pew. As the next decade began; *again Our Blessed Mother came forth. Her face radiated love as her arms again moved downward until her hands appeared to be holding the monstrance in the* **fourth vision**.

<div align="center">†</div>

In the *fifth vision*, while still in a yoke of time and silence, came forth another vision: *a man's side profile. His hooded head looked up as though he could still see where Our Mother had been. He remained for some time.* (I did not know who he was as he faded in departure.)

<div align="center">†</div>

In a **sixth sequence vision**, *Our Blessed Mother came forth, he head tilted, and looking downward upon her Son in the monstrance. Her arms came in once again, as if to lift the illuminated monstrance and she once more* **cradled** *her Son in her hands.*

<div align="center">†</div>

Our Lady left us all this day with a bouquet of roses aroma which filtered the air over the pews. Most could feel her presence and many told me they smelled a strong aroma of roses.

444

This sequence of visions was powerful. It left me feeling as if I were in slow motion, in *total peace.*

♦ ♦ ♦

Later that afternoon, after more devotions, I took several of our pilgrims into a side chapel in Our Lady of Lebanon Church in Hillside. As we walked up the right aisle, I saw off to the right, candles and a shrine. I looked, and to my amazement, I saw a painting of the hooded man of my vision earlier that day. I quickly went back to the vestibule and asked a worker, *"Who is the man in the hood in the picture at the right front of the church?"*

She replied, "That's St. Sharbel."

"Who?" I responded. "I never heard of him!"

She explained, "He is a saint of the Eastern church.

†

We proceeded to the chapel to which Joseph had once led me. He placed a special blessing on me, as requested by Our Lady. We prayed before the white crucifix which holds a rosary of Ivan's.

†

I felt somewhat withdrawn from the remainder of the day, although I shared my vision with my fellow pilgrims.

Upon arriving home, I called my spiritual director.

Mother was saying, in cradling emotions, "This is my Son!" Thank you, Father. I believe you are right.)

♦♦

I then asked Ginny to research St. Sharbel. She called the next day, responding to my request, and the visions came together smoothly and meaningfully. It seems that St. Sharbel, a Lebanese Maronite priest, always said his daily Mass at eleven a.m. Mass that day!) St. Sharbel promoted devotion to Our Blessed Mother and was known for his deep love and devotion to the Holy Eucharist! This information made the meaning of the series of visions complete, except for the Baby Jesus. Why was the little Baby Jesus showed to me in the vision?

†

Again, Ginny called back with that answer, too. "Guess what, Carol? St. Sharbel died on Christmas Eve!"

"Oh, wow!" I exclaimed. "That explains the vision of Baby Jesus!"

༄

Prudy McKenzie is an established artist
from Sun City West, Arizona.

Her works are seen throughout the West
in Professional buildings. Her portraits of
children are beloved. She is well known for her
commercial art Indian portraits .

༄

PORTRAITS OF VISIONS
LIMITED EDITION AVAILABLE

All proceeds from lithographs will be directed
and divided amongst the non-profit charities,
the Children's Orphanage in Mostar, Bosnia and
the Preservation of the Hands of Priests
and Adopt-A-Priest Programs in the U.S.A.

To order a lithograph call: **708.636.2995**

Address for Adopt-A-Priest:
Our Lady of the Holy Spirit
5440 Moeller Ave. • Norwood, Ohio 45212-1211
Phone: 513.351.9800

Donations for Orphanage in Mostar:
Make checks payable to: Franciscan Sisters of Mostar
c/o CMJ Associates, Inc. • P.O. Box 661
Oak Lawn, IL 60454

Vision One*: Jesus comes forth from the Consecrated Host.*

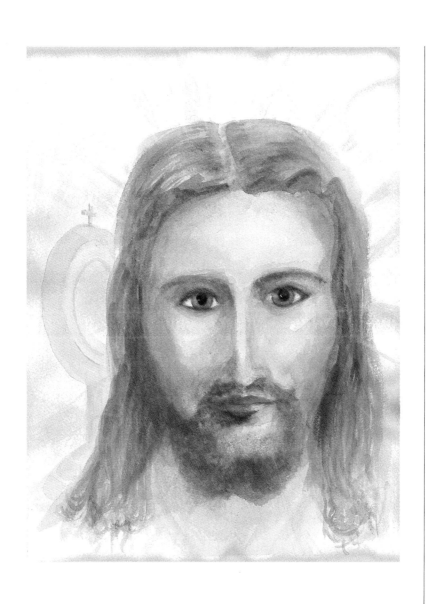

Vision Two*: Gentle Face of Jesus.*

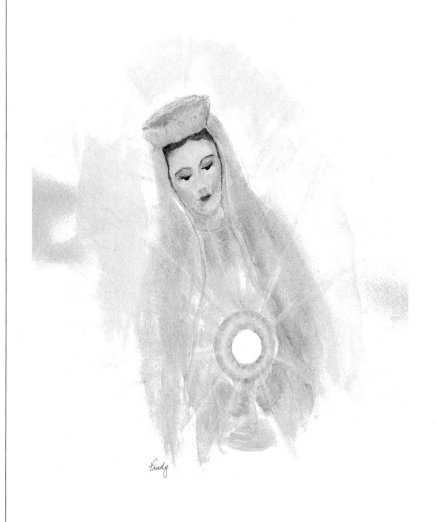

Vision Three: *Our Mother cradling the Monstrance.*

Vision Four: *Little Baby Jesus.*

Vision Five: *St. Sharbel.*

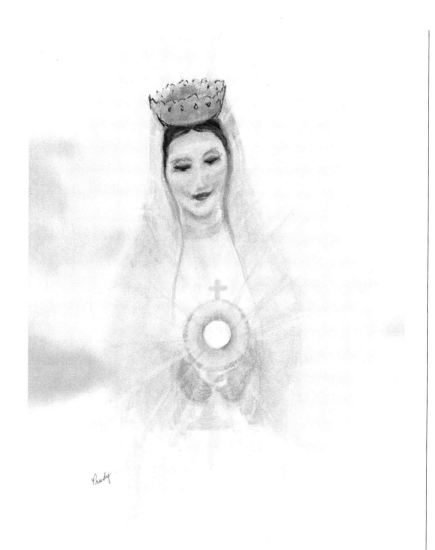

Vision Six: *Our Mother Mary, "This is my son."*

Who Is St. Sharbel?

†

WHY WAS I SHOWN ST. SHARBEL in this vision and who was this saint? It is my belief that when I have been shown a saint or messenger for God that He means for me to know more about him and then *reveal* to your the knowledge which I have gained.

♦♦

St. Sharbel, to my discovery, was a mystic (visionary) of the east (1828–1898). He was a man filled with a yearning for God. He lived as a Trappist monk and hermit from Lebanon. As a child, St. Sharbel was contemplative and silent. All plants and life-creation spoke to him of God. He was a mystic who can truly open to us the mystery of God's inner love. St. Sharbel is canonized, accepted as a saint, in the Eastern rite of our Catholic church. (When I refer to Eastern Rite, it is because the Catholic church is made up of two "lungs", being the Roman Catholic-western rite, and twenty-one rights which belong to the Eastern church. These twenty-two rites are under the Pope, a one-body of Catholics. The separation of rites is normally seen by the difference in liturgy; in some rites of the Eastern churches, they allow priests to marry and have families. Also do not confuse the Eastern rite Catholics with the Eastern Orthodox

454

churches which are under the Orthodox Patriarch.)

<p style="text-align:center">♦ ♦ ♦</p>

To return to the discovery of St. Sharbel, I continue to share with you his love.

The steady flame of St. Sharbel's burning love would last as a reminder forever. St. Father Sharbel believed that keeping the commandments means *making a change and getting out of sin, giving all you have.* For St. Sharbel, this is getting into perfection. For this saint, it was his only counsel of perfection, to please God. He liberally taught that "What Blessed Mary gave was purely human, and what God gave was divine."

<p style="text-align:center">†</p>

As a great evangelist wherever he appeared, the crowds went wild and even priests bowed to him shouting "Let's see the man of God!"

<p style="text-align:center">†</p>

Saint Father Sharbel meditated day and night on the sayings of the Desert saints. His life resembled theirs; it was only separated by years.

<p style="text-align:center">†</p>

Even in his small monastery, the demons were so vicious and appeared so often in visible forms, that the monks, took turns to stand guard, as the devils came as impure women, or even as a cleric with arguments against the faith itself, and tempting

doubt. The devils often came disguised as angels to give confusion.

<div align="center">†</div>

At one point, St. Sharbel had a bout with the devil. When the others heard him wail, they asked him, "What's the matter with you?" St. Sharbel answered, "A diabolical temptation attacked me and I was upset."

<div align="center">†</div>

In his humility, what St. Sharbel did not ever see was how his holiness had an effect on others.

<div align="center">†</div>

When Father Sharbel was innocently accused, he would remain meek, and kneel down, and with open heart, say to his accuser, "Forgive me, brother, for the love of Christ."

<div align="center">†</div>

This is the reason why this world will endure, when there remain Christ-like souls. (Hands tied by love.) The more St. Sharbel saw Christ in others, the more they saw Christ in him. Only people saw the grace of God in him, while he saw the indwelling of God in them.

<div align="center">†</div>

His sanctity became hard to hide, and as people heard of him, they came for healings. St. Sharbel would allow long lines to come before him as he prayed over them. He sent them away cured in mind and body. St. Sharbel had a deep love for Jesus in his

heart and the truth of Jesus' words in his mind.

<div align="center">†</div>

St. Father Sharbel was known as a most devout priest. His thanksgiving after Mass would last as long as two hours. One time, while praying before the altar, a storm came and lightning struck and burned his habit. The saint was oblivious to everything around him. While in prayer, he was in heaven.

<div align="center">♦ ♦ ♦</div>

Oh, how well I understand, being so one with Jesus that I do not even hear my prayer or realize that I am of this earth at times.

<div align="center">♦ ♦</div>

St. Sharbel was granted by God a chrism of control over nature. Moreover, St. Sharbel was known for his Eucharistic miraculous signs, although he did not report what he saw. One day, he held the Host, saying before those present, "Father of Truth" (and he felt a sharp pain and was unable to move.) Another monk had to pry open St. Father Sharbel's fingers (which were paralyzed) and put the Host and Chalice on the altar for him. For eight days the saint kept repeating the Sacred Name of Jesus, Mary, Joseph and all the apostles.

<div align="center">♦ ♦</div>

Once again, I relate to his being frozen during the consecration. How many times have I been so frozen

in a time-span unknown to me, as my eyes look upon the Presence of God in His light about the Host and Chalice! Oh, how many times have I been overjoyed as I walk up to receive my God in Holy Communion. I recall also those times His brilliance in light before me. I would be so filled with drawing His Presence into me, that I would stand before the priest or extra-ordinary minister of the Eucharist, in moments of ecstasy, filled with God's love, frozen in a time-span of peace, so that I did not even put my tongue out to receive Communion. Except when I melted into a union with Him, then my burning hunger took over and my mouth would open to receive His Presence in the Eucharist.

†

Yes, I understand the love St. Sharbel had for the Holy Liturgy in his favorite 11:00 a.m. Masses. He spent considerable time honoring Our Blessed Mother, whom he credited for the conversion of souls.

†

St. Sharbel was about one hundred and five years old when he died on Christmas Eve in 1898. He was a man of simpleness and because of the custom of his day, he was buried with no casket. After three months in a ditch with water, his body was still incorrupt.

♦ ♦

I am not aware if others (who have visions) have

ever been shown this saint besides me. Because I am Western *Roman* Catholic and have no knowledge of saints from the Eastern Catholic rites, I was in wonderment of how this saint's life *related* to mine!

<center>†</center>

Having clearly discerned this vision and all of its meanings, including the vision of St. Sharbel, I have come to appreciate the gift God gives all of us when He gives us faith. He gives us a burning love for Him. This vision is truly a message by the movements of Our Blessed Mother. Each time in the vision, she lovingly cradled her Son! Without words, she said, "This is my Son!"

<center>♦♦♦</center>

I also believe that this visionary-mystic, St. Sharbel, also must have seen, as I do, the "Sacramental Eucharist"—His Light, His Presence, around the consecrated Eucharist! Why else would he also have frozen? Like myself, he too must have really felt what it is like to be frozen while in-love!

<center>♦♦♦</center>

St. Sharbel's final resting place is located: AMAYA Lebanon Monastery–thirty-five miles north of Beirut. A priest says, recently, it was discovered and it is believed that St. Sharbel's body is extruding oil.

<center>†</center>

Thank you, Jesus, for in learning of this saint, I was

given a private confirmation of the gifts you give to me.

The remainder of this year was a continued surrender.

It was on December 12, 1983 in a visit at the cross in Hillside, our Blessed Mother called me to witness again. I was humbled like a small child before her, filled with joy. I watched her graceful movements in her pure white gown, with her gold crown dazzling.

To the left of the cross, I witnessed Divine Jesus in a dazzling white gown?

On December 13, 1993, again, I witnessed Our Blessed Mary all in white with a gold crown. I did not see Jesus on this day. In devout prayer with my friend, Shirley, I shared in seeing the joy as she was given her first experience at the cross. Our Lady gave drifts of the aroma of roses and lillies. Symbolic of her visits.

Before leaving Joseph Reinholtz approached me and said he had a message for me.

"From your Mother, you are to be more careful. Why is my daughter impatient? I am with her."

As the year came to a close I reflected my life. This year being the most memorable.

◆ ◆ ◆

Surrender...He Is Knocking On Your Soul

HO AM I TO EVANGELIZE'?"

Oh, yes, how correct you are. The least surely is me.

To be a Western Roman Catholic is to believe in the Scriptural teachings, that God gave the Apostles, our first bishops of the Church, a special gift: the power to forgive sin; to grant or to withhold absolution of sin; to give *assurance* that when we repent and have true contrition, our sins are forgiven:

"Receive the holy Spirit. Whose sins you shall forgive are forgiven them and whose sins you retain are retained." (John 20: 22-23)

†

Does this mean that we cannot, as children of God, speak directly to God and repent? Would He hear us?

Surely, for Non Catholics, for those near death, for those unable to have a priest nearby, God hears you.

Jesus, in His Crucifixion and Resurrection, saved all his children. But Jesus requests repentance for sin, true sorrow, and *change.* It is not enough to say

461

simply: "I'll do my thing; Jesus did His." We must change:

"*. . . Go and sin no more.*" *(John 8: 11)*

Baptized Catholics are obligated to confess through a priest. Baptized Catholics are obligated to confess any mortal sin of which they are aware (another name for a mortal sin is serious sin or grave sin, they are all the same) **at least once a year because church law requires** Catholics to receive Holy Communion at least once a year. This is called the Easter Duty. Time after time in private revelation, Our Blessed Mother has requested we go to Confession at least once a month.

The healing graces received in confession help us to *change*. God wishes to guide us to holiness. Through confession with a priest, we receive counsel, comfort, **true absolution from our sins**. We receive graces for strength and peace of mind each time the priest says, "Your sins are forgiven, and all those in your past." Wow!

If we have been in the state of mortal sin, we are returned to the state of grace and friendship with God. We must, however, **do penance for our forgiven sins, since the temporal punishment still remains** after confession and forgiveness.

After a good confession, we are now ready to receive our true Jesus, His true Presence, Body and Blood, Soul and Divinity, in His Eucharist.

462

Remember always that neither a minister, nor a deacon, nor a woman, have the power to mystically change bread and wine into His Presence. Only an ordained, sanctioned priest who is part of the unbroken line of Apostolic Succession, has this power. Ministers may break bread and share the bread among us. We may share the juice. But we have **not** received His Presence in Communion unless the man before you is an ordained priest with a line of laying-on of hands dating directly from the apostles.

Others may distribute the Holy Eucharist. They are instruments of aid. But only a priest has the mystical power of Consecration.

Will I share bread and juice within another's faith? Surely, with the permission of my own parish priest, when I am in the house of another, I will not turn away from the food I am offered. Surely, I will join in glorious praise to our Eternal Father with my brothers and sisters in Christ.

Is God present in the Protestant church? Oh, yes. *Where two or more are present, He is present.* (Matthew 18: 20). Is Jesus present in the communion bread in the Protestant church? No, but He is in our presence to glorify! The Apostolic Succession present within the sacrament of Holy Orders (the priesthood) was not preserved in the Protestant churches (although in the case of the Anglican [Episcopalian]

463

and Lutheran churches, we do have a great deal in common.) Therefore, communion in a Protestant Church is a memorial service of unity in the living Jesus, while awaiting His glorious return, rather than the actual Body-Blood-Soul-Divinity Presence as it is found in the Catholic church.

May Protestants come to a Catholic church to receive Holy Communion (this is called inter-communion). Normally no, although there are exceptions under certain circumstances, thus, not by church law.

Do we invite our Protestant brothers and sisters to Catholic Mass? Yes! We are delighted to have you join us in our worship, but we may not offer you the Eucharist unless one is a Catholic. Therefore, when visiting us during Catholic Mass, enjoy being among His people, in His Presence, and in His Word. Exult in happiness, in praising God in song with us.

<div align="center">†</div>

Catholics may receive Holy Communion in an Orthodox church if we have the permission of the Orthodox pastor. Permission is not needed from the Catholic authorities for this.

<div align="center">†</div>

As Catholics, we believe in spiritual Communion. When and how often can we receive spiritual Communion? Just as often during the day as we wish. All we need to do is invite Jesus into our hearts and

our souls.

<div align="center">†</div>

Some Protestants believe that they were the first to discover and adopt the Holy Spirit. Untrue. Our Catholic Bible first mentions the Holy Spirit in its very first book:

> *"And the Spirit of God moved upon the face of the waters," (Gen 1,2).*

Jesus began developing His revelation about the Holy Spirit during the Last Supper. Just before His ascension, He left us these words,

> *"Go into the whole world, baptizing them in the name of the Father and of the Son and of the Holy Spirit". (Matthew 28).*

And since 325 A.D. (the Council of Nicea) our Mass has always included the Nicene Creed which says, *"I believe in the Holy Spirit..."*

It is true that the Protestants were the first to receive the current outpouring of the Holy Spirit in the United States. In our country, the Holy Spirit and his charismatic gifts were first poured out in a little prayer group in the Topeka Bible College, Topeka, Kansas in 1906. It finally reached us Catholics on February 20, 1967 during a retreat weekend of students from Duquesne University in Pittsburg, which has come to be known *as the Duquesne Weekend.*

All of us may call upon His Holy Spirit to come

into us, to fill you up! When we become enveloped in and bask in His Love, we will invite His Holy Spirit into our heart and soul often during the day. Listen and His Holy Spirit will be our greatest teacher and guide.

Do Muslims believe in a Spirit? Yes. Do they believe in Jesus as God? No. They believe He was a prophet, but not God.

Neither do Jehovah's Witnesses believe that Jesus is God, but also, a prophet.

However, most believe in the same Eternal Father—God—the Creator of all. Spoken as Jahova/YHWH, Lord.

<div align="center">†</div>

We believe God sent His Son, Jesus, to save His children by sacrificing Himself for our sins. God sent His Holy Spirit, that we may be baptized in His Spirit, filled with Him! When you believe in this, you believe in the Holy Trinity—*three individual and unique persons in one God!*

<div align="center">†</div>

A greatly misused sacrament today is our Holy Eucharist. Yes, one is encouraged by our Blessed Mother to attend Mass and to receive Christ's Body and Blood in the Holy Eucharist, as frequently as we can. However, we must be very careful not to receive Holy Communion without first repenting and being cleansed of our sins. We must be in a state of grace.

466

Frequent visits to the confessional and frequent examination of conscience are a must. Of course, one may never receive Communion if one is aware of being in a state of mortal (serious) sin. This is a sacrilege, a serious sin, in itself. Repent while examining your conscience. Make a promise to change.

Confess your sins to God through a priest.

"GO IN HASTE."

My dear Brothers and Sisters in Christ,

Those who wish to send prayer petitions or letters to me, The Little Olive Branch, please feel free to write and send to:

<div align="center">

The Little Olive Branch

P.O. Box 5357

SunCity West, Arizona 85376

</div>

SUMMARY

I HAVE BARED MY SOUL, my life; God's Mercy poured over me.

†

I was told that my life and my soul would be a window, through which the world would judge me, for I claim to be a *witness*, a locutionist and visionary, sharing my experiences with you. When you come to know that we are all **equal**. You will know I am merely my Eternal Father's instrument.

†

Join me in the Mass and share Bread and Wine, in Memory of Him, receiving His Presence in our mystical Holy Eucharist.

Finally, join me at the foot of the Cross. Be my prayer partner, my brother, my sister. Repent with me. Help me to give *PEACE* to this world by respecting and loving each other.

Your sister in Christ Jesus,
Little Olive Branch

†

~**Suffering is misunderstood by the majority of Christians. Why me, Lord?**

~*By Way of the Cross* is a didactic piece of contemporary literature whose aim is to help men and women of the 90's face their daily lives with peace and hope.

~Carol Ross is a living testimony that suffering, combined with a living faith, can redeem the modern soul.

~A victim of polio from earliest years, Carol Ross overcame this dreaded disease only to find herself in the grips of multiple struggles.

~One of the most moving chapters is *By Way of the Cross* describes how her thirteen-year-old son is accidentally shot. This telling chapter is an example to any of us who at times have the urge to complain about our trifling sufferings. His courage and the courage of this mother is strength for our times, in the power of healing through prayer.

~*By Way of the Cross* is the first of a series which will narrate the miraculous nature of this remarkable woman who is truly a heroine of the 90's.

~Four years ago, Carol Ross began receiving visitations from her Gentle Jesus and His Mother, Mary.

~Her after death experience of the 1960's provides a fascinating glimpse into the afterlife, when she is met in a tunnel of light by a "Lovely Lady" and three mysterious men. The center man said:

"You must go back. You have more to do."

~The work that Carol Ross soul has returned to her body to accomplish is beautifully described by the author herself.

~*By Way of the Cross* is written in a pleasant style, with its' short chapters moving quickly across the exciting life of a modern-day St. Catherine of Siena.

~For those who are living without hope today, *By Way of the Cross* comes highly recommended by me Reverend Richard.

—*Reverend Richard*

**~I believe, for I have no reasons not to believe
in my wife, Carol.**

~I also believe a visit from God in a Shekinah light and Jesus vivid
before me was also to assure me that we are really in his plan.

~Carol was honest and shared most experiences of her life with me
before we married. I admire her strengths and deep faith.
I credit my wife for deepening my faith.

~Having encouraged Carol for years to tell the world
the truths and facts and morals of her incredible life.
Over the years I've listened and seen others up-lifted in spiritual
growth by the moral examples of her life.

~As a mother, I have seen Carol's dedication and love for the
children; as well as her care and guidance of the children from
other families and troubled souls who come to her.

~Her generosity in time and of monies,
surpasses anyone I've ever met.

~For me, my wife is a living angel, a gift from God for me.
A living angel in today's world.

~When you read her autobiography, and of the incredible stories
with credible facts to support them. You will be left to your own
growth in loving her as your humble, and loving sister.

~It was her intention to share her life in condensed stories
under the name Jesus has given her (Little Olive Branch)
so no attention be given to her.

~However, I and others have requested she be open and let the
world know her as Jesus sees her and as we know her.
Maybe then you will understand why she is called
to such a great ministry today.

~This book will touch you in some way I am sure.
As you read this book, remember God has a plan for you to.
Just ask God to guide you every day.

—Bob Ross

BY WAY OF THE *C*ROSS

ORDER FORM

Name _____

Address _____

City/State/Zip _____

Cost per book _____ Quantity of books _____

(Sales tax 7.75% for Illinois residents only)

+ Shipping & Handling _____

Total Amount $ _____

Check/Money Order in the amount of: _____

Charge my Visa, MasterCard or other: _____

Card number _____

Expiration date _____

Signature _____

Send or Fax to:

CMJ Associates, Inc. • P.O. Box 661 • Oak Lawn, IL 60454
708 636 2995 phone *or* 708 636 2855 fax
Please allow 3-5 weeks for delivery

Bookstores

If you know of a bookstore who can spread the message,
please pass this information on to them.

New Release Coming Soon

By the Way of Rome • By Carol J. Ross